GILBERT MUNGER

Quest for Distinction

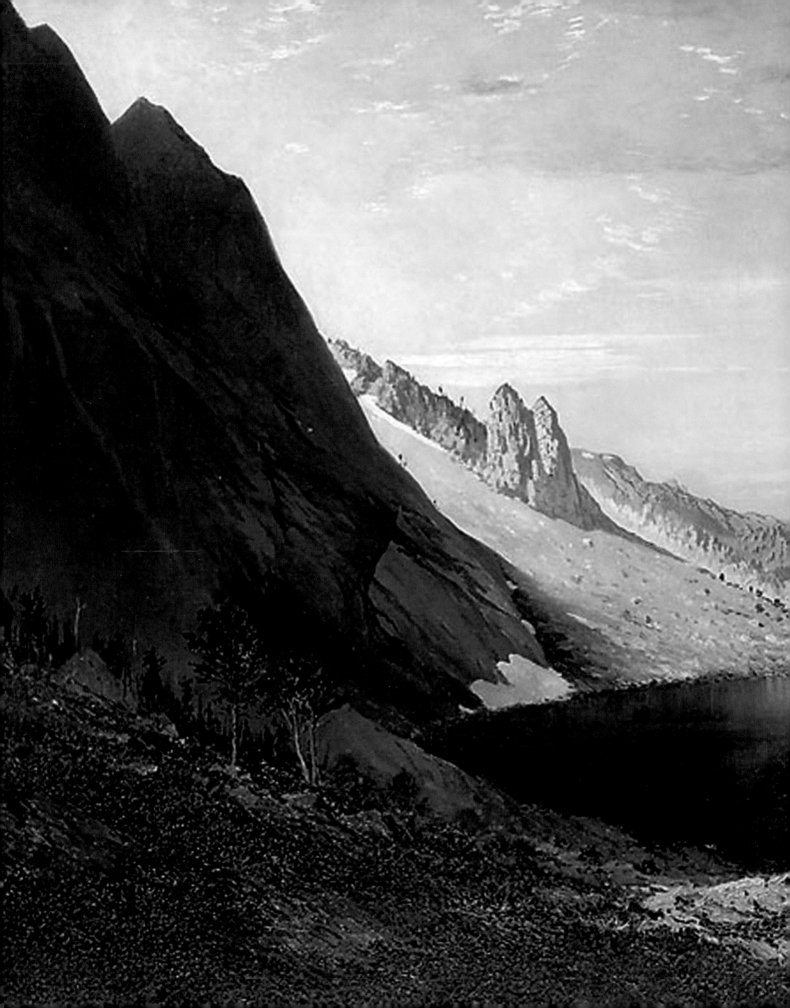

GILBERT MUNGER

Quest for Distinction

Michael D. Schroeder
J. Gray Sweeney

Foreword by Alan Wallach

Afton Historical Society Press
Afton, Minnesota

The publication of
GILBERT MUNGER:
Quest for Distinction
was made possible by
generous gifts from

Lucy C. MacMillan Stitzer,
Katherine MacMillan Tanner,
Alexandra MacMillan Daitch,
and
Sarah MacMillan Chaney
in memory of their mother,
Sarah Stevens MacMillan

The Henry Luce Foundation
New York, New York

The Alice Tweed Tuohy Foundation
Santa Barbara, California

Mary A. Anderson
in memory of
William R. Anderson Jr.

Edwin and Sarah Pomphrey

GILBERT MUNGER:
Quest for Distinction
is published on the occasion of
an exhibition organized by the
Tweed Museum of Art,
University of Minnesota Duluth.

Exhibition dates:

Tweed Museum of Art
University of Minnesota Duluth
July 26–October 12, 2003

The North Point Gallery
San Francisco
January 14–March 6, 2004

Lyman Allyn Art Museum
New London, Connecticut
September 24–December 5, 2004

Frontispiece: *Lake Marian – Humboldt Range – Nevada,* 1871, 26 x 44,
oil on canvas. Collection of Mr. and Mrs. Daniel A. Pollack, New York.
Image courtesy of the North Point Gallery, San Francisco.

Edited by Michele Hodgson
Designed by Mary Susan Oleson
Printed by Pettit Network Inc., Afton, Minnesota

Library of Congress Cataloging-in-Publication Data

Schroeder, Michael D.
 Gilbert Munger : quest for distinction / Michael D. Schroeder,
J. Gray Sweeney.
 p. cm.
Includes bibliographical references and index.
ISBN 1-890434-57-4 (alk. paper)
1. Munger, Gilbert, 1837–1903. 2. Landscape in art.
I. Sweeney, J. Gray. II. Title.

ND237.M868A4 2003
759.13—dc21

 2003001473

Printed in China

The Afton Historical Society Press publishes
exceptional books on regional subjects.

W. Duncan MacMillan Patricia Condon Johnston
 President Publisher

Afton Historical Society Press
P.O. Box 100, Afton, MN 55001
800-436-8443
aftonpress@aftonpress.com
www.aftonpress.com

CONTENTS

FOREWORD

WHEN THE LANDSCAPE painter Gilbert Munger died in Washington, D.C., in January 1903 at the age of sixty-five, he was an almost forgotten man. Thirty years earlier he had enjoyed an enviable reputation for his paintings of such exotic western subjects as the Donner Pass (which he had sketched with Albert Bierstadt), Shoshone Falls, and Yosemite Valley. And yet, despite praise from critics and solid sales in San Francisco and New York, in 1877 Munger decided to leave the United States for England, where he restarted his career painting Scottish landscapes in the company of no less a personage than the veteran pre-Raphaelite John Everett Millais. After nine years in London, where he achieved real success with renditions of American, English, and Venetian scenery, Munger moved on to France. In England he had fallen under the spell of J. M. W. Turner and the pre-Raphaelites; in France he adapted his style to the traditions of the Barbizon School. He remained in Paris and Fountainebleau for seven years before returning to the United States in 1893. He spent the last decade of his life trying, unsuccessfully, to regain a foothold in the American art world.

Munger contributed to his own posthumous obscurity. Cautious and often secretive, he was not in the habit of maintaining a relationship with a dealer or middleman but instead dealt with patrons and buyers directly. Consequently, as Gray Sweeney points out, no one in the United States was sufficiently invested in Munger's work to keep his name alive. It is true that after the artist's death James Cresap Sprigg, a businessman active in New Jersey Democratic politics, took on the job of upholding Munger's reputation. Sprigg published a brief memoir of the artist and organized a retrospective at Noé Gallery in New York early in 1904. He also tried, unsuccessfully as it turned out, to donate examples of his friend's work to the Metropolitan Museum and the Yale University Art Gallery.

Sprigg, an art-world outsider, had become acquainted with Munger in the late 1890s and knew little of the artist's training or the early years of his career. Although he attempted in his memoir to trace the artist's development, beginning with the works Munger had painted in New York in 1866, he was unable to grasp fully the artist's range. Sprigg summarized Munger's achievement as follows:

> *It can be truthfully said of Gilbert Munger, as of Millet, Corot, and Daubigny, that he created not only a distinct style of treatment, but a distinct style of subject, and revealed to the*

world the artistic possibilities of the very simplest phases of nature when translated with a sympathetic appreciation of their modest beauties and the subtle poetry which invests them.

In Sprigg's view, Munger was the heir of the leading lights of Barbizon. Like Millet, Corot, and Daubigny, Munger had found "artistic possibilities" in "the very simplest phases of nature." But this was to ignore his earlier achievements: the great, panoramic renditions of western scenery that had won him the critics' applause in the 1870s along with an American and English following.

Sprigg's ignorance can be easily explained. He was no connoisseur, and while he claimed for Munger "a distinct style of treatment," he could not readily distinguish between the different phases of the artist's oeuvre. Moreover, he probably had seen only a small portion of the artist's output, mainly works from the 1880s and 1890s. Of the six paintings he reproduced in his memoir, only one, *The Falls of Minnehaha*, predated the artist's move to Europe. Of the other five canvases, one was a view of Venice, the others typical Barbizon School subjects painted in a style reminiscent of the Barbizon masters—the border of the Forest of Fountainebleau, the Seine at Poissy, the Forest of Fontainebleau itself, and Saint-Germain.

If Sprigg believed that Munger would be remembered as a subtle landscapist in the Barbizon mode, he was sadly mistaken. The Noé Gallery exhibition drew only one notice and that was from a writer for the *New York Commercial Advertiser* who had never previously encountered Munger's work and who wrongly assumed that the artist had made his whole career in France. To his eyes, Munger's dark landscapes looked hopelessly out of date.

The same could have been said of Munger's paintings in the style of the Hudson River School since they belonged to an era in the history of American art that turn-of-the-century critics and collectors had learned to despise. As early as 1877 the influential Clarence Cook was using the term "Hudson River School" to disparage the outsize ambitions—and outsize canvases—of Bierstadt, Frederic Church, and Thomas Moran, artists Munger had admired in his youth.

Despite Sprigg's best efforts, the unfashionable Munger was quickly consigned to art-historical oblivion. There he remained for the better part of a century. Munger went unnoticed in the revival of the Hudson River School that began in the late 1930s. His paintings did not figure in the rediscovery of American Barbizon that took place in the 1960s and 1970s. His name received no mention in the *Grove Encyclopedia of American Art Before 1914,* published in 2000.

The reasons for Munger's obscurity are not difficult to locate. His art divides into two large stylistic categories—Hudson River School, Barbizon—and a host of subsidiary categories. Consequently, the artist who could so convincingly portray both Yosemite and the Forest of Fontainebleau turns out to be an art-historical nondescript, impossible to pigeonhole and therefore impossible to assimilate to the sort of history of art that relies on conventional

narratives of style and stylistic evolution. Munger's oeuvre cannot be understood, à la George Inness's, in terms of a slow and seemingly inevitable progression from one landscape style to the next. Nor does his apparent eclecticism, his ability to work in a variety of styles at once, square with traditional art-historical ideas about nineteenth-century artistic development.

Seeing Munger whole—seeing this protean figure as a complicated artist with a complicated history—is a daunting task. Happily, a number of scholars, foremost among them the authors of the present book, have recognized that understanding Munger's contribution to the history of American art is very much worth the effort. As this book and accompanying exhibition reveal, that contribution has to do not only with Munger's artistic achievements, although a close examination of his work confirms that he was, to paraphrase Gilbert and Sullivan, the very model of a major minor master, an artist who could on occasion produce truly spectacular work. It also has to do with his historical role as an artist-explorer. Munger's participation in Clarence King's U.S. Geological Survey of the Fortieth Parallel in 1869–1870 constitutes an important and hitherto barely noticed chapter in the history of western American art. The artist's chromolithographic illustrations for King's *Systematic Geology,* published in 1878, by themselves merit an exhibition for the light they shed on King's survey.

This book brings together the fruits of more than two decades' worth of collaborative research: Gray Sweeney's insightful interpretive study of the artist and Michael Schroeder's extraordinary Munger catalogue raisonné, readily accessible on the World Wide Web. Thanks to Sweeney and Schroeder, we can now understand Munger's achievement in relation to American artistic culture of the period 1865–1900. As this study makes clear, that culture was far more multifaceted, far more complex than we may have ever imagined.

Alan Wallach
RALPH H. WARK PROFESSOR OF ART AND ART HISTORY
PROFESSOR OF AMERICAN STUDIES
THE COLLEGE OF WILLIAM AND MARY
WILLIAMSBURG, VIRGINIA

CURATOR'S FOREWORD

WHEN GILBERT DAVIS Munger's brothers Roger and Russell ventured to Minnesota from their Connecticut birthplace in 1859, they unwittingly set into motion the chain of events that, exactly one hundred years after the artist's death, culminate in *Gilbert Munger: Quest for Distinction.* The music business Roger and Russell established in St. Paul became a Midwest stopping place and sometime studio for brother Gilbert. There he painted the largest canvas of his early career, *Minnehaha Falls,* in 1868. After 1869, when Roger moved north to the western terminus of Lake Superior, where he was instrumental in founding the city now known as Duluth, Gilbert traveled and painted there as well.

Another accident of history that led to the Tweed Museum of Art's role in the organization of this project is the fact that Gilbert Munger never married. Had he, it is likely that the body of work left in his Washington, D.C. studio when he died in 1903 would have ended up in an entirely different location than Duluth. As it happened, it was Roger Munger's duty to close up his brother's studio, oversee the settling of his estate, and bring Gilbert's body to Duluth for burial. Paintings left unsold in the artist's studio also came to Duluth at that time. Roger's descendants, many of whom remained in the Midwest, had the foresight to preserve Gilbert's works and donate them to the Tweed Museum of Art.

As caretaker of the largest group of paintings by Munger in any one place, the Tweed Museum of Art sees this and similar projects as an exact fulfillment of one of the main goals underlying its mission—"to collect, preserve, research, document, broaden access to, and develop as a resource, works of significant artistic and cultural value." Our Munger project also highlights the important role regional museums play in reconstructing an accurate picture of the history of American art. Smaller institutions across the country house countless bodies of excellent work that have been missed by the searchlight of American art history. Until the Internet became a tool for art historians, artists were often overlooked simply because the evidence of their lives and careers—paintings, letters, artifacts, descendants—were located in places far off the beaten track of researchers. With assistance from the Henry Luce Foundation and the Alice Tweed Tuohy Foundation, and in collaboration with scholars J. Gray Sweeney and Michael D. Schroeder and Afton Historical Society Press, the Tweed Museum of Art is finally able to give Munger's work the attention it deserves.

It has been my great pleasure to function as curator of this exhibition, and to work among the riches of the collection at the Tweed Museum of Art, which include outstanding examples of French Barbizon and American landscape painting, many of which are related in spirit, style, and/or subject to Munger's work. Having spent the majority of my fifteen years in museums working as a contemporary curator, I am dedicated to the goal of helping the public relate to the complexities of recent art. In the case of Munger, though, the question is, what can these paintings say to contemporary viewers? How, through twenty-first century eyes, do we consume the work of an artist whose earliest known work is now 140 years old?

Whether triggered by an image, a novel, a movie, or a song, the process of allowing the objects and images of history to connect us with the past is always somehow therapeutic. In tandem with the facts assembled here, which lend the story invaluable context, such nostalgic musings give us a framework in which to imagine the texture of Gilbert Munger's life as we view his art.

When you see Munger's work, you are looking at paintings of natural phenomena created by an individual for whom the latest technological innovation was the steam engine. These "old" landscapes also give rise to a keen awareness of how relatively unspoiled and quiet the nineteenth-century physical environment must have been when compared with our own. Landscapes like Munger's necessarily remind us of the gap between historical and contemporary attitudes about the environment. As Nancy K. Anderson has stated, "Looking at nineteenth-century paintings with twentieth-century eyes carries unavoidable risk, for the modern viewer is privy to history's judgement, while his nineteenth-century counterpart (both artist and viewer) was charting a new course on untrodden land."[1]

Munger's paintings function as windows onto the past, and the work's rich visual detail and specificity give us an especially clear and precise look at the historical landscape. What is presented here about Munger's life from age thirteen on also creates a richly detailed and entertaining story about the self-willed construction of an artist's career in post–Civil War America. Our project sheds light as well on the progress of art and science, American westward expansion, the evolution of late-nineteenth-century painting styles, and the art markets in Europe and America.

Munger's American works through 1877 reflect a time when artists, scientists, and entrepreneurs worked together, if not always for the same reasons. His paintings of the American West existed simultaneously as aesthetic objects for art collectors, as teaching tools for geology students at Yale University, and as illustrations for Clarence King's *Systematic Geology.* So it was that Munger's two *Duluth* (1870–1871) paintings were used to convince Congress to fund that city's development, and are now an important part of its historical record.

Because we can usually identify the places, and sometimes even stand at the same vantage point, from which he painted, Munger's

images offer us the opportunity to see first-hand what has happened to the landscape in the interim—to literally see across time. This may be especially helpful with the lesser-known locations Munger painted in both America and Europe. His *Minnehaha* (1868), for example, documents a powerful waterfall, where development has since reduced the flow of Minnehaha Creek to a stream. Another case in point is *Berkeley Springs*, which Munger dated 1894, one year after his return from Europe. My search for the painting's location revealed Berkeley Springs, West Virginia, the site of a popular hot springs, and then accessible by train from Washington, D.C. When I visited the site, discussions with local residents pointed to a property owned by the town's mayor, on which there had once been a resort hotel next to a stage line.

A 1904 postcard published next to the painting in the *Morgan Messenger* recently showed the property ("Fruit Hill"), where a private mansion had been turned into the St. Elmo Hotel in the 1880s. So it was that the painting's location and a bit of local history confirmed each other.

It is my hope as a curator that *Gilbert Munger: Quest for Distinction* opens wide a new window on a rich and fascinating history that deserves to be much better known. It offers many exciting visual rewards for contemporary viewers, to most of whom this material will be new and freshly discovered. Through ambitious projects such as this, the Tweed Museum of Art is proud to throw a powerful searchlight on America's rich artistic heritage.

Peter F. Spooner
Curator, Tweed Museum of Art
University of Minnesota Duluth

NOTES
1. Anderson, Nancy K. "'The Kiss of Enterprise': The Western Landscape as Symbol and Resource," in *Reading American Art,* eds. Marianne Dozema and Elizabeth Milroy, New Haven: Yale University Press, 1998.

PREFACE

IN MID-NOVEMBER 1872, during intensely cold snowstorms at Donner Lake on the summit of the Sierra Nevada, an aspiring landscape painter from Connecticut made notes as he sketched alongside one of the nation's most illustrious artists. "I am now sketching this place with Bierstadt," he wrote. "We work from sunrise to sunset, muffled up to our eyebrows in furs. . . . We are sketching in the snow, sketching snow-storms and snow effects. . . . I am now familiar with the scenery and know where all the best things are." He went on to relate that Bierstadt "wishes me to accompany him on his sketching tours." That aspiring artist was Gilbert Munger. Albert Bierstadt's impressions of his sketching companion are unknown, but the two artists remained in social contact in New York through the 1870s, although they apparently never again sketched together.

For more than a century, this dramatic meeting of two landscape painters in search of snow effects—one regarded today as a giant figure of landscape painting, the other now little known—was forgotten. Yet Munger went on to claim a high place in the best circles of art and culture in San Francisco and New York. Later, in London, he was quickly accepted by leading artists for his artistic talent and by society as a dinner guest valued for adventurous tales of the exotic American West.

How did art history overlook Gilbert Munger? Frequently at the heart of art history are stories of discovery. The finding of "genius," of charismatic figures of art, descends as a leading narrative from the first art historian, Vasari, to William Dunlap, who claimed to have discovered Thomas Cole, to Clement Greenburg's finding of Helen Frankenthaler and the abstract expressionists. Our story is also one of rediscovery, but with a critical methodology. It results from new ways of working collaboratively. *Gilbert Munger: Quest for Distinction* presents the fullest account of Munger to date. Research for our study, along with the unique Gilbert Munger Web site, has accelerated recovery of details about the artist and his works. We hope our book will offer a useful model for twenty-first-century cultural studies.

Munger was often called a genius by critics of his time. His great mentor, Clarence King—scientist, seasoned explorer, writer—was by every measure of the age charismatic. Munger's early success as an artist began with an invitation from King to go out west in 1869. The opportunity to paint western scenery, along with an astute sense of how to "perform" the game of art, launched Munger's career. In his prime, he was equally skilled at holding his own at a fashionable dinner party among famous artists, scientists, and intellectuals of

his time, sketching alone in a wilderness camp, and painting late into the evening aboard his solitary houseboat on the Thames or the Seine. In London he appeared as a fascinating, if mysterious, member of a small expatriate American cultural elite that could have figured in one of Henry James's novels.

Gilbert Munger painted at a historical moment when conditions in the field of art production first allowed American artists in large numbers to stake new positions and command increased economic and cultural status. Munger flourished in these social conditions. He rapidly earned national professional recognition, mastering two of the most complex customs of the art world: self-fashioning and acquisition of powerful friends and patrons. Entirely self-sustaining from his art, he parlayed these advantages into a long, successful career in America and Europe.

From his youth, Munger believed he was destined to become an artist. Early in his career he aspired to produce a "great picture" that would win fame and fortune. His training and alliances in the world of scientific exploration gave him an appreciation of the importance of topographic accuracy, and he recognized photography as a visual benchmark. Scientists valued his ability to represent Darwinian ideas of Earth's history in a crisp, realistic style based on close, accurate observation while applying the aesthetic conventions of the Hudson River School to make his paintings emotionally appealing.

The interaction of visual art and Earth science at the core of Munger's practice has emerged as an issue of importance in contemporary cultural studies. Munger provides a compelling case study for these concerns through his long career. Drawing on the theories of Pierre Bourdieu and recent scholarship in American art history, our book illuminates Munger's quest for recognition in which he learned to please both scientists and art connoisseurs.

It is a pleasure for me, a historian of American art, to collaborate with Michael Schroeder, a computer scientist and a student of Munger, in sharing our study of the artist through the Tweed Museum of Art at the University of Minnesota Duluth. The 2003 exhibition, "Gilbert Davis Munger: Quest for Distinction," highlights the Tweed Museum of Art's major holdings of Munger's work and includes never before exhibited paintings, photographs, graphic art, books, letters, and memorabilia.

J. Gray Sweeney

FOLLOWING HIS DEATH in 1903, Gilbert Munger's name virtually disappeared from the art world. For the next three-quarters of a century, a few pictures circulated in the art market, but with no fanfare and at bargain prices. Art historians made no effort to find Munger's rightful place until 1980 when two scholars, J. Gray Sweeney and Hildegard Cummings, began the process of rediscovering Munger. They knew of about eighty pictures.

In the mid-1990s, while researching the geographic locale in a Munger painting I had come across, I began to assemble a list of his paintings and associated historical information. The list gradually turned into a catalogue raisonné: the historical compilation into an archive of

period writings related to Munger. Having professional expertise in computers and networks, I put the growing collection of information and images on the World Wide Web. I made this choice, rather than take the traditional approach of publishing the catalogue raisonné as a book, to avoid the expense of publication and the need to be completely finished before publishing.

The Web allows information to be presented as part of the research process, making it quickly available to potential contributors in the art establishment and the public worldwide. Here is how the Munger Web site has worked. Sensitized to the potential for "treasure" in old paintings by popular television programs like *Antiques Roadshow,* someone remembering an old painting in the attic is likely to search the Web as a first step in establishing a valuation. Munger paintings are almost always clearly signed. Simply typing the name "Gilbert Munger" to a Web search service leads to the Munger Web site, hosted by the Tweed Museum of Art, http://gilbert munger.org, where one can compare a picture to the growing on-line catalog. From the site it is easy to contact me by E-mail. Additions to the catalog from E-mail sources have more than doubled the number of known Munger paintings to about two hundred. The Web and E-mail have also speeded the process of finding historical information,

allowing quick interaction with museums, libraries, historical societies, auction houses, and galleries that are on-line. Sometimes the Web is used in turn to provide unexpected help. A mountaineering club in Scotland, for example, posted my E-mail request for verification of a painting's locale on the club Web site, along with the image of the painting in question. (I have received several E-mail responses, but so far no definitive identification.)

As the Munger site grew and attracted attention in the field, I contacted J. Gray Sweeney, author of the earlier study on Munger and contributor to the Web site, to discuss how best to move forward. Our ensuing collaboration resulted in this book.

From a personal perspective, I find Munger's western paintings to be remarkable records of exploration and first encounter, as well as compelling art that communicates the beauty and wonder of the landscape. Initially I found the European works less appealing, but through my work with Gray I have learned to appreciate the trees in the later paintings almost as much as I liked the mountains in the earlier ones.

As an outsider to art history I have enjoyed getting to know Gilbert Munger. I hope my work and our interdisciplinary collaboration will prove a stimulating model.

Michael D. Schroeder

For the complete Gilbert Munger catalogue raisonné and document archive,
visit the Web site at

http://gilbertmunger.org

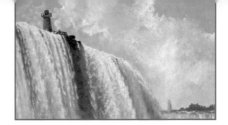

Acknowledgments

THE TWEED MUSEUM OF ART at the University of Minnesota Duluth is proud to present *Gilbert Munger: Quest for Distinction*, a detailed study of the life and work of Gilbert Davis Munger, in conjunction with Afton Historical Society Press. This important Tweed Museum of Art project began with the publication of Munger's work by J. Gray Sweeney in the *American Paintings* collection catalog for the museum in 1982. His study, along with that of Hildegard Cummings, laid a foundation for modern critical discussion. Our Munger undertaking has been nurtured by dozens of individuals over twenty years, and we extend our utmost gratitude to J. Gray Sweeney and Michael D. Schroeder, scholars and authors of *Gilbert Munger: Quest for Distinction,* and to Alan Wallach for his insightful foreword to their meaningful work.

Our thanks go as well to Afton Historical Society Press, publisher of *Gilbert Munger.* We are deeply indebted to Michael D. Schroeder, who is largely responsible for the Gilbert Munger Web site, an on-line catalogue raisonné that represents Schroeder's technological insight and dogged pursuit of works by and sources of information about the artist. The site blends traditional methods of art-historical research with the relatively new frontier of the World Wide Web, and it is due to his efforts on behalf of the Munger project that many artworks and relevant historical details have been discovered, and are organized in such a useful format.

Our sincere gratitude goes to Tweed Museum of Art curator Peter F. Spooner for his comprehensive involvement in the Munger project, handling all aspects of the companion exhibition and offering extensive research assistance to Schroeder and Sweeney. Thanks are due to all the dedicated staff and interns at the Tweed Museum of Art, university officials, and the Tweed advisory board. Special gratitude is extended to Kathryn A. Martin, chancellor, and Jack Bowman, dean, School of Fine Arts, for their encouragement and ongoing support of the Munger project. Our sincere thanks is extended to the many individuals and institutions who lent paintings to the exhibition and granted permission to have works reproduced in this book. Scores of individuals, including former Tweed intern Jabob Esselstrom, offered assistance in locating information and paintings.

We are grateful to the American Art Program of the Henry Luce Foundation for providing a substantial grant to the Tweed Museum of Art in support of this book and its companion exhibition. A generous grant from the Alice Tweed Tuohy Foundation of Santa Barbara, California,

has helped to offset expenses related to the exhibition. Additional financial support has come from the Minnesota State Arts Board through an appropriation from the Minnesota Legislature and the National Endowment for the Arts, as well as the University of Minnesota Duluth School of Fine Arts, Art and Design Lecture Series, UMD Student Service Fees, and the Tweed Museum of Art.

Martin DeWitt
DIRECTOR
TWEED MUSEUM OF ART
UNIVERSITY OF MINNESOTA DULUTH

THE AUTHORS acknowledge the assistance of many individuals who have contributed to this book, particularly the late Jane Jamar, descendant of Gilbert Munger's brother Roger, who kept the memory of Munger alive in Duluth. Alice Jamar Kapla, Henry Woodbridge, Roger Woodbridge, and Lorraine Jamar, all relatives of Roger Munger, provided additional valuable information.

Alfred C. Harrison Jr., president of the North Point Gallery in San Francisco, generously shared newspaper clippings relating to Munger in California and offered helpful comments on the manuscript. Merl M. Moore at the National Museum of American Art similarly shared clippings from New York and Boston newspapers. Their contributions proved fruitful in establishing Munger's reception during the early phases of his career.

Peter Spooner, Tweed Museum of Art curator, and Martin DeWitt, director, enthusiastically supported our efforts.

Hildegard Cummings reviewed the manuscript, while Nancy Anderson, Joni L. Kinsey, Lois M. Fink, and others offered helpful comments during its preparation.

Librarians at the Rare Book Reading Room at the Huntington Galleries and Gardens, San Marino, California, and in the Rare Book and Manuscript Collections of the Library of Congress were helpful in locating materials on Clarence King and Samuel Franklin Emmons. Pat Lynagh and Celia Chin at the library of the Smithsonian American Art Museum, and Jessie Dunn-Gilbert at the North Point Gallery, San Francisco, were helpful with our research.

At Arizona State University, J. Gray Sweeney is pleased to acknowledge the assistance of the Katherine K. Herberger College of Fine Arts Dean's office and Research Council for travel and research support. His colleagues Corine Schleif and Lindsey Pedersen offered helpful reviews of the text.

At the Smithsonian American Art Museum, senior curator William H. Truettner supported two research fellowships for Gray Sweeney and reviewed an early draft of the book.

Finally, we acknowledge the superb work of Steven M. Bardolph at the University of Minnesota Duluth, who prepared the images for the figures and plates, and Patricia Johnston and her staff at Afton Historical Society Press, who edited and designed the book.

Michael D. Schroeder
J. Gray Sweeney

INTRODUCTION

GILBERT MUNGER achieved artistic success by representing recently colonized western landscapes with an accuracy and style admired by scientists and art connoisseurs. Following the Civil War, Munger explored the far West with scientist-writer Clarence King and leading landscape photographers Timothy O'Sullivan and Carleton T. Watkins. Munger's talent and sharp eye for spectacular western subjects carried him to the top of the hurly-burly San Francisco art market of the early 1870s. By the centennial, he had achieved professional standing among the fraternity of nationally recognized landscape painters, yet his artistic ambition led him to go abroad in search of new styles and fortune.

Munger's European experiences further developed his distinctive style of painting. His talent, hard work, and astute self-fashioning provided him with success in a highly competitive field of artists. Entirely self-supported from his artistic production, Munger enjoyed patronage and distinction in England. Although financially successful for most of his career, he did not achieve the wealth he desired: "It will not be my fate to become a millionaire (this misfortune has come to many of my friends)."[1]

The artistic achievement of Gilbert Munger is a body of paintings and graphic work that is gaining renewed respect. His early works are painted in the realistic style of the Hudson River School, while the later ones are suffused with the atmosphere and color of J. M. W. Turner and John Everett Millais, and the rural repose and historic air of Barbizon. Through his long career, Munger's perceptions of nature deepened and matured. His finest paintings equal the work of leading artists of his generation.

Munger began as an engraver before the Civil War. In his early twenties his energy and determination gained him introduction to a powerful circle of explorers, geologists, cartographers, and writers associated with the federal government's expeditions to survey the American West. He was especially fortunate to become a friend of Clarence King, whose magnum opus, *Systematic Geology*, Munger illustrated. His first notice and early patronage, like Albert Bierstadt's, resulted from his production of dramatic images of sites popular with tourists. In the East, he tried his hand at painting famed Niagara Falls, but it was in the West, particularly in California, that he gained recognition as one of the nation's most promising young explorer-artists.

Working beside photographers Timothy

O'Sullivan and Carleton Watkins, Munger produced large finished oil sketches on the spot that are impeccable visual records, with almost as much precision as the images provided by the "photographic operators." His early work also displayed a fine appreciation of aesthetic conventions of poetic sentiment. These he could masterfully manipulate when it suited his purposes or the desires of patrons. By the centennial, he had gained a highly respected position in New York and San Francisco.

Munger returned to New York between his painting trips out West and also spent time in St. Paul and Duluth, Minnesota. His career flourished. After the centennial, perhaps because he had already profited handsomely from selling to English tourists in the United States, he moved his studio to London in 1877.

His European stay was marked by artistic maturity, prosperity, the esteem of critics and collectors, and acceptance in leading artistic and literary circles. He embraced a new personal style of painting emphasizing a proto-ecological relationship with nature in images of places filled with repose and soothing nostalgia. In his early career Munger painted rocks, volcanoes, glaciers, and alpine lakes; later he sought out riverbanks, marshes, and rural harvests. He seemed to focus on the restorative power of trees. During his European period he perfected his persona as a gentleman artist.

He quickly became a successful painter and etcher working among the cosmopolitan expatriates who thronged the imperial capital.

Shortly after he arrived, Munger was befriended by one of the leading artists of the day, John Everett Millais. Munger gained favorable notice of European critics, the encouragement of English art writer John Ruskin, and financial security via sales of his pictures by fashionable London art dealers. Munger's pictures from his European period blended an American sensibility grounded in empiricism with the aestheticism of Turner, pre-Raphaelitism, and the French Barbizon style, all of which he skillfully absorbed into his personal style.

In the decade following his return to the United States in 1893, despite financial adversity and illness, Munger's paintings took on a new weight and concentration of emotion while he further refined the lessons of Europe. With characteristic self-deprecating irony, he told an interviewer in 1893: "I would like to earn the recognition in my own country which I have won abroad. I should like to identify myself with the people of my own land and take an interest in their art life. A man ought not to forget his own country even after a long residence abroad. At least, I shall visit here for several months."[2]

In attempting to resume the place he had left more than sixteen years earlier, Munger hoped to capitalize on his self-fashioning as an artist of distinction, honored by European monarchs and museums, but he never regained the national recognition he once enjoyed. His connections with the American art market had grown stale. Buyers for his paintings were hard to find and critics largely ignored him. When Munger died at age sixty-six in 1903, the art world quickly forgot him.

A photographic portrait (Plate 1) taken in Nice, France, in 1890 represents Munger at the peak of success, in formal "honors" attire. His suit is a full cutaway with tails, beribboned with the medals bestowed upon him. His hair and beard are impeccably coiffed. He commissioned a bronze bust that reproduced the courtly gaze of the photograph. The bust and his art collection were focal points of Munger's self-fashioning as a gentleman artist of distinction, and prime artifacts of his studio with its ambience of high culture. His adaptability was manifest in the way he matured his personal style of painting.

A year after Munger's death, his friend James Cresap Sprigg (1858–1946) published *Memoir: Gilbert Munger: Landscape Artist.*[3] It is the foundation upon which knowledge of Munger rests. Not until 1982 did J. Gray Sweeney[4] and Hildegard Cummings[5] produce the first contemporary scholarly studies of Munger. Before that, William H. Goetzmann published one of Munger's plates from *Systematic Geology,* providing early scholarly recognition of the artist's contributions to King's Fortieth Parallel Survey,[6] and Rena Coen included Munger in her book on Minnesota artists.[7] Later Munger received coverage in the survey of Rocky Mountain painters by Patricia Trenton and Peter H. Hassrick[8] and in the survey of Washington, D.C., painters by Andrew J. Cosentino and Henry H. Glassie,[9] both published in 1983. Munger is included in William H. Gerdts's compendium of regional American art,[10] published in 1990.

Since 1995 Michael D. Schroeder has discovered new documentation, along with many

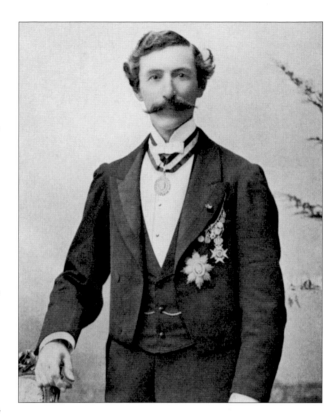

Plate 1: Gilbert Munger, ca. 1890, photograph frontispiece from *Memoir: Gilbert Munger: Landscape Artist,* De Vinne Press, New York, 1904.

previously unlocated paintings, etchings, and photographs, while gathering information for his catalogue raisonné of Munger's work. His Munger Web site[11] contains the full text of period commentary on the artist along with images of almost all presently located works. Today Munger's oeuvre numbers more than two hundred works dating from 1853 to 1902. The new data and this collaboration among scholars are generating renewed appreciation of Munger's place in the history of American art. Among his most enduring accomplishments are his western landscapes. Their scientific precision and aesthetic subtlety place them as major achievements of the nation's explorer-artists in the 1870s.

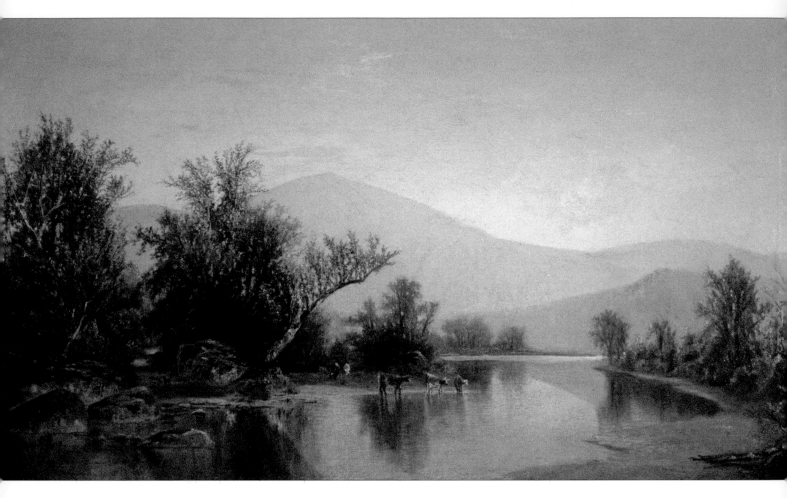

Plate 2: *Cattle Watering in a Placid River,* 1866, 14 x 24, oil on canvas. Private collection.

I

AMERICAN YEARS

1

APPRENTICE ARTIST IN A COMPETITIVE FIELD

STUDENT OF ART

Gilbert Munger followed a promising path to become a professional artist. Born into an old, educated Connecticut family in 1837, Munger had relatives who included accomplished painters of portrait miniatures, although his father was listed in the North Madison census as a "laborer," presumably a member of the working class. Gilbert was the youngest of five children. One of his brothers, Russell, would become a musician and opera backer and, along with another brother, Roger, would promote Gilbert early in his career. After the family moved to New Haven, young Gilbert's talents at drawing were discovered by his English tutor, a Professor Lovell, who said the child would grow up to become an artist.

According to later accounts, Munger's family resisted the idea, an artist's career being an uncertain choice, but the Englishman persisted. As a result, at age thirteen, when boys commonly went to work as apprentices, Gilbert was sent to Washington, D.C., to learn engraving. This was considered a desirable first step toward becoming a professional artist. Gilbert's tutor was to be his first exposure to English culture, and the impression must have been indelible, for he would decades later become a leading Connecticut artist in Britain. His niece remembered replies to his mother's anxious

inquiries as to how the teenager spent his spare time: "Don't worry about me, Mother, I'm always in the best of company and that is Gilbert Munger's."[12]

Early on, Munger developed his distinctive autograph that varied little through his career (see Appendix I) and makes identifying works by him more certain. Very few of his works are unsigned, and some of those may have had the signature cut off when being "resized." The few extant letters from the artist are written with an easily recognizable, well-schooled hand.

Munger's first jobs as apprentice helped to produce engravings of zoological, botanical, and landscape plates for the elaborate government publications that resulted from official explorations in western territories. Government printing and engraving offices, at the service of science and national expansion, were some of the best "schools" for young artists to learn techniques of graphic-art production. Federal-government patronage that supported the production of enormously costly, highly illustrated volumes provided substantial employment for small armies of artists, engravers, printers, binders, and publishers. To have a position, even that of an apprentice, in this extensive government enterprise for graphic arts and scientific-book production

was an important advantage for the youthful art apprentice. Munger gained his first appreciation of the geology and botany of exotic western landscapes working there.

Munger spent more than a decade in Washington. His first exposure to high art thus was in the capital with its comings and goings of artists involved in the massive arts projects adorning state architecture. Knowledge of his activities during this early period is sketchy, but he always maintained that he had worked on the plates illustrating Commodore Charles Wilkes's expedition (to what destination it's unclear) and for Professor Louis Agassiz's books on geology. No images signed by Munger have been identified, although the work of his artistic mentor and landlord, William H. Dougal (1822–1895), who was also a Connecticut man from New Haven, is well represented. Dougal had been out West in 1849–1850 and returned with sketches Munger would have seen either at work or home. As Dougal himself was an accomplished painter, it is fair to surmise that Munger first learned the craft of oil painting from him and through him was exposed to the idea of becoming a fine artist. Munger later recalled studying J. D. Harding's popular books on drawing. In 1853 Munger exhibited his first recorded work at the Metropolitan Mechanics' Institute in Washington, D.C. He contributed a sculpture titled, prosaically, *Clay Model of the Foot.* In 1860 he was listed in the Georgetown (Washington, D.C.) city directory as "engraver," residing with Dougal, also entered as an engraver.

The formative influence on Munger's aesthetic was the English art writer John Ruskin.

(Later in England Munger would seek out the venerable arbiter of mid-nineteenth-century British and American taste.) Munger came of age as an artist at the height of Ruskin's influence in America during the decade before the Civil War. He probably read Ruskin's *Modern Painters* and his letters to *The Crayon,* the leading art magazine of the day.[13] In 1855, in response to the question whether the artist's feelings are more important than truth to nature, Ruskin advised: "The artist is a telescope—very marvelous in himself as an instrument. . . . [T]he best artist is he who makes you forget every now and then that you are looking through him."[14] The attitude of visual detachment that Ruskin prescribed and a belief that sketching in oils outdoors could represent truth to nature became hallmarks of Munger's style.

Munger's early career exemplified a fashionable marriage of art and geology. As an article in *The Crayon* on the "Relation between Geology and Landscape Painting" advised, "The landscape painter studies *mute* creation; and this is his anatomy. He must necessarily scrutinize whatever is pregnant with interest before he reproduces it on his canvas. It is for this own interest and reputation as an artist to understand [that] consequently, although perhaps unintentionally, he is a geologist." Young Munger must have taken to heart the observation that when a landscape painter is "continually meeting with different strata, the query naturally arises, why this diversity? He meets with immense fissures and volcanoes, and he asks himself whence did they originate and by what convulsion were they produced? To him, therefore, properly belongs the study of

geology, as he more thoroughly than any other can imitate what nature has produced."[15]

Meeting important artists visiting Washington such as John Mix Stanley, a friend of Dougal's, stimulated Munger's artistic education. He soon became "boon friends" with fellow landscape painter John Ross Key (1837–1920), and together they sketched in nearby Virginia, where Munger painted his first pictures. They would work together again in California a few years later. Munger always claimed that since youth he had wanted to be an artist and that he had never taken a formal lesson in art. While he did not attend an academy or studio, the decade he spent working in the printing and engraving trades was a well-worn route into fine art for aspiring artists by the 1850s. The engravers' concern with accuracy, detail, and technical refinement in the production of images was to be a lasting lesson for him.

EARLY WORKS

Munger rapidly absorbed traditional aesthetic formulas. His early work skillfully rehearsed long-established conventions of the picturesque, the beautiful, and the sublime. The young art student's assimilation of the style and technique of the Hudson River School is evident in his earliest dated picture of 1866, *Cattle Watering in a Placid River,* representing mountainous landscapes of West Virginia (Plate 2). It deployed conventions of the beautiful mode with its luminous effects and pastoral repose that recall Sanford R. Gifford. Another early work in the topographic style Munger later perfected is a small oil sketch titled *The Great Falls of the Potomac River* (Plate 3). Its precise depiction of the place

makes it possible to identify it as a view from the Virginia shore, about ten miles north of the capital. Its close-up reportorial image of rocks and waterfalls would have been readily recognized within the aesthetic conventions of the view picture.

Scenes filled with light had gained fame and patronage for leading New York artists such as Gifford or John F. Kensett, whose works Munger saw and admired. As an apprentice and self-taught landscape painter, Munger, like so many of his generation, could not have failed to notice the excitement occasioned by the highly publicized displays of "great pictures" by Frederic Edwin Church, Albert Bierstadt, and others. These large, often theatrically sized paintings, such as Church's *Heart of the Andes* (Figure 1) or Bierstadt's *The Rocky Mountains,* represented exotic scenes and invited spectators to survey vast panoramic spaces from a commanding vantage point. To paint a "great picture" and reap its financial rewards became a definition of artistic success in the 1860s. The press cast Church and Bierstadt as superstar artists of the midcentury. Their wealth and national reputations excited the ambitious apprentice from Connecticut looking to make a career in the uncertain world of art.

Perhaps Munger's most distinctive early work before he went out West is an undated *Mountain Lake Scene* (Plate 4). Its crisp definition of forms and an expansive vista in luminous repose suggest his rapid assimilation of conventions that Church, Kensett, Gifford, and Jasper Cropsey made popular. It foreshadows Munger's western landscapes and may date from the mid-1860s,

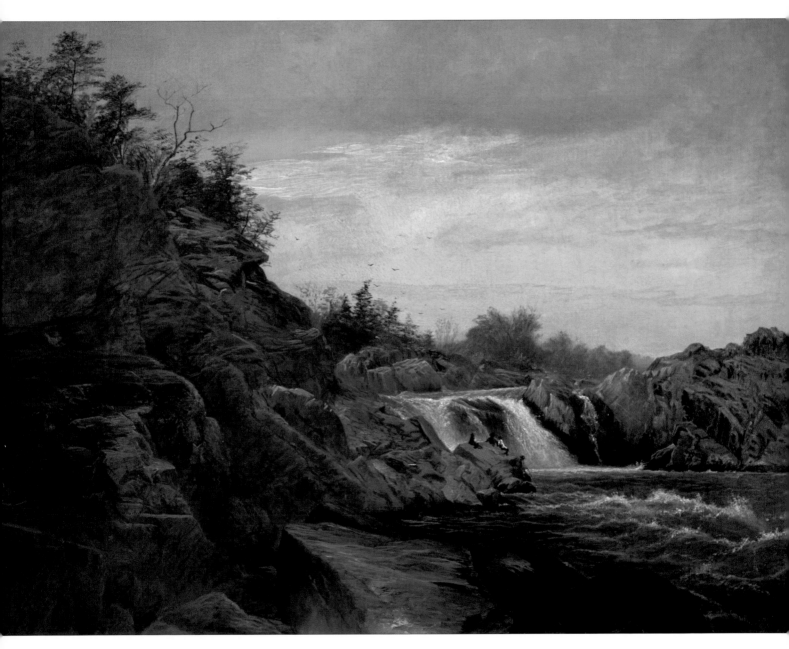

Plate 3: *The Great Falls of the Potomac River,* 16.5 x 22, oil on canvas. Collection of Alice Jamar Kapla.

Figure 1. Frederic Church's *Heart of the Andes,* seen here as exhibited at the 1864 Metropolitan Sanitary Fair in New York City, set the standard for "sensation pictures" of the 1860s. Image courtesy of the New-York Historical Society.

tion shows that from the war's outbreak until early 1863, Munger served as a civilian employee, working as a timekeeper overseeing the records of perhaps eight hundred men assigned to defend the capital city.[16] At the war's end he probably resigned his commission, if he actually took one, and moved to New York, the art capital of the nation. There he rented a studio in the same building with Frederic Butman (1820–1871), who had already painted out West, around Mount Shasta in California, and Munger is likely to have seen his sketches and paintings.[17] Within five years Munger was to produce his own sublime views of the mountain.

A CROWDED FIELD:
CULTURE AND COMMODITY

Munger's official entrance into the art world came in the fall of 1866, when several of his paintings were selected for the National Academy of Design annual exhibition. He showed a landscape of the Cheat River in West Virginia, which he may have sketched with Key, and a literary picture, *The Long Path Together—Autocrat of the Breakfast Table,* based on Oliver Wendell Holmes's story. Both pictures remain unlocated. The latter title is suggestive of a figure or genre scene, a theme Munger chose not to pursue. Although art critics noticed neither of these early academy pictures, during his early career Munger received substantial press coverage, underscoring his rapid emergence in San Francisco and New York. Coming of age as a professional artist following the Civil War was a handicap in some respects because the field of landscape painters was well supplied. The enormous public response to the great

perhaps before he moved to New York. The scene is thought to represent West Virginia, where he sketched with his artist friend John Ross Key.

Like others of his generation with aspirations to begin careers, Munger had to set aside his desire to become a professional artist during the Civil War. Much about his activities between 1861 and 1865 remains unknown. Early sources claimed he mustered out as an engineer in the Union Army, assigned to develop the defenses of Washington, D.C, and rising, one report claimed, to the rank of major. No documentation exists of his military service, although later reports of it are believed to be reliable, if exaggerated. New documenta-

men, like Church and Bierstadt, stimulated the young Munger, but their preeminence and that of others who competed for position and patronage constrained him. The fierce competitiveness of the period and the desire to gain a high level of distinction led the ambitious artist to a new set of challenges and opportunities that would dominate the trajectory of his career through the following decade.

Munger's arrival in New York was propitious because, following the war, a short-lived financial boom ensued as such war profiteers as Marshall O. Robert, A. T. Stewart, and John Taylor Johnson speculated heavily in fine art, running up the market for pictures. Henry T. Tuckerman, called the American Vasari, observed shrewdly in his 1867 *Book of the Artists:* "The increased value of Art as a commodity and its appreciation as an element of luxury, if not of culture, is evinced by the statistics of the Picture trade in the commercial metropolis . . . every year the demand and supply have constantly expanded."[18] The rapidity of change in the Reconstruction era was unprecedented, and Munger, aspiring to gain a position and patronage, quickly adapted himself to the demands of the art market. His decision not to follow a conventional path to

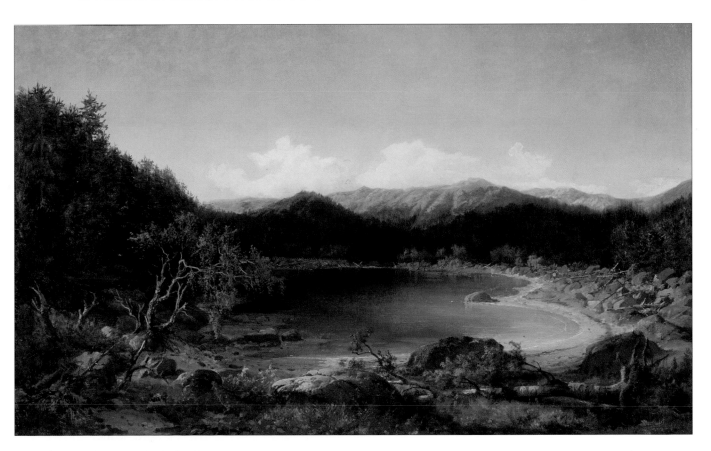

Plate 4: *Mountain Lake Scene,* 17 x 25.5, oil on canvas. Collection of Tweed Museum of Art, University of Minnesota Duluth. Gift of the Orcutt family in memory of Robert S. Orcutt.

success and affiliate himself with the National Academy of Design is indicated by the fact that he did not exhibit there again until 1871, preferring to sell directly from his studio by word-of-mouth through his well-connected friends like explorer Clarence King (1842–1901) or in the field directly from his easel.

NIAGARA FALLS AND "MR. CHURCH"

One sure way for Munger to propel himself over the crowd and lay claim to a leading position was to discover a scenic wonder and sensationalize it through a "great picture." The nation, only recently reunited by force of arms, was eager for images of its western territories with their vast natural resources and magnificent scenery. Munger's early paintings of Niagara were preparations for the "great pictures" he aspired to paint. On June 22, 1868, the *New York Evening Post* reported, "Mr. Munger had gone to Niagara Falls." Less than a year later the high-culture magazine *The Home Journal* noted, "Gilbert Munger of #82 Fifth Avenue, has painted a large view of Niagara Falls as seen from the Canadian Side."[19]

Munger's 1869 *Niagara Horseshore Falls with Rainbow* (Plate 5) was an accomplished reprise of Frederic Church's famous *Niagara* of 1857, already an icon of American culture and a

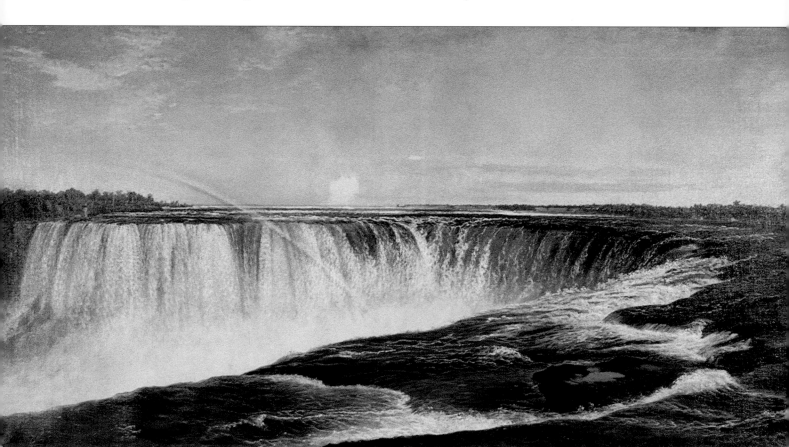

Plate 5: *Niagara Horseshoe Falls with Rainbow,* 1869, 27 x 52, oil on canvas. Private collection.

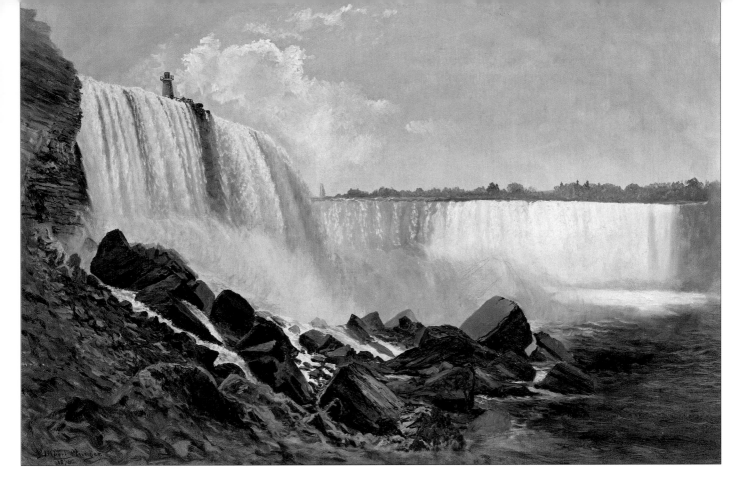

Plate 6: *Niagara,* 1870, 25 x 36, oil on canvas. Collection of Tweed Museum of Art, University of Minnesota Duluth. Gift of Miss Melville Silvey.

symbol of artistic success. Munger's composition followed Church's faithfully and by doing so demonstrated command of Ruskinian techniques of painting "truth to nature" in the manner of America's most successful landscape painter, the famed artist known to the public simply as "Mr. Church." Through the conscientious exercise of reproducing Church's masterpiece, with its sweeping panoramic vision and relentless display of realistic detail, Munger rehearsed the most up-to-date conventions of representing scenery with a degree of clarity that recalled photographs or the experience of sight through the optics of a telescope. This "scopic regime" invites the spectator to inspect closely a painted surface that contains a high degree of detail.

A year later Munger produced *Niagara,* a second painting of the falls as seen from below on the American side (Plate 6). It too suggests a youthful, even studentlike reprise of another painting of the falls by Church. Munger probably saw Church's *Niagara Falls from the American Side* of 1867 (now in the National Gallery of Scotland), but his own work also represented his close observation of the sublime scene. Viewing the falls from below was popular with tourists, and Munger probably hoped it would also prove attractive to patrons of fine arts. *The Home Journal* was enthusiastic about one of Munger's Niagara paintings: "The work is one of real promise, showing a good deal of skill and graphic power. It bespeaks for the artist an honorable position among American

Plate 7: *Minnehaha,* 1868, 108 x 72, oil on canvas. Collection of Notre Dame de Namur University, Belmont, California.

landscapists and at once advances him a long stride in his career."[20]

Demonstrating technical mastery of Church's style announced to fellow artists, critics, and patrons that Munger intended to claim a high place in a competitive art market. One report states that one of his first commissions was from "a wealthy gentleman of France, for which he received £1,000."[21] For aspiring artists of the 1860s, painting an acclaimed picture of Niagara Falls was a virtual guarantee of patronage. Munger, like many others, hoped to paint pictures that would establish his reputation, just as images of South America and the Rocky Mountains had earned fame a few years earlier for Church and Bierstadt. But there was a problem with this strategy. By the late 1860s the market for pictures of the sublime falls was well supplied, while the unexplored West offered many exciting prospects of scenic El Dorados for eastern artists. Munger would not paint his "great picture" of Niagara until the end of his career, but he would expend considerable effort to discover a western counterpart to the celebrated eastern falls.

"GREAT AND GROWING GENIUS"

Keeping his career options open, Munger also opened a studio in St. Paul, Minnesota, where his brothers Russell and Roger had settled and would establish a music-publishing business. He also painted in Duluth, Minnesota, where Roger became a founding citizen. Following the Civil War, Minnesota was still western frontier. Its citizenry eagerly embraced an accomplished eastern artist who had moved west and was painting local scenery. Throughout Gilbert Munger's career, newspapers in St. Paul

reported on his artistic successes, claiming him as one of the city's own residents. The *St. Paul Pioneer Press* urged its readers to patronize the artist: "Investments in the works of such great and growing geniuses [as Munger] are the best that can be made."[22]

Documenting frontier conditions that were rapidly passing, Munger produced a rare genre painting, *The Halt on the Prairie* (unlocated). According to contemporary description, it represented "the camp of a Red River [ox-drawn wagon] train in the evening." The painting would have historic interest, the reviewer felt, "for these trains, now an institution of this pioneer State, like all other landmarks of the semi barbarous customs are disappearing with the advance of railroads and civilization."[23] Munger painted and sketched other Minnesota frontier scenery, such as the St. Croix River, and the scenic bluffs near Trempealeau, Wisconsin, about 120 miles downriver from St. Paul on the Mississippi. The latter work, which remains unlocated, was described as representing mists rising from the water at sunrise.[24] The view was purchased by George Lean, "a wealthy gentleman from Scotland to be placed on exhibition in the Academy of Fine Arts in Glasgow."[25] Lean was the first of Munger's many British patrons.

PAINTER OF LAUGHING WATERS

Perhaps the most important painting Munger produced during his stay in Minnesota was a dramatic view of the falls on Minnehaha Creek, where it empties into the Mississippi near St. Paul. A sure way for a visiting artist to gain patronage in a developing community

like St. Paul was to produce good views of local scenery. The paintings might be noticed and tourists would travel to see the attraction. In St. Paul the falls of Minnehaha Creek offered a dramatic geological feature on the prairie landscape. Munger painted a huge picture of Minnehaha in 1867. The *St. Paul Pioneer Press* called it "a rare production."[26]

Minnehaha Falls received an extensive review when it was displayed in Chicago at the Crosby Opera House Art Gallery. Munger's painting of the "Laughing Waters" of Longfellow's much-admired poem was praised for its realistic effects and its "delicate indication of the rainbow produced by the sun's rays glancing on the rising mist." The geological accuracy of Munger's rock portraits was singled out. But the critic reserved his highest praise for what Munger edited out of the picture. "The artist has had the good taste to leave out the straight, hard lines of the bridge just below the base of the falls." The reviewer admired the figures of two Native Americans in the foreground because "both look[ed] mournfully at the falling water, listening to the voice of the Great Spirit, which tells them in tones of thunder the downfall of their race."[27] Nostalgic images of "doomed" natives gracefully accepting their fate were also agreeable to patrons eager to have visual proof of the scenic value of lands recently wrested from the First Nations. Although Munger would see many Native Americans on his western explorations, he never painted them, except as diminutive mementos of history.

The *Minnehaha* reviewed in Chicago, one of several Munger painted, is probably the painting he exhibited prominently after his arrival in

California (Plate 7) and eventually sold to prominent San Francisco real-estate developer William Chapman Ralston (1826–1875). Ralston hung it at his new mansion in the hills south of San Francisco, where it remains to this day.

Munger's most useful Minnesota painting was his *Duluth* (Plate 8). One version was produced for display in Washington, D.C., to aid with lobbying efforts promoting a proposed Lake Superior and Mississippi Railroad. The scene represented the geographic advantages of the railroad's terminal in Duluth, with trains approaching the frontier town in the foreground. Duluth's superb harbor, suddenly accessible from Lake Superior by the stealthy dredging of a ship canal across the sandbar, is shown in the foreground. Roger Munger, the artist's brother who was called the "Father of Duluth," led this excavation in defiance of a court injunction, thereby stealing the harbor franchise overnight from nearby Superior, Wisconsin.[28] Gilbert Munger's picture carries the spectator's gaze across Lake Superior into the far distance, where the curvature of the earth merges water and sky in a luminous horizon. Through its commanding, panoramic vista, entrepreneurs and tourists were invited to admire Duluth's deep, well-protected harbor, advantageously located at the far-western head of the nation's inland seas, soon to be serviced by a railroad that would unlock gold and grain-rich prairies.

The place of Munger's Duluth-harbor painting in local history was noted by the *Duluth Herald* upon the painting's rediscovery in 1911: "The picture was in the back room of an art dealer in the city of Washington, and had been there until [the dealer] had nearly forgotten its existence. It

was covered with dust when found. . . . The picture hung at one time in the old Wormley Hotel in Washington. It is believed that it was taken there at the time an effort was being made to secure a land grant for the old Lake Superior & Mississippi Railroad. . . . After the hotel was torn down the picture made its way in some manner into the art dealer's shop. There it has been ever since. . . . Old-time Duluthians who have seen it think it should become the property of the city and be preserved with the relics of its day."[29]

The Wormley Hotel has an unexpected connection with Munger's great patron, Clarence King. Donet D. Graves Sr., great-great grandson of James Wormley and historian of the Wormley Hotel, says that King was an intimate friend of Wormley. In fact, one of Wormley's grandsons was named Clarence King. Graves provides an inventory of James Wormley's widow's estate, listing the painting *Duluth* and recording it as located in the main dining room of the hotel. During its heyday the Wormley Hotel was *the* hotel for Washington's political elite, making a display of Munger's painting especially useful to backers in Duluth.

Munger visited St. Paul and Duluth several times before going to England in 1877 and stayed briefly in Minnesota upon his return from Europe in 1893. After Munger's death in 1903, his brother Roger brought many of his paintings to Duluth. At some point, however, there must have been a family quarrel, because a note written by a good friend after Munger's death states that Munger "despised" his brother in St. Paul, Russell Munger.[30]

Plate 8: *Duluth,* 1871, 25 x 50, oil on canvas. Collection of City of Duluth, Duluth Public Library, Minnesota

2

ARTIST-EXPLORER OF THE WEST

GO WEST, YOUNG ARTIST, GO WEST

Gilbert Munger's youthful expectations of artistic success placed him aboard one of the first Union Pacific trains heading west in late May or early June 1869. He stayed out west more than a year, returning to the East an artist on the verge of achieving national recognition. Brisk sales of California landscapes in booming San Francisco and Albert Bierstadt's remarkable success with Pacific Coast subjects in New York led a San Francisco critic to note interest in western scenes: "Bierstadt's success . . . has infected several American artists with a desire to come here. . . . The Railroad makes the trip an easy one."[31] The late 1860s was an age captivated with explorers as heroes as the nation completed its transcontinental expansion that opened the last pockets of unexplored land. Exploring artists could also be well rewarded.

Coming of age as a professional artist in the late 1860s would have made Munger aware of Henry T. Tuckerman's influential *Book of the Artists,* published just a year after Munger moved to New York.[32] Tuckerman did not mention Munger, who was just beginning to exhibit, but he strongly advised young artists to carry forward the "indomitable explorative enterprise of the New England Mind" that Frederic Church and other New Englanders had initiated.[33] To

do so was to gain the highest success and to serve national interests. Perhaps, as a Yankee son of Connecticut like Church, Munger might have been stimulated to follow the example of the commonwealth's most illustrious artist. Art news from New York continued to be dominated by the search to discover great, new scenic treasures for the nation by Church, Bierstadt, and other artists who would soon be named the Hudson River School.

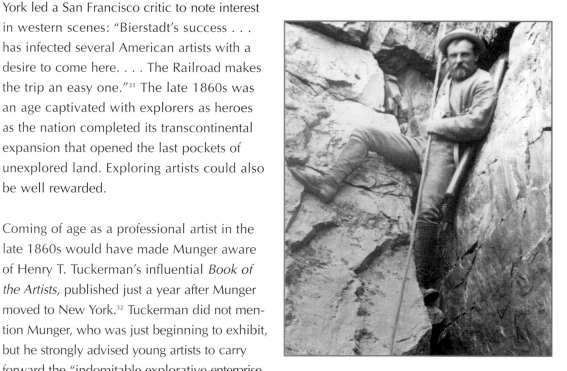

Figure 2. Timothy O'Sullivan's 1869 photograph of Clarence King shows the charismatic explorer and geologist as a mountaineer. The George Eastman House, Rochester, New York.

With his Washington, D.C., connections and Yankee pedigree, Munger got his break when he secured an invitation to join the U.S. Government Geological Survey of the Fortieth Parallel as guest artist. The expedition, headed by Clarence King, was in its second year of operation (Figure 2). It was one of the most lavishly funded federal land and resource surveys of the era, thanks to King's skill as a political lobbyist in Washington. Second in command of the Fortieth Parallel Survey was Samuel Franklin Emmons (1841–1911), a European-trained geologist who was as knowledgeable about visual art as King was about literature (Figure 3).

Emmons's diaries have not previously been studied for references to Munger, but such references abound.[34] From June 1869 to December 1875 they provide numerous eyewitness reports of the artist's activities in the field, his working methods, and his long-term associations with photographers and scientists of the expedition. The first mention of Munger is on June 29, 1869. Emmons, who was already in the field, wrote that he had "reached camp at Salt Lake [City] to find King & [Timothy O'] Sullivan there. Munger with the latter. Go to Warm Spring with King. Evening go to canyon with Munger, [O]'Sullivan."

The relationships Munger forged that season as he painted the western wilderness for King—the youthful Yale-educated scientist, explorer, bon vivant, and art collector—and for Emmons, the sober geologist, would prove of enduring value. Munger would see and communicate frequently with them over the next decade. Their relationship continued

even after Munger went abroad. Although this relationship with scientists was leveled in some respects by his artistic talents and genial personality, a decided class distinction existed between the artist and the scientists. Both Emmons and King came from old-money New England families. Emmons's family was descended from Boston's East India and China Merchants, and King's family was descended from Newport (Rhode Island)'s India Merchants. The Emmons guest book reads like a who's who of nineteenth-century literary and cultural life. Samuel "Frank" Emmons embodied the newly minted, rigorously methodical, professional scientist and would in time become wealthy from his prudent investments in mining enterprises. King, the leader of the expedition, was charismatic but extravagant. Emmons's ledger books show several large personal advances to King to cover survey expenses until government funds became available. Munger, by contrast, was the son of a laborer, was not college educated, and had very little money. He depended entirely on his art to make a living.

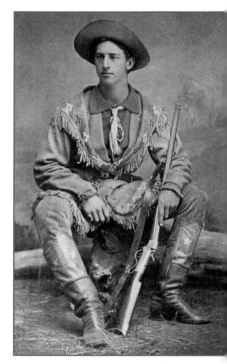

Figure 3. Munger's lifelong friend, diarist and leading geologist Samuel Franklin Emmons, posed in a western dude outfit at Fort Sill, Indian Territory, during King's 1872 survey travels. Library of Congress.

A KING MARKED BY NATURE

According to his close friend Henry Adams, Clarence King "had in him something of the Greek—a touch of Alcibiades or Alexander." In his autobiographical *The Education of*

Henry Adams, the historian recalled encountering King as a "miracle . . . a bird of paradise rising in the sagebrush . . . an avatar." King was educated in chemistry and geology at the progressive Sheffield Scientific School at Yale, yet Adams particularly admired him because King knew more of art, poetry, and especially the West beyond the hundredth meridian than Adams ever would. For Adams, as for Munger and Emmons, King's "personal charm of youth and manners, his faculty of giving and taking, profusely, lavishly, whether in thought or in money, as though he were Nature herself, marked him almost alone among Americans."[35] In addition to his scientific and artistic interests, King was an avid adventurer, consummate explorer, and stylish figure. Emmons humorously observed in his diary during an ascent of California's Mount Shasta that "King's buckskins are so tight he can hardly climb."[36]

Although a Yale student, King also attended the famed geological lectures of Louis Agassiz at Harvard. At a time when geology was America's most fashionable science, Agassiz's teachings were a major stimulus to scientists, intellectuals, and a number of landscape painters, as Rebecca Bedell shows in *The Anatomy of Nature.*[37] Agassiz was interested in glaciology and was the first to conceive of an Ice Age, issues that deeply concerned King on his survey of the Fortieth Parallel. However, unlike Agassiz, who later defended the importance of religion against Darwinian skepticism, King had a vision of Earth's history that was relentlessly secular. Out of respect King would later name Mount Agassiz in the Uinta Mountains of Utah for the geologist and Munger would paint the scene for King's

Systematic Geology. Louis's son, Alexander Agassiz, would become a silent partner in one of King's ranching ventures and a prime backer of King for the first directorship of the U.S. Geological Survey.[38] King was profoundly affected by the teachings of Professors George Brush and James Dwight Dana, both ardent proponents of the Darwinian Revolution with its new, sternly materialistic vision of nature. Munger learned of these controversial and much debated ideas through King, whose "bubbling energy swept everyone into the current of his interest," Adams thought. Munger also would have learned of them from Emmons, with whom he spent a considerable amount of time, both in camp and later back in New York. Importantly, nowhere in Munger's oeuvre or his recorded statements are there references to current ideas of transcendence or of natural divinity. Unlike the works of Church or Gifford, Munger's art from its inception demonstrated no discernable interest in contemporary aesthetic issues of allegory or religious symbolism. That market had mostly expired by the time Munger came of age as a productive landscape artist.

King and Emmons were leading representatives of a new cultural type, the professional scientist. Munger sought similar status in his aspirations to become one of America's professional artists. King, with his passionate ideas about scientific nature, would become the single greatest intellectual influence on the youthful Munger as patron, mentor, and friend. That summer, however, the main charge of King's exploring party was practical: surveying for coal to supply the expanding

transcontinental railroad.[39] Munger joined the King survey in hopes of discovering a future scenic wonder such as Church had found at Niagara and Mount Desert Island in the East and in the exotic tropics of South America; as Bierstadt had discovered at Yosemite; and as Thomas Moran soon would do in Yellowstone and the Grand Canyon.

ENCHANTED IN A GENTLEMANLY WAY

In King's classic literary account of his explorations of California, *Mountaineering in the Sierra Nevada* (1872), the modern Alcibiades forcefully expressed his wish for an artist as great as J. M. W. Turner "to paint our Sierras as they are, with all their color-glory, power of innumerable pine and countless pinnacle, gloom of tempest, or splendor, where rushing light shatters itself upon granite crag, or burns in dying rose upon fields of snow."[40] King valued images for science and enterprise, but he was also a connoisseur of fine painting. In addition to other landscape painters that he invited to accompany him, most importantly Bierstadt, King astutely engaged some of the finest photographers operating in the West. He was among the first federal-government explorers to capitalize on the advantages of the new medium. Munger's first encounter with King's survey photographers was with Timothy H. O'Sullivan (1840–1882), whose work King also selected to illustrate *Systematic Geology*. Munger and O'Sullivan spent considerable time together during the 1869 expedition. That first summer in the West, Munger also traveled with the Mormon photographer Charles S. Savage (1832–1909) and the Union Pacific Railroad photographer Andrew J. Russell (1830–1902). On June 12,

Munger accompanied Savage to sketch in "Paridise [sic] Valley" near Salt Lake City.[41]

Munger's association with leading landscape photographers reinforced new standards of representational accuracy and optical detail. Under King's demanding guidance, painter and photographer were brought together in a new professional relationship in support of King's scientific, publicity, and aesthetic objectives. During that exciting summer of 1869, evidence abounds in Emmons's diaries of a close collaboration between Munger and O'Sullivan and later with photographer Carleton T. Watkins, each determined to succeed in prospecting for pictures. On June 30, the day following Munger's arrival in Salt Lake City, Emmons noted that he went with "King, [O'Sullivan] & Munger." A few days later, on July 4, the party saw "spectacular granite cliff and boulders." On August 29 Emmons noted: "Munger decides to stay over while we are here and picture the scenery of the canyon which he says is very fine. [O'Sullivan's] team goes back today. Munger, Arnold [Hague] & I ride up the canyon which we find as grand as M's description . . . trail pretty bad in places . . . go up on hill for general view of structures, on way back hunt fossils. Find Munger in canyon painting, return to camp about sunset." The painter and survey photographers spent long days working side by side to capture the evidence of natural history in field sketches and photographs.

One of O'Sullivan's photographs captures an artist in a scene such as Emmons described, posed at work (Figure 4). The setting for the

Figure 4. An exploring artist, almost certainly Munger, paints in the field in this detail from an 1869 O'Sullivan photo taken on King's Fortieth Parallel expedition. The National Archives.

Figure 5. Munger likely is the artist sketching in a small boat on a Utah lake in this detail from another 1869 O'Sullivan photograph from the King expedition. The National Archives.

outdoor studio is a wilderness camp with rugged mountains filling the background. Standing in the middle distance, the painter turns self-consciously toward the photographer. He is holding a brush and palette and is carefully posed in front of a large canvas on a portable easel. O'Sullivan pictures the artist painting *en plein air*. The artist cannot be absolutely identified as Munger, but the geographical and chronological context for the photograph, along with Emmons's diary entries, pinpoints Munger and O'Sullivan as working together at this time. No other artist is known to have been working with King's expedition during that period. Thus, it is highly probable that the figure at work painting is Munger.

In another O'Sullivan photograph from the same expedition, a figure that may also be Munger is seated in a crude wooden boat, gazing intently at a large sketchbook or oil sketch (Figure 5). The lake is below the north face of Mount Agassiz, which Munger and O'Sullivan observed together. Munger's newfound photographer colleague poses the artist in a traditional gesture of introspection.

One thing is clear about Munger's activities on the Fortieth Parallel Survey: he was indefatigable. Emmons's diary on July 3 states: "Munger in late [to camp] as usual." On August 28 he noted: "About dark Munger and Watkins came in, [O'Sullivan] about eight." King reported excitedly from the wilderness heart of Utah's Uinta Mountains that "Munger seemed enchanted in a cool and gentlemanly sort of way, sketching on four-foot canvases."[42] A year later Munger was

photographed, at work and facing one of his four-foot canvases,[42] by Carleton Watkins (Figure 6). King considered Watkins, a San Francisco photographer who had pioneered the visual discovery of Yosemite, "the most skillful [photographic] operator in America."[43] Once again absorbed in his work, Munger turns his face away from the camera lens. He appears carefully posed so that the painting on which he is working is partially visible. He is wearing what appears to be a straw bowler hat, an item of apparel that appears in other photographs. King is lounging evocatively in the foreground while Frederick Clark, an expedition geologist, examines a survey transit. In the background Watkins's mobile photographic laboratory can be seen. Both King and Clark would later collect works by Munger. The painting glimpsed on Munger's easel is a view of Mount Shasta, a work that remains unlocated. Munger's production of finished pictures in the field was praised by San Francisco art critics and it would become key to his early success.

Besides the O'Sullivan photograph of Munger at his easel, one other image from the expedition may show the artist as explorer. Munger is identified in an Andrew Russell photograph as the youthful figure at right with a fresh beard, seated with two rough-looking companions around a campfire (Figure 7). Years later Munger recalled his early life as a western explorer with King as a defining moment in his early artistic development.

Munger's chromolithograph *Summits – Wah-satch Range – Utah* (Plate 9), published in King's *Systematic Geology,* illustrates the collaboration

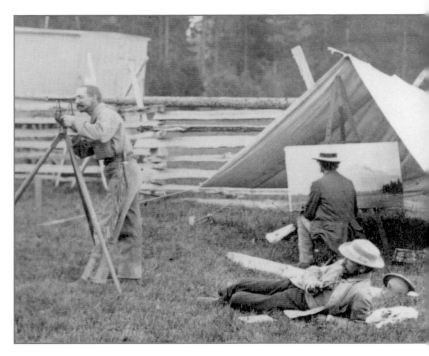

Figure 6. A Carleton Watkins photograph of the King expedition camp at Mount Shasta, California, in the fall of 1870 shows King, Munger, and geologist Frederick Clark. Clark is seen at the left, while Munger works on a large painting of Mount Shasta. Department of Special Collections and University Archives, Stanford University.

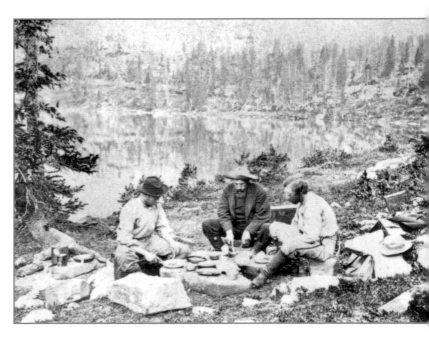

Figure 7. Andrew Russell photographed Munger (right) at a campfire in Utah's Uinta Mountains in August 1869 during the artist's summer with the King survey. Union Pacific Museum Collection, Omaha, Nebraska.

Figure 8. In San Francisco in October 1869, Munger stayed at the luxurious Lick Hotel, whose walls were lined with paintings of California scenery, a subject the artist intended to prospect for himself. Private collection.

in San Francisco, whose walls were crowded with paintings of California's scenic wonders (Figure 8).[44] In San Francisco Munger linked up with his Washington, D.C., friend John Ross Key. The two artists from the East soon began producing and selling pictures. Munger's were based on his experiences with King's expedition and Key's on his recent visit to Yosemite. By November they had exhibited at San Francisco's premier fine-arts gallery, Snow and Roos Company, in a benefit for the Mercantile Library. Among the 112 paintings shown by artists of "celebrity" were works by Bierstadt, Thomas Hill, T. Buchanan Read, Eastman Johnson, and Key, reported the San Francisco *Daily Evening Bulletin:* "Mr. Munger, who was recently artist to Clarence King's geological survey across the continent, exhibits two sketches . . . they show that Mr. Munger paints with an honest purpose."[45]

between Munger and O'Sullivan. It closely matches O'Sullivan's photograph *Wasatch Mountains, Lone Peak Summit, Utah* (Plate 10). The images are virtually identical in composition, but with slightly different vantage points. It is as if painter and photographer positioned themselves a short distance apart as they recorded the scene. The similarities include tiny details, such as the man and horse ascending the brilliantly lighted snowfield. The objectivity and detail of photography strongly appealed to King, and its standard of representational faithfulness was readily absorbed into Munger's early aesthetic. His western paintings were consistently praised for their fidelity to nature.

"TWO EASTERN ARTISTS DOING CALIFORNIA"
By the end of October 1869 Munger and King were settled at the luxurious Lick Hotel

Munger was very active in San Francisco, taking advantage of opportunities associated with his position on a federal-government survey. Under King's sponsorship the city's cultural elite welcomed Munger. Its leader and chief publicist was Bret Harte, editor of the influential *Overland Monthly.* Munger was among the inner circle of literati who met in Harte's newspaper office. It must have been a heady atmosphere. In 1871 Harte was the best-paid and arguably most popular writer in America, a supernova in the literary

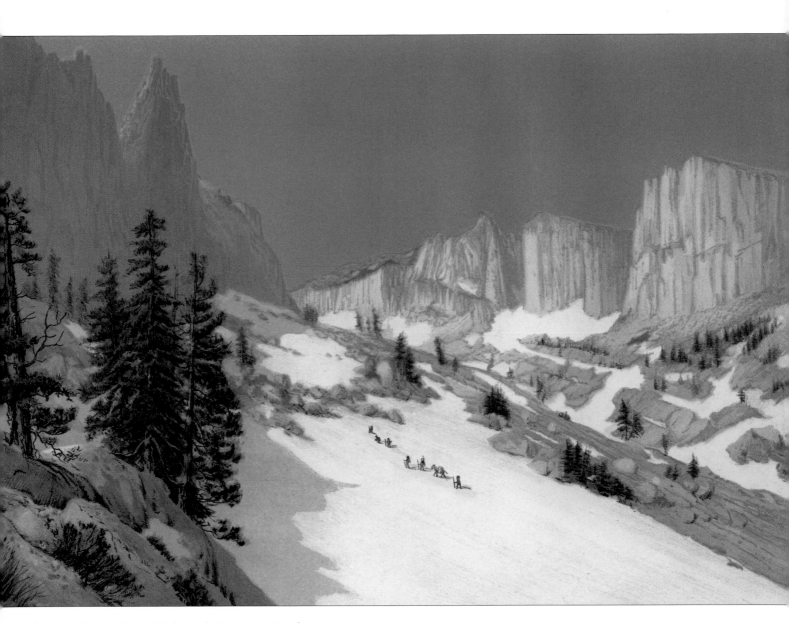

Plate 9: *Summits – Wahsatch Range – Utah,* 6 x 8, chromolithograph. From Clarence King's *Systematic Geology,* Government Printing Office, 1878.

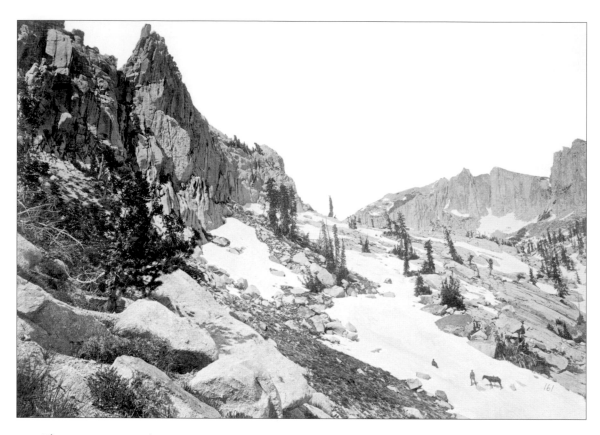

Plate 10: *Wasatch Mountains, Lone Peak Summit, Utah,* 1869,
photograph by Timothy H. O'Sullivan. National Archives.

firmament whose visit to Boston later that year was described as "the progress of a prince" by William Dean Howells.[46] In August 1870 King and Munger saw Harte frequently as King was preoccupied writing an article on Shoshone Falls for the *Overland Monthly.* The group around Harte included the fascinating poet, editor, and collector Ina Coolbrith (1841–1929), a niece of Joseph Smith, founder of the Mormon church. Emmons recalled in his diary one of these exhilarating encounters in Harte's office, where he and other members of Harte's circle looked "over Munger's sketches, putting snow in Lake Marian and desecrating Starr King's bust."[47] Later in England, Harte and Munger may have continued the association.

Munger and Key unveiled freshly made paintings for delighted San Francisco patrons in the spring of 1870. The *Daily Evening Bulletin* described Munger and Key as "two Eastern artists who have been doing California for the past six months or so." Local pride of place and an eagerness to promote regional scenery offered visiting artists opportunity, the article continued: "Mr. Key and Mr. Munger, who came here only for a brief visit, have prolonged their stay because the climate and richness of material for landscape studies enchant them. Their paintings of California scenery are remarkable for fidelity and are valuable additions to our local school."[48] In March they held an exhibition and auction of about fifty "sketches of

American scenery" at the Mercantile Library building. It was widely noticed, and the *Alta California* was enthusiastic: "These sketches are really highly meritorious cabinet pictures and evince good artistic feeling in handling and treatment. Most of them are painted from nature and all have the freshness and freedom of outdoor study. No such exhibition has ever before been offered in this city."[49] The sale must have been a disappointment to the artists, however, because it realized less than $1,000 and none of the pictures surpassed the benchmark $100 figure. This led the *San Francisco Chronicle* to lament: "Art has not been making very progressive strides of late among our local artists. The season of the year, dullness of business and scarcity of money are generally urged as the cause; but we believe the artists are hibernating."[50]

A WORTHY PLACE: AS GOOD AS BIERSTADT

Munger and Key quickly became favorites of the local art community. Newspaper critics and art partisans extolled the duo of eastern

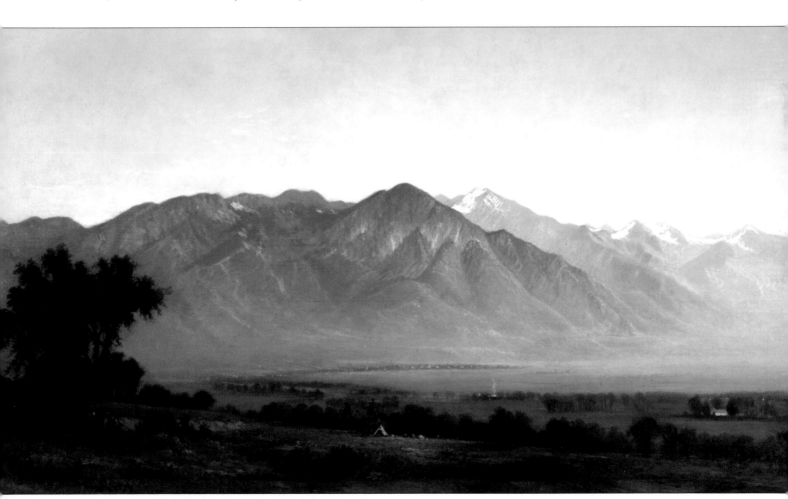

Plate 11: *Indian Camp at the Base of the Wasatch Range,* 1879, 24.5 x 42, oil on canvas. Collection of Northwest Museum of Arts and Culture, Eastern Washington State Historical Society, Spokane, Washington.

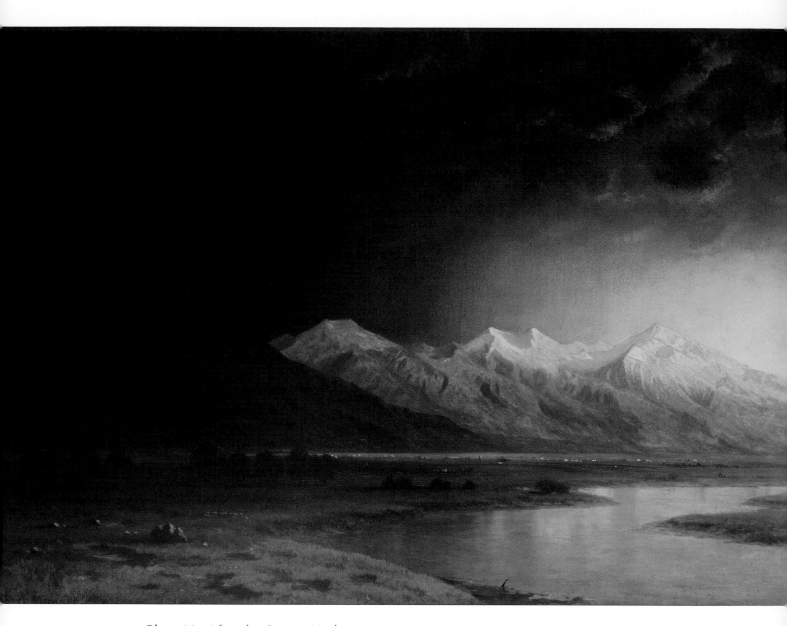

Plate 12: *After the Storm, Utah,* 20 x 28, oil on canvas. Collection of Mr. and Mrs. Edwin Pomphrey, Rumson, New Jersey.

artists out painting the West. On April 24, 1870, *The Golden Gate* published *A Desultory Poem* by "Caliban," identified by Alfred Harrison as Hector A. Stuart, a San Francisco art critic. It reviewed a lineup of California's most important artists, including Bierstadt, Charles Nahl, and Samuel Marsden Brookes. Several stanzas compare Munger and Key. The poem suggests a sophisticated reading of their personal styles, its author disclosing, "I too have daubed":

> *In landscapes Munger claims a worthy place.*
> *Neutral in tone his pictures never glare. . . .*
> *They spread their beauties in a quiet way,*
> *And to be felt require long survey.*

Playing on Key's name, the next stanza began:

> *Key is his comrade and Key you must know,*
> *Paints much like him, but in a different Key.*

Munger and Key's color was pleasing compared to:

> *Bierstadt—that name would spoil a line*
> *As strong as Byron's—yet how few can vie*
> *With him in execution and design?*
> *'Tis true, his color does not meet approval,*
> *But would it be improved by removal?*

Munger's painting *Wasatch Mountains, Utah Valley* was the worthy artist's first "hit." It was the most highly praised painting in the Mercantile Library exhibition and an image that proved valuable to the painter late in the 1870s after he moved to England. The Great Salt Lake and nearby Wasatch Mountains were attractive subjects for eastern collectors, tourists, and investors. Through Munger's faithful images one could vicariously visit the Mormon colony near the Great Salt Lake, suddenly accessible with the completion of the transcontinental railroad. A San Francisco reviewer wrote of Munger's paintings: "Some of the views near Salt Lake are very grand and picturesque. Sketches at earliest sunrise, or just as the sun, sinking in the west, throws its opal light upon the extreme mountaintops, their glowing summits in strange contrast with gray gloom, all the way down from the flush line along the gleaming pinnacles to where the broad foundation mingles with common earth, dark and indefinable."[51]

Although Munger's first picture of the scene is unlocated, it probably resembled a work known today as *Indian Camp at the Base of the Wasatch Range* (Plate 11). Munger and O'Sullivan worked together, sketching and photographing the area. The work of both men shows the expanding Mormon settlement of Salt Lake City in the distance. According to the *San Francisco Call* on March 22, 1870, the picture "was as good a picture as was ever on exhibition in this city, not surpassed by anything taken from Bierstadt's easel, full of study, experience, sentiment and poetry, with an atmosphere and perspective as correct as if you were looking through a window at just so much of the earth's surface. The clump of trees at the left, without anything else, stamp him as an artist." The critic praised foreground passages that included a peaceful Indian encampment. A "home-like farmhouse nestled among the foliage, the lazy climbing smoke, the distant hamlet" provided pastoral repose, with "the grandeur and adamantine solidity of the mountains . . . changing to transparent vapor as they slide

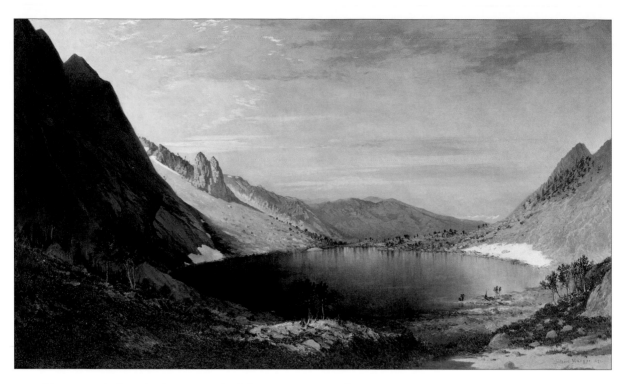

Plate 13: *Lake Marian, Humboldt Range, Nevada,* 1871, 26 x 44, oil on canvas. Collection of Mr. and Mrs. Daniel A. Pollack, New York. Image courtesy of the North Point Gallery, San Francisco.

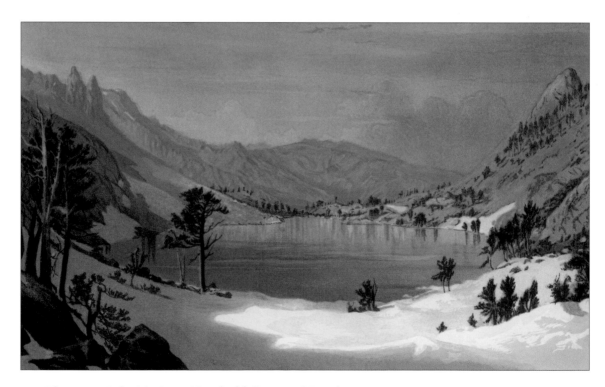

Plate 14: *Lake Marian – Humboldt Range – Nevada,* 6 x 8.5, chromolithograph. From Clarence King's *Systematic Geology,* Government Printing Office, 1878.

down the rolling globe." Playing to his audience's nostalgia for images of a rapidly disappearing way of life, Munger's *Wasatch Mountains* made "the vivid realities of today disappear in the dreamy haziness of fading memory," the anonymous critic thought. The painting was sent to the Sacramento Art Union for exhibition, and the *Sacramento Bee* was unabashed in its praise: "Munger's great painting is said to be a perfect representation of that grand old mountain range 'where vast walls have pinnacled in clouds their snowy scalps.' "[52]

When it suited his purposes Munger could produce the same scene with amplified sentiments of sublimity, as, for example, the romantic *After the Storm, Utah* (Plate 12). This was the kind of visual effect preferred by art connoisseurs more than sober geologists.

SCIENTIST AND ARTIST

King needed accurate images to illustrate his geological conclusions. On occasion the images artists and photographers produced for him could also reflect personal and poetic interests. A site that combined both for King and Munger was Lake Marian in northeastern Nevada. Now known as Overland Lake, it is located in the Ruby Mountains, a rugged wilderness southeast of Elko. King discovered the remote lake in 1868 and named it for one of his sisters. O'Sullivan accompanied him and photographed it. It proved to be a popular subject for Munger as well; he painted at least four versions. King owned one, which he exhibited at the National Academy in New York in 1871 and loaned to Yale. The pictures capture the visual drama of a perfectly symmetrical lake cradled among

granite crags carved from the Earth's oldest and hardest rock at an altitude of ninety-five hundred feet. The largest version (Plate 13) is a fine example of Munger's poetic use of light and is one of his most compelling paintings.

The subject was of such importance to King that he included a chromolithograph, based on Munger's painting, in *Systematic Geology* (Plate 14). Critics admired the pellucid reflection of the lake, reposing in a perfect rock bowl glazed with snow. Yet on careful inspection the chromo differs from the painted versions of the scene in that its foreground is filled with snow while the oils mostly depict bare rocks. Year-round snow was of particular interest to King. He was intent on determining how glaciers shape the landscape and ascertaining their specific geological age. The question of whether the West's glaciers were still active as a result of recent snowfall was debated among progressive geologists seeking to interpret the Earth from a new scientific perspective.

One test of the topographical accuracy of the Lake Marian plate is its remarkable similarity to one of O'Sullivan's photographs (Plate 15). Yet the production of Munger's Lake Marian paintings remains mysterious. O'Sullivan's photograph is dated 1868, when he and King are known to have visited the remote lake, before Munger joined the survey. But during the 1869 and 1870 expeditions when Munger accompanied him, so far as is known, King did not revisit Lake Marian. If Munger's painting is based on firsthand observation, as was his practice, then he must have visited the lake sometime before August 1870, when Emmons advised him on adding snow in Bret

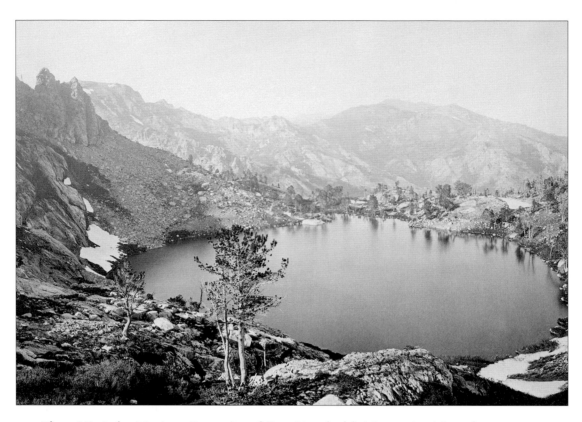

Plate 15: *Lake Marian, Summits of East Humboldt Mountain, Nevada,* 1868, photograph by Timothy O'Sullivan. National Archives.

Harte's office in San Francisco. One opportunity to do so, according to a detailed study of Munger's chronology, was at the end of 1869, when Munger was returning from Utah to San Francisco via that region of Nevada. In any case, visual accuracy was of paramount concern to King. In *Mountaineering in the Sierra Nevada* he had strongly ridiculed Bierstadt's overblown, inaccurate western productions. "It's all Bierstadt and Bierstadt and Bierstadt nowadays," he wrote. "What has he done but twist and skew and distort and discolor and belittle and bepretty this doggoned country. Why, his mountains are too high and slim, they'd fall over in one of our fall winds."[53] Later, despite these harsh words, King would invite Bierstadt to accompany a survey expedition.[54]

GIANT'S BOWL IN AN EARTHLY PARADISE
Lake Marian was also the subject of a poem by King. Its metaphors offer insight into how Munger's pictures of the lake were received by King and his contemporaries. King's poems were written for his sister Marian and her friends Lall and Jan and published in an elegant private edition titled *The Three Lakes: Marian, Lall & Jan, and How They Were Named,* its three copies serving as Christmas gifts for 1870. King's text featured rhetorical personifications of the lakes as a "Stone Giant's Bowl" and an "Ice Dragon's Nest." In hiking to Lake Lall, King noted: "The deep valley I followed was carved out of the solid rock and its whole surface was strangely polished by the old *glacier* which ages ago the

48

sun had melted away. At every step I saw the tracks of the ice monster . . . there lay great trains of boulders just where they had fallen when the glacier perished." The naming of Lake Marian, as humorously recounted by King, demonstrated why Henry Adams and so many others admired the scientist's culture and charisma. Saddling two mules, Mini and Max (minimum and maximum are common scientific terms), King rode up to see the stone-bowl lake held in the arms of the Mountain Giant. Resolving to whisper in the Mountain Giant's ear the name of the hidden lake, King said he climbed like a sailor. "At last I stood on the head of the statue and whispered, 'old fellow, I name your rock bowl down there, LAKE MARIAN.' The sun just then streamed through the clouds and the whole face of the mountain smiled as if he quite liked the name."[55]

Munger also provided a chromolithograph of Lake Lall in Utah's Uinta Range for *Systematic Geology* (Plate 16). A matching oil sketch has been located (Plate 17). Lake Lall was created, according to King in his poetic persona, by the same ice dragon that shaped lovely Lake Marian, but in his role as scientific geologist in *Systematic Geology* he could dispense with the sentimental rhetoric of nature lovers. "Plate VIII shows Mount Agassiz at the head of Bear River, as seen over a lake which occupies a deep glacial basin excavated in the horizontal Weber beds."[56] For King, Mount Agassiz was a geologist and geochemist's dream mountain, being composed of brilliant white and red quartzite and jasper, residue of an ancient igneous action subsequently shaped and burnished by glaciations.

Plate 16: *Lake Lal(l) and Mount Agassiz – Uinta Range – Utah,* 4.5 x 8.5, chromolithograph. From Clarence King's *Systematic Geology,* Government Printing Office, 1878.

Plate 17: *Lake Lall and Mount Agassiz, Uinta Range, Utah,* 18 x 30, oil on canvas. Collection of Tweed Museum of Art, University of Minnesota Duluth. Gift of the Orcutt family in memory of Robert S. Orcutt.

For the landscape painter the sheer vertical sublimity of the high Uinta range offered a dramatic visual contrast to the luminous calm of an alpine lake in a scene of arresting, almost fantastic color. O'Sullivan photographs of the same scene share an identical prospect (Plate 18). Here, as elsewhere, artist and photographer worked side by side. Munger was so taken by the visual drama of Lake Lall and Mount Agassiz that he painted another, more elaborate version of the scene in which he emphasized the lustrous white and reds of the local rock (Plate 19). In the later picture of 1871, the foreground allowed Munger an opportunity for a virtuoso display of color and the relentless, exacting geological detail John Ruskin prescribed and King demanded.

The sublime visual drama of remote Lake Marian and Lake Lall, with their scientific and poetic appeal, shows Munger's enthusiasm for his western adventures and vividly reflects his experiences as described in *Memoir:* "In the vast mountainous region which divides the continent he found some of the grandest scenery the mind of man could conceive; on every side was a new subject for his brush. . . . Well supplied with food, with health, youth, and strength, and, above all with a reverence and delight in the beauty of nature, the artist was in an earthly paradise."[57]

A "SAMPLE CHIP" OF OLD CALIFORNIA
In San Francisco Munger quickly established himself as one of the most talented artists to paint the environs. He sketched around the

Bay Area, producing two dramatic views of Mount Tamalpais, north of the city. The smaller painting (Plate 20) has the freshness and topographical feel of a plein air sketch. It includes abundant evidence of human occupation; a road and drove of cattle are stirring up dust in the right foreground, and the green fields of the Murray Ranch are strongly marked in the middle distance, nestled at the foot of Mount Tamalpais. The lighter colors of the foreground and the absence of framing trees, or a conventional elevated prospect, underscore the accuracy of the image as a report of what Munger saw.

The second painting of Mount Tamalpais from San Rafael is larger, slightly more fin-ished, and bears the date of 1870 (Plate 21). Its size and higher degree of finish suggest it was the picture Munger exhibited in San Francisco. In it, a cooler, more mysterious light prevails and most evidences of human occupation that appeared in the sketch are suppressed, adding a sense that the spectator is viewing the scene as it might have appeared in an earlier time. The foreground, with its Bierstadt-like trees and rocks, is introduced as a necessary visual convention, and from its elevated position the viewer easily surveys a scene now wreathed in atmosphere. Yet topographic details of mountain ridges and valleys, including the appearance of the extensive Murray Ranch, are virtually identical in both pictures.

Plate 18: *Summits of Uinta Mountains, Utah,* 1869. Panorama of two photographs by Timothy O'Sullivan. National Archives.

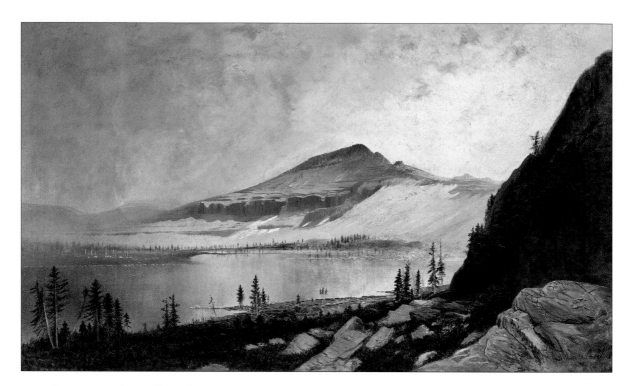

Plate 19: *Lake Lall and Mount Agassiz, Uinta Range, Utah,* 1871, 26 x 44, oil on canvas.
Private collection. Image courtesy of Montgomery Gallery, San Francisco.

Plate 20: *Mount Tamalpais from San Rafael,* 19.5 x 33.5, oil on canvas.
Private collection. Image courtesy of the North Point Gallery, San Francisco.

The practice of "improving" a scene, particularly historicizing it by removing evidence of human presence, dates back to early tourist pictures. Thomas Cole's well-known elimination of the stairs for tourists in his early picture of *Catskill Falls* is an example. Munger absorbed this visual convention of absence and developed it throughout his career.[58]

Mount Tamalpais was a triumph for the youthful painter. The *Alta California* lavished praise: "If we wanted to send a 'sample chip' of California . . . we might send this picture

the time of day "when the mountain is no longer gay and garish in the sunlight, but has taken on a mysterious veil of gloom; light flocks of joy come drifting in from the westward across the mountain's brow." Here and there a farmhouse gives human interest to the picture and "tall thin columns of smoke rising straight up from homely chimneys mark the stillness of the air and suggest evening time." The *Alta California* reviewer found the foreground most admirable: "On the left is a vigorous painted acclivity, broken with rock and rich in the color of summer grasses and

Plate 21: *Mount Tamalpais from San Rafael,* 1870, 30 x 57, oil on canvas. Collection of Alfred Goldyne.

with complete confidence and satisfaction." The reviewer did not think the subject "promising" because the view had "no distance," but "the artist has contrived, while conscientiously interpreting nature, to infuse a poetic feeling into his work." Munger selected twilight as

hurbage. A group of admirably drawn redwoods are painted strongly against the opal evening sky, their rugged tops catching the last yellow light of the sun. The whole picture is admirable for its conscientiousness of detail and poetic feeling which pervades it."[59]

"ABLEST OF OUR LANDSCAPE PAINTERS"

Munger's early fame rested on his much admired paintings of California scenery. The *New York Evening Post* reported, "Mr. Munger is at work on a view of the Ocean Beach south of the Cliff House, which is already very striking and faithful."[60] Munger exhibited his first major California picture, *A Glimpse of the Pacific,* at Snow and Roos Gallery in San Francisco, and in 1871 he showed it in New York at the National Academy of Design (Plate 22). Images of the nation's Pacific coastline were especially popular with California tourists and newly wealthy patrons. To gaze westward from beaches near San Francisco in 1869 or 1870 upon the vast Pacific toward Japan and China was to realize, in geographical metaphor, feelings of national pride in successfully conquering the continent.

As he often did, Munger painted at least two versions of the image. The picture was enthusiastically reviewed in the *Alta California* on May 28, 1870: "Among the ablest of our landscape painters may be ranked Mr. Gilbert Munger, whose works are distinguished by a quiet but natural tone of color, a free, light and expressive pencil, and a poetic choice of situations." The painting has "won deserved admiration, both from critics and those whose taste and cultivation give their opinions a claim to consideration." The anonymous critic praised the simplicity of "the rude but picturesque region adjacent to the Cliff House." A valley, covered with the stunted vegetation of that locality, fills the foreground; in the mid-distance a range of serrated hills extends down to a sandy beach, and "beyond this the boundless waters of the Pacific, its verge lost in thin, quiescent vapors." The *San Francisco Call*'s reviewer thought "the picture most intensely Californian."[61] "The sky is warm and full of atmosphere; the clouds light and lustrous. The color is tender and harmonious, the distance well-retired and the general feeling of

Plate 22: *A Glimpse of the Pacific,* 1870–1871, 24 x 42, oil on canvas. Collection of Mr. and Mrs. Ward Carey. Image courtesy of Montgomery Gallery, San Francisco.

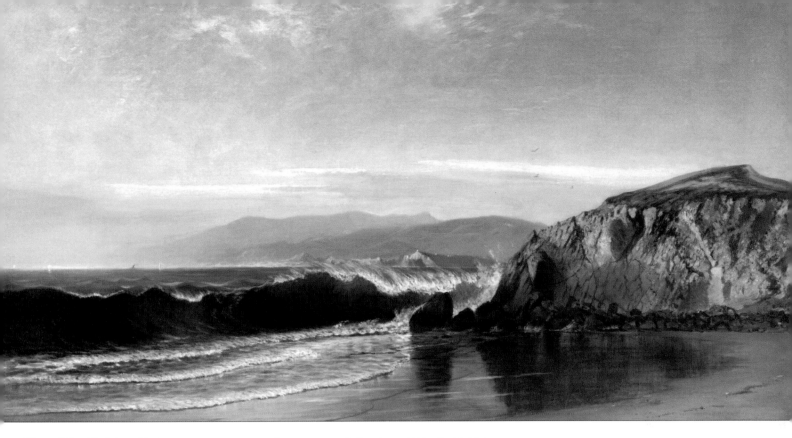

Plate 23: *Golden Gate,* 1871, 18 x 33.5, oil on canvas. Collection of Wanda M. Fish.

the picture gentle and poetic." *A Glimpse of the Pacific* sold for $1,000, "a high figure, but not above its value."[62]

A related marine painting *Golden Gate* (Plate 23) demonstrates Munger's technical excellence in painting moving water, a skill he had absorbed from Church and Bierstadt, and his close observations of the geology of the famed point so beloved by tourists and settlers. An enterprising production of western painting during his San Francisco sojourn accelerated the maturing of Munger's early style.

During his first visits to California, Munger also sketched along the picturesque Monterey Peninsula and around the old Spanish missions. The *San Francisco Evening Post* noted that Munger was sketching in Monterey: "The romantic old churches of the Mission have

found a place in his sketchbook."[63] An oil sketch of the *Mission San Carlos Borromeo de Carmelo* (Plate 24) is typical of his field sketches, while *Along the Monterey Peninsula* (Plate 25), dated 1873, demonstrates mastery of luminous effects of sea and sky. The former picture is particularly noteworthy because it was once in King's collection, descending through the family of Ada Todd, his secret African-American common-law wife, to a Baltimore art dealer in 1974.

The contrast between Munger's earlier *Minnehaha* and his California paintings was noted by the *Alta California:* "[Minnehaha] is ambitious in size and style of treatment, but is not so vividly real and genuine in hue and atmosphere as some of his later [western] works. . . . There is some good painting on the circling rocky base of the fall, but . . . the

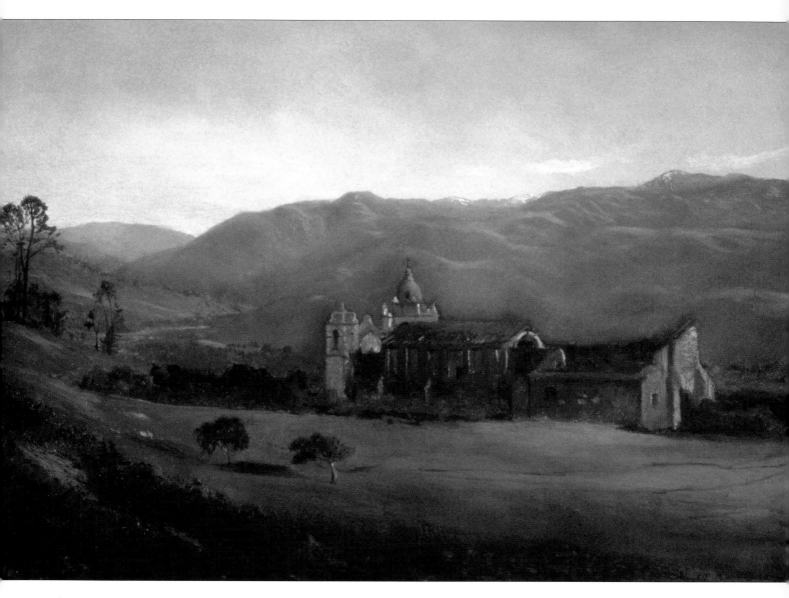

Plate 24: *Mission San Carlos Borromeo de Carmelo,* 14 x 20, oil on canvas. Collection of Arthur J. Phelan, Chevy Chase, Maryland.

general effect is not satisfactory, being entirely destitute of that freshness and tender firmness which [Munger] has shown in pictures executed during his sojourn on this coast."[64]

Munger saw a way to gain a patronage niche by producing works favored by the new scientific specialists, geologists such as King, Emmons, and their sophisticated friends among San Francisco's elite. Bierstadt and Munger were rivals in the field, one a Goliath, the other ambitious, well connected, and determined to make his place. The "objective" lens of art in the service of a new science of geology seemed to offer real opportunity for professional advancement to the less-known painter.

TO MOUNTS SHASTA AND HOOD

On August 30, 1870, Munger left San Francisco to accompany King on the second leg of the Fortieth Parallel Survey trip, this time to Mount Shasta. Munger had first learned of the mountain from William Dougal and Frederic Butman back east. The conical mountain was a geologist and artist's dream. Sublime and glacier-capped, Shasta and Hood, its sister volcano to the north, resembled famed South American volcanoes, like Cotopaxi, which had been admired by the New York art world through Church's paintings. The San

Francisco *Daily Evening Bulletin* reported: "Munger has gone to Mt. Shasta, intending to both climb and paint it. He accompanies a party of geologists. He will afterwards go to Oregon and Washington Territory, where he intends to sketch Mt. Hood."[65] Munger joined a party that included King and Carleton Watkins, the pioneer explorer-photographer who had first introduced easterners to the wonders of Yosemite Valley and California's

Plate 25: *Along the Monterey Peninsula,* 1873, 13.5 x 23, oil on canvas. Private collection. Image courtesy of A. J. Kollar Fine Paintings, Seattle.

big trees. The seasoned photographer, the young landscape painter, and their leader, King, worked, camped, and rode side by side.[66]

Emmons's diary and letters give fascinating details of the scientists' and artists' visit to the great volcano. The decision to leave San Francisco to explore Mounts Shasta and Hood was delayed until Munger could accompany

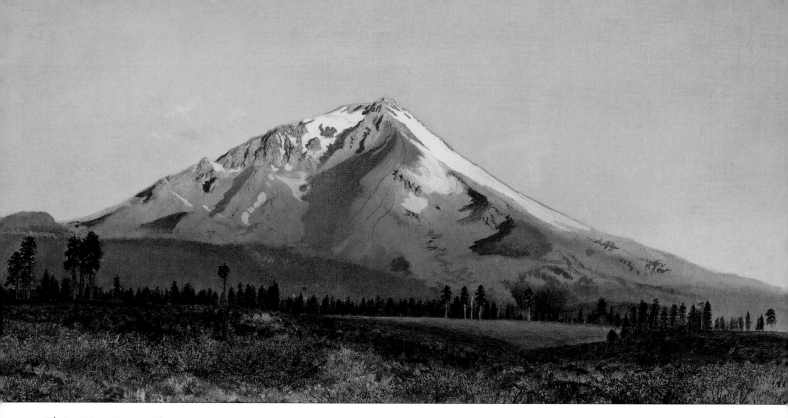

Plate 26: *Mount Shasta,* ca. 1870, 19 x 34.5, oil on canvas. Private collection.

the party, according to Emmons. In a letter of November 14, 1870, written after the fact from Jacksonville, Oregon, Emmons described the journey to the great mountain: "—My dear [brother] Arthur: We left [San Francisco] on August 27 by steamer for Sacramento, and thence by rail to Chico the N Terminus of the Calif. & Oregon R.R. Here we got together our outfits, Clarke having to get 18 Govt. Mules from Nevada. We had our army wagon, and Watkins' photographic wagon; our party consisted of King, Munger, Watkins, the two Clarke's. . . . Palmer, who gave us trouble all the way until we got him into camp near Charlie Staples, a good natured miner-trader, who enlisted as teamster and packer, knowing nothing of either business, and a camp meeting cook, who was of no account. . . . [As soon as camp was established at Shasta] Munger, though disappointed as to the small amount of snow, got

to work steadily, and soon had a fine picture of the mountain on his easel."[67] On September 3 Emmons noted in his diary: "Day in camp [with] Watkins and Clark. Munger makes good head way with his pictures from meadow just east of Sissons [inn]." By September 6 the party had reached the hotel and Emmons wrote: "Nice camp with magnificent views of Shasta." The next day the party made the difficult ascent. "Reached base at 12," Emmons noted, "climb straight up over debris slopes of lava blocks of about 40°— very hard climbing, and dangerous at times. Reached top at 2 . . . stayed till after 3." Over a week the party explored the mountain thoroughly and on September 13 Emmons noted: "Descended Mt. Shasta for Sissions house . . . [and] admire Munger's painting which is progressing finely." Munger did not participate in this ascent of the mountain, preferring to paint it from a distance.

Munger's exhibition-scale paintings of Mount Shasta are unlocated, but a smaller picture suggests one way he represented it (Plate 26). Here he shows an unusual prospect from the southeast side, in which the distinctive second cone of Shastina is hidden behind the mountain. Shasta, King thought, was as "reposeful as a Greek Temple." From their campground King described the view in *Mountaineering:* "We enjoyed the grand, uncertain form of Shasta, with its heaven-piercing crests of white, and wide, placid sweep of base. . . . Its dark head lifting among the fading stars of dawn appealed to our emotions." The actual mountain paled, however, in comparison to the powers of art. "But best," King wrote, "we liked to sit at evening near Munger's easel—watching the great lava cone glow with light almost as wild and lurid as if its crater still streamed."[68]

Before returning to San Francisco Munger traveled north from Shasta with survey geologist Arnold Hague to Mount Hood, where they met Emmons returning from the first ascent of Mount Rainier in Washington Territory. The *New York Evening Post* mentioned a sketch of Mount Hood for January 10, 1872; the prospect was the view from the mouth of the Hood River at the Columbia at "an elevation about twenty miles distant from the mountain." The sketch was made in midsummer and "illustrates the mountain under the effect of what is termed 'summer snow.' Mount Hood is one of the most symmetrical mountains in North America. Mr. Munger's delineation is from a new standpoint, which shows many of its most remarkable and interesting features," not the least of these being "the glacial formation, the existence of which is new[ly] acknowledged as an accepted fact in connection with this celebrated peak."[69] The issue of glaciers was important to King, who in *Systematic Geology* would denounce naturalist John Muir for his "vagaries" in believing that the snow packs of the Sierra Nevada were living glaciers.[70] Munger made several finished paintings from the sketch.

A critic thought Munger had "been remarkably successful in getting the topography, the sculpture of Mt. Hood, not showing it as a flat pyramid, but exhibiting its gorges, clefts and crags, its snow beds, its shadows and its wonderful variety of color. No other artist has so thoroughly and faithfully sketched these noble peaks, and we anticipate that he will delight New York with the large pictures he intends to paint there from his numerous sketches, including many details of scenery, of trees, plants, rocks and living figures." The critic's estimation is born out in *Mount Hood from Hood River* with its superb detail and precision (Plate 27). One thing was certain, a San Francisco critic averred: "His paintings will be entirely true in detail as well as in grand general features, in local color and atmosphere, as well as in topography. They will not be compositions. This assurance is of great value in regard to the professed portraits of noted scenes."[71]

By the middle of November Munger was back in San Francisco with Emmons and King. On November 16 Emmons noted, "Found Arnold & Munger in King's rooms—just arrived. After breakfast view Munger's sketches."

PICTURES FOR A GALLERY OF MEMORY

The precise date of Munger's first visit to Yosemite is unknown, but judging from when

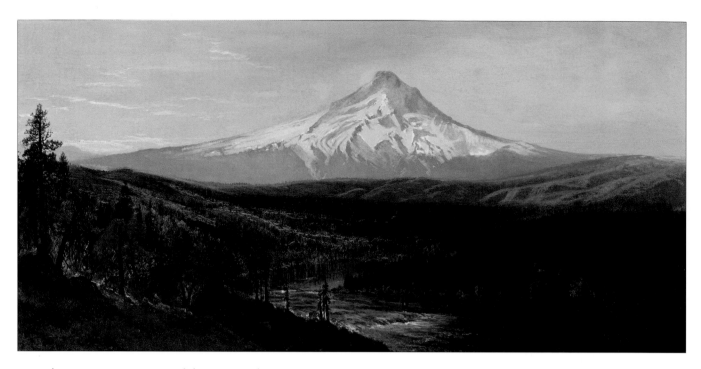

Plate 27: *Mount Hood from Hood River,* 1870, 11 x 22, oil on canvas. Private collection.

sketches were first exhibited, he probably arrived in the spring of 1870. He must have eagerly anticipated prospecting the scenic potential of the newly established wilderness park and nearby sequoia groves after hearing about them from King, who had first explored the valley in 1864 as part of the California Geological Survey, and from Key, who had already painted there. And after learning of Bierstadt's successes with these subjects in New York, Munger wanted to sketch the famed valley himself. We know that he visited Yosemite again several times. The hotel register for Snow's Casa Nevada in the valley records Munger as a guest on October 19, 1873. He visited again in 1875 from July to October, registering at at least two valley hotels.[72]

Yosemite was valuable to Munger because its rich veins of scenery yielded many pictures. At Yosemite the artist met Lord Skelmersdale, a member of parliament, and other English gentlemen, who gave him commissions for works illustrating the scenery for which he was reputedly paid $10,000, the *Memoir* claims: "The English visitors earnestly advised him to set out at once for London with his collection of western studies."[73] Lord Skelmersdale had gained notoriety by paying $40,000 for a prized U.S. breeding bull to be taken back to the United Kingdom. Munger would soon follow the English aristocrat's advice and continued to produce western pictures into the early 1880s, both in New York and London, where they proved highly salable.

Munger was influenced by King. Certainly the artist would have been familiar with King's *Mountaineering in the Sierra Nevada.* Munger was present in King's hotels rooms in San Francisco while King was writing sections for Bret Harte's *Overland Monthly.* The book was

enormously popular when it was first serialized in the *Atlantic Monthly. Mountaineering*'s 1872 edition quickly sold out and was reprinted in 1874. Undoubtedly Munger heard King tell tales of the parklike valley around the campfire. In essays written over nearly a decade, King condensed the descriptions in prose poems that he called "delightful pictures to forever hang in the gallery walls of memory."[74] For King, as it became for Munger, Yosemite was grand natural drama and a living textbook of glacial geology—a source of many pictures to adorn "the gallery of memory." King's fastidiousness about the visual truth of images and the power of language was matched by disdain for overblown literary rhetoric. He noted acidly: "I always go swiftly by this famous point of view now. . . . Here all who make California books, down to the last and most sentimental specimen . . . dismount and inflate."[75] Such

rhetorical inflation is depicted in William Hahn's humorous painting *Yosemite Valley from Glacier Point* (Figure 9). Munger's work avoided all such exaggerated pretense.

When King observed Yosemite he saw geology in action. "Nothing in the whole list of irruptive products, except volcanoes themselves, is so wonderful as the domed mountains," he wrote. "They are every variety of coniodical forms, having horizontal sections accurately elliptical, ovoid, or circular, to the graceful infinite curves of the North Dome." King concluded the whole region was solid granite carved by ancient glaciers. In a passage in which the concerns of science guide the artist's hand and mind, King wrote that in painting a scene, in "defining the leading lines of erosion an artist deepens here and there a line to hint at some structural peculiarity."[76]

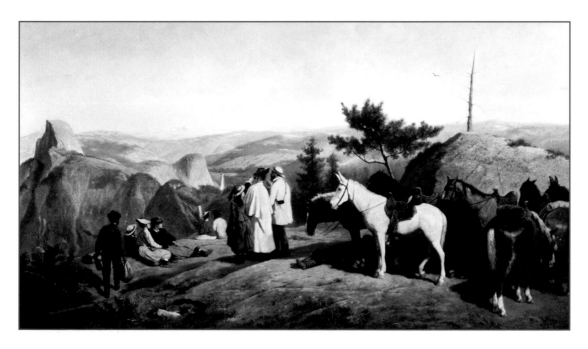

Figure 9. The tourist's conventional response to a grand view was captured in William Hahn's well-known painting *Yosemite Valley from Glacier Point.* Collection of California Historical Society, San Francisco. Gift of Albert M. Bender.

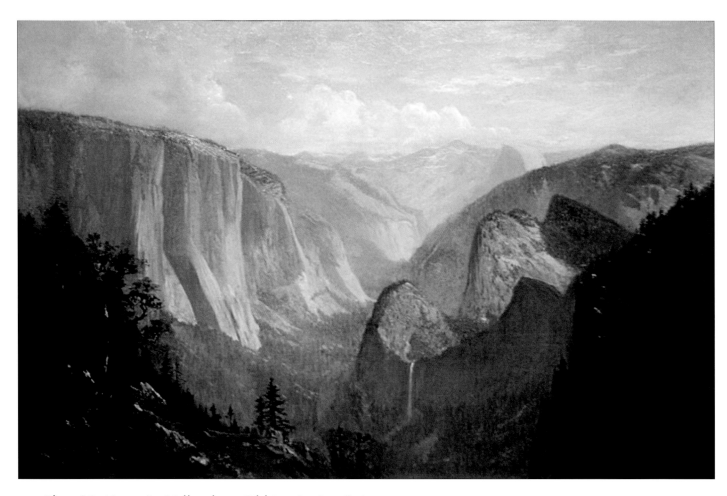

Plate 28: *Yosemite Valley from Old Inspiration Point,* 16 x 24, oil on canvas. Collection of Mr. and Mrs. George C. Rough.

Munger's version of the view from Inspiration Point, the site of much rhetorical and visual "deflation," was so "correct" that it was acquired by expedition geologist Frederick Clark, in whose family it has remained (Plate 28). Doubtless such pictures would have also won King's approval. After all, under his charismatic guidance Munger deepened a line "here and there" in the interest of greater scientific accuracy and authenticity.

DELICATELY TINTED CHARTS
Bridal Veil Falls, Yosemite (Plate 29) is an image of the California natural paradise that a geologist, tourist, or art connoisseur could admire, with its clarifying light and precise topographical detail. The canvas bears the stamp of a London artists' materials supplier, showing that Munger continued to mine his Yosemite sketches in London.

King's prose-poem description of the scene in *Mountaineering* could almost be a gloss on this image. "The rock fell away in one sheer sweep," he exclaimed upon first seeing Yosemite. "Upon its face we could trace the lines of fractures and all prominent lithological changes. . . . Outspread like a delicately

tinted chart lay the lovely park of Yosemite, winding in and out about the solid white feet of precipice, its spires of pine, open expanse of buff and drab meadow, and families of umber oaks rising as background for the vivid green river-margin and flaming orange masses of frosted cottonwood foliage. Bridal Veil brook . . . falling in white water-dust and drifting in pale, translucent clouds out over the tree-tops of the valley."[77]

ROYAL ARCHES, LICHENS, "CLOUDLINGS"

Royal Arches and Half Dome, Yosemite (Plate 30) exhibits scrupulous attention to geological and botanical specifics combined with luminous effects of sunlight. This was Munger's sophisticated alternative to Bierstadt's popular

grandiloquence. Munger's representation is defined by its geological precision and optical clarity. In selecting the subject of the Royal Arches, Munger necessarily invoked the visual conventions of representing natural formations as if they were architecture. The perception of arches, domes, spires, battlements, and sphinxes enabled viewers and tourists to read landscapes, or representations of them, as if they were grand metaphors or even books of natural history where God, the Great Architect, had worked. But Munger sought to deemphasize these historicizing and transcendent associations in the interests of scientific truth, even as he painted the very places in Yosemite that convention had invested such symbolic associations.

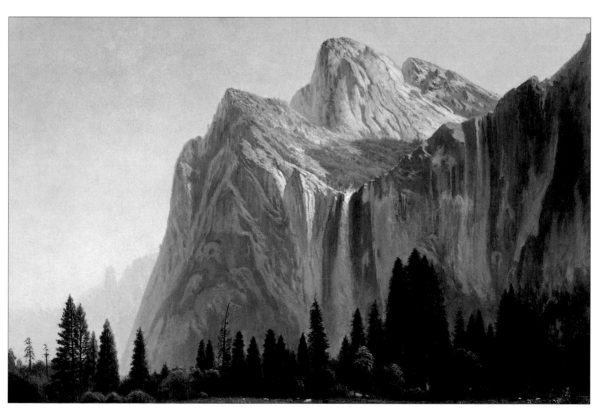

Plate 29: *Bridal Veil Falls, Yosemite,* 1877, 20 x 28, oil on canvas. Private collection.

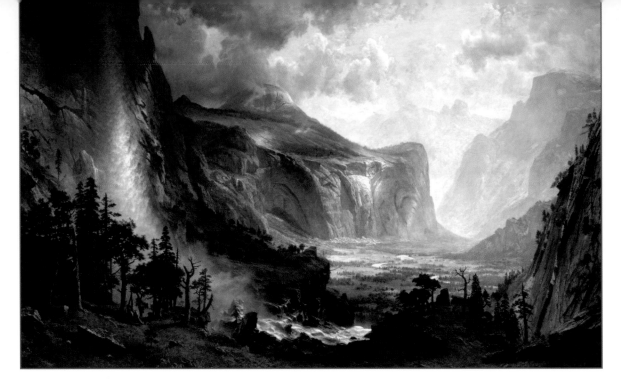

Figure 10. As a young artist Munger saw Albert Bierstadt's "great picture" *Domes of the Yosemite*. Munger toned down the great painter's visual rhetoric in his pendant paintings of the same scene. Collection of the St. Johnsbury Athenaeum, Vermont.

In doing this he followed King's lead. When King looked at the Royal Arches he saw geological history, the wasting hand of erosion, and colorful lichens. As he made a dangerous climb "down a smooth granite roof-slope to where the precipice of Royal Arches makes off, I was able to look down and study those purple markings which are vertically striped upon so many of these granite cliffs," he wrote. "I found them to be bands of lichens growth which follow the curves of occasional water-flow." When this happened it "formed those dark cloudings which add so greatly to the variety and interest of the cliffs."[78] Munger was careful to emphasize forms in the painting to represent these subtle "cloudings."

YOSEMITE PENDANTS: REVISING BIERSTADT
Bierstadt's spectacular success with Yosemite subjects and the increasing accessibility of the place because of the railroad to the foothills made Yosemite subjects perennially salable.

Earlier, as an aspiring artist trying to break into the New York art market in May 1867, Munger witnessed one of Bierstadt's greatest artistic coups. The sensational event of the season was the display of his "great picture" *Domes of the Yosemite* (Figure 10), a ten-by-fifteen foot painting that railroad speculator Le Grand Lockwood had ostentatiously acquired for a huge sum. It was exhibited at Bierstadt's commodious studio at the Tenth Street Studio Building in a special, almost theatrical installation that provided spectators the illusion of actually standing above the valley and looking down it. The painting set off "newspaper wars" among art critics who defended or damned the picture's factual "correctness." The incident would be another stimulus to Munger's seeking to distinguish his more accurate, scientific style from Bierstadt's. Understood in this light, an occasional competitive revision of the famous man's work by the young artist was inevitable.

An example of Munger's response is a pair of unusual, undated, untitled vertical paintings identical in size that might be considered pendants. Popular in Victorian art, particularly in landscape painting, pendants allowed artists to play one image against the other, creating points or counterpoints in visual narratives. In Munger's Yosemite pendants he produced his revision of parts of Bierstadt's *Domes* as *The High Waterfall, Yosemite* (Plate 31) and *Yosemite Valley from a Cliff* (Plate 32). The painting of the high waterfall distinctly recalls the left side of Bierstadt's composition, while the view of the valley from a cliff suggests the right side of Bierstadt's picture. Munger's pendants produce a compelling sense of vertical height and suggest the imme-

diacy of direct experience, as though Munger were subtly attempting to evoke Bierstadt, then surpass him with an ambitiously "correct" diptych of the valley. Unusual for Munger, these paintings are on artist's board, suggesting they are plein air productions.

PERFECT GLORY OF SUNSET

Munger could paint the specifics of a landscape to please a geologist, but he also knew how to delight connoisseurs of art. In the only exhibition-sized painting of Yosemite Valley currently known (Plate 33), Munger painted what appears at first glance to be another standard valley view at sunset. Unlike the sometimes exaggerated effects of light in Bierstadt's pictures that were increasingly criticized by art

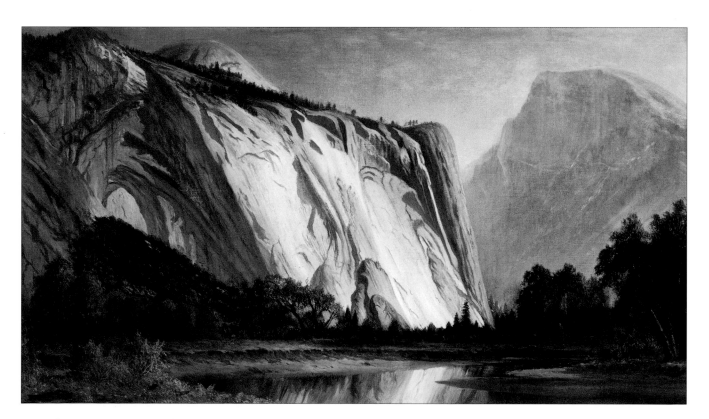

Plate 30: *Royal Arches and Half Dome, Yosemite,* 18 x 31.5, oil on canvas on board. Private collection.

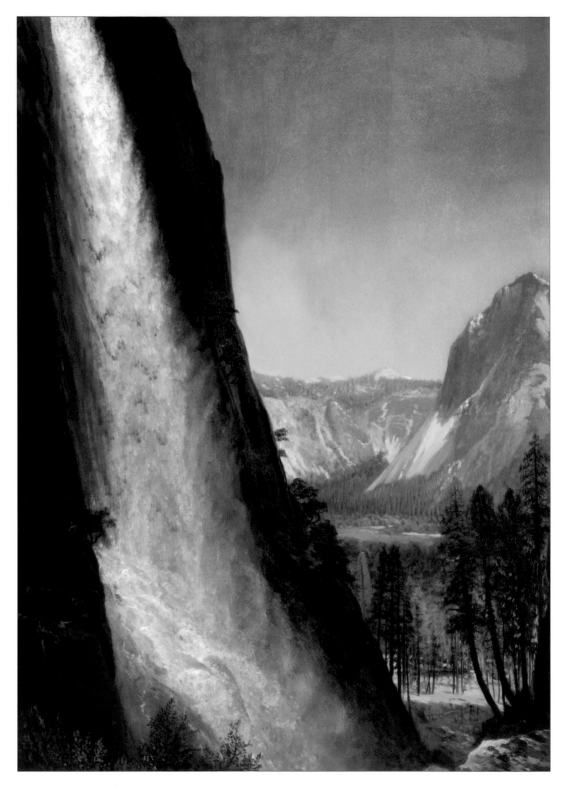

Plate 31: *The High Waterfall, Yosemite,* 27 x 19.5, oil on artist's board.
Collection of Eldon and Susan Grupp.

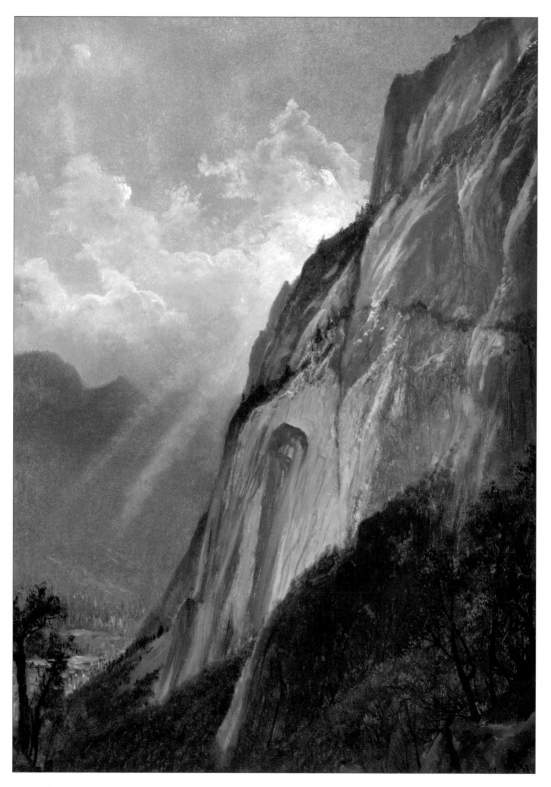

Plate 32: *Yosemite Valley from a Cliff,* 27 x 19.5, oil on artist's board.
Collection of Eldon and Susan Grupp.

critics, Munger's sky seems restrained, yet it is illuminated by glowing light expressing the requisite sentiments of transcendence so commonly associated by nineteenth-century viewers with the end of the day. The foreground places the viewer on the valley floor, obscured in shadows by the retreating sun. The realistic disposition of trees suggests the accuracy of Munger's picture, unlike the idealized foregrounds of certain Bierstadt paintings.

In 1874 a critic wrote of another of Munger's Yosemite sunsets that "[we see] the golden rays of descending sun falling upon the mighty cliffs, transforming their dull gray to perfect glory of splendid hues. Through the golden mist the mighty peaks rise and fade far into the distance. The sunbeams shimmer on the foliage and dance on the placid stream."[79] King's description of a Yosemite sunset could serve as commentary on Munger's painting with its strong scientific inflection: "Sunset, at this hour there is no more splendid contrast of light and shade . . . rocks rising opposite in full light, while the valley is divided equally between sunshine and shade. Pine groves and oaks, almost black in the shadow, are brightened up to clear red-browns . . . the last sunlight reflected from some curious smooth surfaces upon rocks . . . I once suspected them to be glacier marks, and booked them for further observation."[80]

A LITTLE CONVENTIONAL: TREE, FOSSIL, RUINS OF ART

By the time Munger reached Yosemite it was already a major California tourist attraction. In addition to the artful geology of the valley, which had become the nation's first wilderness park during the Civil War, there were the oldest living things known: the great sequoia trees. Munger painted *Giant Sequoias* (Plate 34) and King extolled their hoary age in *Mountaineering*. In another of the Yosemite paintings on artist's board, which measure generally nineteen by twenty-seven inches, Munger shows the trunks of the great trees with tiny figures gazing toward them. The figures are positioned beneath a broken-off fragment of one of the great trees, a veritable ruin of nature's art, gazing in awe at a still-standing giant.

Munger was careful to precisely characterize the rugged bark of the sequoia. They are shown, King wrote, growing "in company with several other coniferous species, all grouped socially together, heightening each other's beauty by contrasts of form and color." According to King, the bark of the monarch of the forest is "thick, but not rough, is scored up and down at considerable intervals with deep, smooth groves, and is of brightest cinnamon color, mottled in purple and yellow." Almost as if describing a painting, King characterized in poetic prose the visual effects of the ancient grove of trees: "There is something memorable in the harmonious yet positive colors of this sort of forest. First the foliage and trunk contrasts finely, — cinnamon and golden apple-green in the Sequoia, dark purple and yellowish-green for the pine, deep wood-color and bluish-green of fir."[81]

Colors from the palette of an artist not withstanding, King's scientific explanation for the longevity of the great trees was due to their "vast respiring power, the atmosphere, the bland, regular climate, which gives such long life, and not any richness or abundance of food received from the soil." The California forest

seemed inconsequential compared with the giant sequoia: "No imperishableness of mountain-peak or of fragment of human work, broken pillar or sand-worn image half lifted over pathetic desert, —none of these link the past and to-day with anything like the power of these monuments of living antiquity, trees that began to grow before the Christian era, and, full of hale vitality and green old age, still bid fair to grow broad and high for centuries to come. Who shall predict the limits of this unexampled life?" The sight of the giant trees prompted King on a meditation of the age of life in a passage that suggests a vision of nature shaped by Darwin, which, it is plausible to suggest, Munger shared. "A mountain, a fossil from deepest geological horizon, a ruin of human art," King wrote, "carry us back into the perspective of centuries with a force that has become, perhaps, a little conventional."[82]

Trees were to become a lifelong fascination for Munger, a theme that deepened and ripened in his European period. At Yosemite

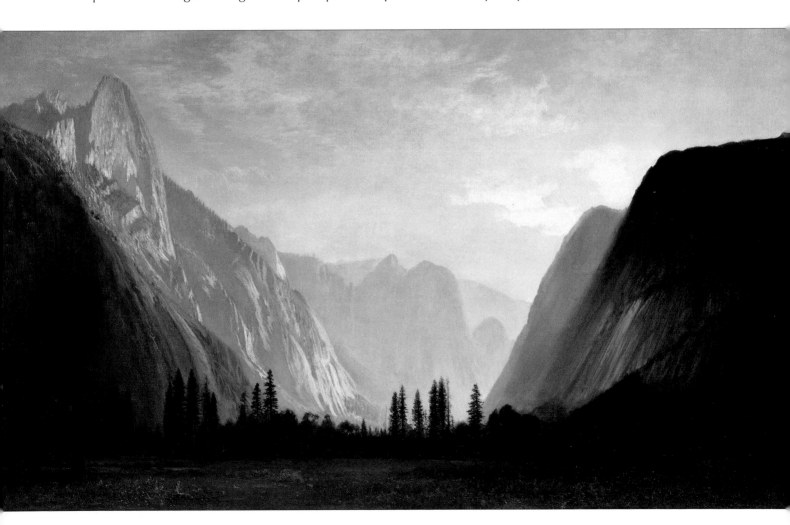

Plate 33: *Yosemite Valley,* 28 x 48, oil on canvas. Collection of Nick and Mary Alexander. Image courtesy of William A. Karges Fine Art, Los Angeles and Carmel.

he painted an evocative grove of trees in *Yosemite Valley Scene* (Plate 35). In the midst of what a casual spectator might think was a manicured, manmade landscape park, three wild bears are glimpsed roaming freely under a canopy of wilderness trees. The bear, symbol of the state, was a near-mythical animal for Californios and eastern tourists prized the sight of one. Munger's painting is historicized, because bears were becoming less frequent by the early 1870s when Munger got to Yosemite. More common would have been the sight of tourists taking the view, a subject that inspired William Hahn's humorous painting. The importance of the picture as a record of early California was recognized in 1982, when it entered the collection at the Oakland Museum.

Trees fascinated King, and in *Mountaineering* he offered extended comments on the life of trees, their respiration, and beneficial effects for humans, and he observed how artists might paint arboreal portraits with their communal beauty: "Trees gather in thicker groups, lift themselves higher, spread out more and finer-feathered branches . . . they are wonderfully like human communities. One may trace in an hour's walk nearly all the laws which govern the physical life of man."[83] Later in his career Munger would expend substantial effort in representing visually a belief in the life of trees, but in a style different from, but influenced by, the expansive vistas of his western pictures.

San Francisco critics praised Munger as "one of the most faithful and conscientious landscape artists who have ever made California scenery a specialty; no other artist has so thoroughly entered into the spirit of local character as he."[84] His success in the West was even noticed in the East. "It must gratify Mr. Munger's old friends here to know that he

Plate 34: *Giant Sequoias,* 27 x 19.5, oil on artist's board. Collection of SBC Communications, Inc.

is rapidly and surely taking his place in the front rank of American artists," the *Washington Evening Star* reported.[85]

NEW YORK INTERLUDE

Munger returned to New York in the late fall of 1870 from his first trip west. He traveled by rail with Samuel Franklin Emmons, Arnold Hague, and Clarence King. Emmons noted in his diary on November 21, 1870: "Arnold, Palmer, Munger and I off at 8 by train, from the number of a certain class of females on the train, M[unger] judges that times are hard in S.F.—go through the Sierra's." The party stopped over in Salt Lake City, where Emmons reported they stayed at the "Salt Lake House—King is painting 'Off the Head'— Plenty of talking and joking."[86] The casual observation that King had taken up painting was confirmed the next day when Emmons noted, "King and Munger paint, and I read." From these entries it appears that the artist had instructed the polymath scientist in the elements of painting. No works by King are located today, but the reference is important as it suggests how close the friendship between Munger and King had become.

News of Bierstadt's impending arrival in San Francisco to explore with King the next season and high hopes of establishing himself in New York may have hastened Munger's departure from California. Upon his arrival in New York in early December 1870, he took a studio at No. 1155 Broadway. He must have been hard at work, because in mid-January 1871 Emmons noted that he and King went to the National Academy of Design "to see Munger's work." King was in the city busily

working on the serialization of *Mountaineering* for the *Atlantic Monthly*. On January 20 a long editorial in the *New York Post* extolled him for exposing the great diamond hoax (he had visited a supposed diamond field in the Utah wilds and proved it a fraud) and the accomplishments of his survey in the national interest. King and Emmons were engaged in preparing for the early volumes of the survey reports. Emmons's diaries suggest that the bonds of friendship forged in the Sierra Nevada and in San Francisco's finest hotels and art galleries between Munger, Emmons, and King deepened during the early 1870s.

Examples of the continuing collaboration and social interactions between Munger and the scientists include entries on January 30, when Emmons notes that he visited Julius Bein, the lithographer for King's volumes and one of the most renowned and expensive printmakers, and "then go to Munger's rooms, 48 West 26th and bring him dinner and finish off the evening at Munger's room." On February 17 he called on Munger, who was "out." A few days later the old San Francisco group was reunited with the triumphant arrival of Bret Harte in the metropolis to what would be regarded today as celebrity status. A few days later, on March 4, Emmons was "Uptown to Munger's who is out." In March Munger exhibited pictures at the Century Association, including one of his Lake Marian views. A month later, on April 4, upon his return to New York after a trip, Emmons writes: "Immediately to Munger's studio. He dines with me at [the] St. James Hotel." On April 20: "Round to Munger's studio . . . to Munger's again." On May 4: "Talk in Munger's studio till noon—

Downtown to Biens." The next day: "Munger's studio . . . Munger and I go to Fisk's Theatre." On May 7 Munger escorted Emmons and King to the train station to see them off for the beginning of the 1871 exploring season, when Bierstadt would join them.

The circumstantial evidence is that Munger remained in New York that year, producing paintings in preparation for the opening of the National Academy of Design annual exhibition, although there are big enough gaps in the chronology for Munger to have made a rail trip west during the summer to join his friends; two newspaper articles claim he intended such a trip. One of Emmons's last entries for 1871 records Emmons's return to New York on December 19 after a season in the field. One of his first acts was to "go down to call on Munger. Go to [the National] Academy with Munger."

Munger headed West again at his own expense in 1872. Dreaming of painting a "great picture" of a waterfall "even higher than Niagara" led him far into unsettled wilderness to explore the remote Shoshone Falls in Idaho Territory. Munger had been with King in San Francisco as King wrote about the falls for the *Overland Monthly* in 1870, and since learning of them Munger had wanted to paint the scene.[87] Apparently Munger intended to go in 1871. The *New York Times* on May 21, 1871, noted with typical Victorian rhetoric, "Munger is again to set his face towards the setting sun. His pictures have already indicated how rich a harvest is yet to be reaped by the artist."[88] But there is no other evidence he made the 1871 trip. On June 8, 1872, the *New York Post* reported

that Munger had closed his studio. On October 16, the San Francisco *Bulletin* noted: "[Munger] will depart for the northern interior again in a few days and visit the celebrated Shoshone falls in the Snake River country, which no painter has yet depicted from original studies." He had gone to find his waterfall.

SKETCHING WITH BIERSTADT, ROOMING WITH KING

Munger's three transcontinental rail trips between the East Coast and San Francisco in 1869–1870, 1872–1873, and 1875 took him through Donner Pass. In early November 1872 he and Bierstadt made a trip to the famed summit to "sketch snow storms and snow effects." Munger painted the rugged pass through the Sierra Nevada with its newly completed railroad snow sheds, hailed as engineering marvels of the time (Plate 36). On first glance his picture seems to resemble Bierstadt's view of the pass with its dramatic light effects. On closer observation it is unusually faithful to the topography of the infamous place, although in this case it is combined with more dramatic than usual rehearsal of aesthetic conventions of light effects appropriate to associations of the ill-fated Donner Party. Munger's handling of light was typically restrained.

An account of the trip with Bierstadt appeared on November 15, as a letter dated November 7, 1872, received by brother Roger Munger from the "Summit Sierra Nevadas" and published in the *St. Paul Daily Pioneer* under the banner "St. Paul Artist High Up in the World Sketching." Munger exclaimed how he had suffered with the cold while sketching Shoshone Falls. At Donner Pass he reported,

"I am now sketching this place with Bierstadt. We work from sunrise to sunset, muffled up to our eyebrows in furs, for the weather is intensely cold, and we are camping in the snow." The letter exuded confidence: "I am now familiar with the scenery, and know where all the best things are. I shall probably work a great deal with Bierstadt, who will remain out a year, and wishes me to accompany him on his sketching tours." His bond with King was also evident: "Clarence King will remain with me, and we propose to take rooms together in San Francisco for the winter."

The meeting of Munger and Bierstadt seems not to have led to further sketching tours or to close friendship, although they remained in social contact for several more years, but it did impart confidence to the youthful Munger. By that time Munger knew of rival artist-explorer Thomas Moran's sensational discovery of the Yellowstone region with King's scientific competitor, the geologist Ferdinand V. Hayden. Congress had declared Yellowstone to be the nation's first national park in March 1872. Munger could not have anticipated how Moran's first triumph, followed by an even more audacious painting of the Grand Canyon of the

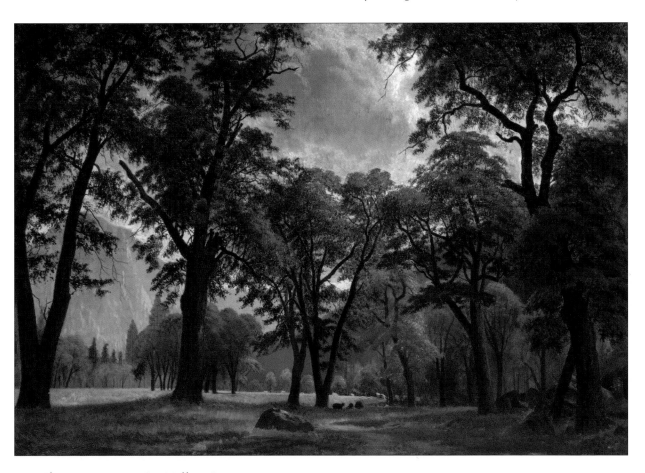

Plate 35: *Yosemite Valley Scene,* 1876, 20 x 28, oil on canvas. Collection of the Oakland Museum of California, Oakland. Museum Donors Acquisition Fund.

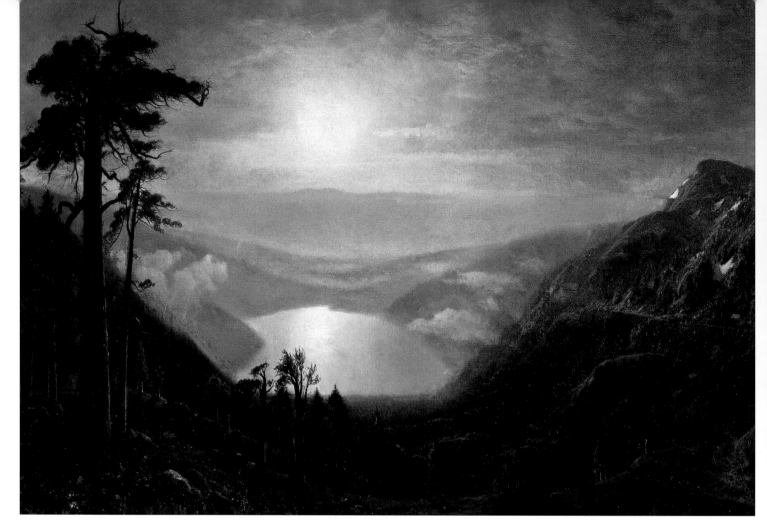

Plate 36: *Sunrise, Donner Lake,* 20 x 28, oil on canvas. Private collection. Image courtesy of the North Point Gallery, San Francisco.

Colorado River (first sketched during an expedition with scientist John Wesley Powell), would affect his own artistic status. Moran's dramatic pictures of western wonders immediately placed him as a leading rival to Bierstadt as the nation's leading artist-explorer, a position Munger might have otherwise tried to claim.

SHOSHONE FALLS: A LOST GREAT PICTURE
Since learning of Shoshone Falls from King and O'Sullivan, Munger had been eager to see the remote falls for himself. Perhaps Shoshone would become the next Niagara. It was far grander than Minnehaha Falls, that much was certain. Seeing O'Sullivan's photographs of

the falls that resulted from his 1868 visit with King further stimulated Munger's interest. He worked alone at the site for two weeks, his guide refusing to remain with him while he made "sketches and studies of this great wonder of nature with the thermometer below zero all the time." Munger had left San Francisco in late June with the intention of sketching Puget Sound. The *Daily Evening Bulletin* noticed his return to San Francisco from the Northwest Coast on October 16 and reported to its readers, "He will depart for the northern interior again in a few days, and visit the celebrated Shoshone falls in the Snake River country, which no painter has depicted from original studies."

Perhaps Munger delayed his departure a few days, because Emmons recorded on October 19 that "King [was back] in town this morning, having returned with Bierstadt yesterday." The next day Emmons wrote, "Sunday Evening go around for Munger but don't find him." Perhaps Munger had already left to discover his falls.

Munger's November 7 letter to his brother, Russell, in St. Paul states he returned from Shoshone a few days earlier. His late start at the end of October for Shoshone and then Donner Pass would provide enduring memories of wilderness hardships for the artist and doubtless exciting tales of western adventure for dinner-party conversation. In the letter Munger wrote about sketching at Shoshone Falls, he said, "I was compelled to camp out alone, cook for myself, and pack my firewood a distance of half a mile on my back. The sides of the canyon in the morning are covered with a sheet of ice, making it difficult to descend to a stream for water. I remained eight days making studies, and the subject will repay me for all the suffering and hardship." He added: "Shoshone is one of the grandest scenes I have ever witnessed, and I have great hopes of the subject making a grand picture." The San Francisco *Daily Evening Bulletin* noted Munger's return to the city, mentioning that he was "hard at work on a most important painting of that remarkable cataract [Shoshone Falls]. Mr. Munger's field studies are very elaborate and faithful, and his finished paintings entitle him to a high rank among American landscape artists. He combines enthusiasm with good judgment and painstaking industry in a rare degree." The painting would be "boldly conceived and finely worked," the *Bulletin*

reported in mid-December.[89] By early January it was "receiving its finishing touches,"[90] although by mid-February "Mr. Munger is still working conscientiously on his Falls of Shoshone."[91] A review of his progress described his "studio" in Room 123 of the Grand Hotel: "Munger's studio is a plainly furnished working area. Two tables, covered with paints, and a sofa constitute but the principal furniture. Among his sketches that are faced against the wall, or rolled up, or in covers, are several fine views of Mt Raignier [sic], on Puget Sound. The Shoshone Falls, on which he is working . . . are interesting geologically, as an erosion into a vast plain of modern [rocks], underlaid by ancient rocks." The reviewer added, "Mr. Munger will go with Bierstadt to the Southern Sierras as soon as the season permits."[92] There is no evidence that Munger accompanied Bierstadt on this later trip.

The critic from the *Alta California* previewed the painting in Munger's studio, where he found the artist at work on a five-by-eight-foot picture that "represents the wondrous cascade in the mellow sunset of a November afternoon. There is a dreamy haze of purple Autumn pervading the picture. . . . Mr. Munger is one of those painters who study harmony rather than contrast and aims to produce the greatest amount of light with the least amount of coloring."[93] After a long run up, at last in mid-May *Shoshone Falls* was triumphantly exhibited at the fourth San Francisco Art Association exhibition.[94]

HONEST BOOKS FOR COSMOGRAPHS

Shoshone Falls – Idaho was Munger's second "great picture." Although the five-by-eight-foot painting is unlocated today, its appearance

may be inferred from the chromolithograph Munger produced of the subject for King's *Systematic Geology* (Plate 37). At its San Francisco presentation it was the largest work in the gallery, except for Thomas Hill's *Royal Arches.* According to the San Francisco *Daily Evening Bulletin,* it was Munger's "conscientiously faithful transcript of a wonder of western scenery which no painter before him has visited or depicted."[95] His representation was deemed so accurate the *Bulletin* confidently assured its readers that "dwellers in distant lands may rest assured that when Munger places before their eyes pictures of far-off scenes on which their gaze has never rested, the delineation will be scrupulously true that cosmographs may read the character of the land like a page from an honest book."

Munger's problem was how to make the falls visually compelling. King had painted a word picture of Shoshone in *Mountaineering* that found it decidedly inferior in visual appeal to both Niagara and Yosemite, yet the scientist ranked it as the third greatest waterfall in the United States and worthy of an excursion from the main work of the expedition for firsthand inspection. The poetry of King's description in *Mountaineering* resonates in Munger's dramatic image of a remote waterfall that only a handful of explorers had actually seen:

> *No sheltering pine or mountain distance of up-piled Sierra guards the approach to the Shoshone. You ride upon a waste,— the pale earth stretched in desolation. Suddenly you stand upon a brink, as if the earth has yawned. Black walls flank the abyss. Deep in the bed a great river fights its way through labyrinths of blackened ruins and plunges in foaming whiteness over a cliff of lava. You turn from the brink as from a frightful glimpse of the Inferno, and when you have gone a mile the earth seems to have closed again; every trace of the canyon has vanished.*[96]

The difficult fact for a landscape painter was that Shoshone Falls was utterly bereft of the conventional attributes of beauty associated with waterfalls, particularly vegetation. The arid region, a volcanic desert through which the Snake River flowed, possessed a weird, desolate, even hellish aspect. Munger's problem was not unlike the one Thomas Moran confronted as he sought to paint the barren Grand Canyon of the Colorado River, or that Henry Cheever Pratt had wrestled with earlier in painting the southwestern deserts for the U.S.–Mexico Boundary Survey in the 1850s.[97]

THE CUNNING OF GENIUS

By now Munger's well-proven option was to downplay an overused reliance on representing weirdly shaped rock formations as metaphors of ancient ruins, castles, or fantastic faces or figures. King had used this all too familiar approach in describing Shoshone: "From the white front of the cataract the eye constantly wanders up to the black, frowning parapet of lava. Angular bastions rise sharply from the general level of the wall, and here and there isolated block, profiling upon their skyline, strikingly recall barbette batteries." But there were definite limits to such associations, the scientist in King lectured: "To goad one's imagination up to the point of perpetually

seeing resemblances to everything else in the forms of rocks is the most vulgar vice of travelers. To refuse to see the architectural suggestions upon the Snake canyon, however, is to administer a flat snub to one's fancy."[98] "At first glance the landscape as a whole would strike the majority of observers as unnatural and purely fanciful," a San Francisco reviewer thought. "Yet upon close examination the improbable looking rocks, with their strange sombre monotony of color, show distinct indications of being close geological studies."[99]

A striking feature of the image was the way Munger painted the falling water with dramatic effects of mist and spray enveloping the falls. His early study of Church and John F. Kensett paid dividends in his faithful handling of the fugitive effects of light and vapor. A sympathetic critic gave the picture a positive reception: "The picture is mostly composed of rock and water, there being scarcely a tree or shrub, or any trace of vegetation in the entire landscape. This feature, with the somber brown of the rocks stretching far into the distance, contributes much to the feeling of grandeur and desolation that pervades the picture." But it was for Munger's treatment of the effects of falling water that the greatest praise was reserved: "It is generally considered a very difficult thing in art to give the effect of falling water. Mr. Munger has triumphed over this difficulty. The tumbling, tumultuous mass precipitating itself over an immense cliff, and emitting marvelous prismatic hues, has a remarkably natural look,

and is finely painted, both in detail and for general effect."[100] The reviewer for the *Alta California* praised the picture as a "study for topographers and cosmologists. The great leap of these seething white waters into the great depth, is so beautifully painted, that it seems like a reflection of actuality, through the instantaneous camera of photography." The reviewer had but one complaint: "The artist has given such a sense of an immensity of rushing waters, that it seems strange that it should be so silent."[101]

Munger's *Shoshone* picture garnered many other positive reviews during its exhibition in San Francisco. In particular, a long review in the *Bulletin* noted that the falls were one hundred feet higher than Niagara, but they were also at present "one hundred miles from the Central Pacific Railroad, in a region wild and unsettled." The scene "presents many difficulties for an artist, but Mr. Munger has produced a picture of singular interest and much beauty, remarkable for its topographical truth and for the very conscientious labor apparent. It is certain to attract a great deal of attention."[102] A reviewer for the *San Francisco Chronicle* was no less enthusiastic, saying that the picture would give Munger a "lasting reputation," its detail and color "the cunning of genius." But a few weeks later *Shoshone Falls* had been moved to the end of the hall at the Art Association to "make room for Bierstadt's big picture."[103] When the "Great Man" came to town, his pictures claimed the place of honor in the gallery.

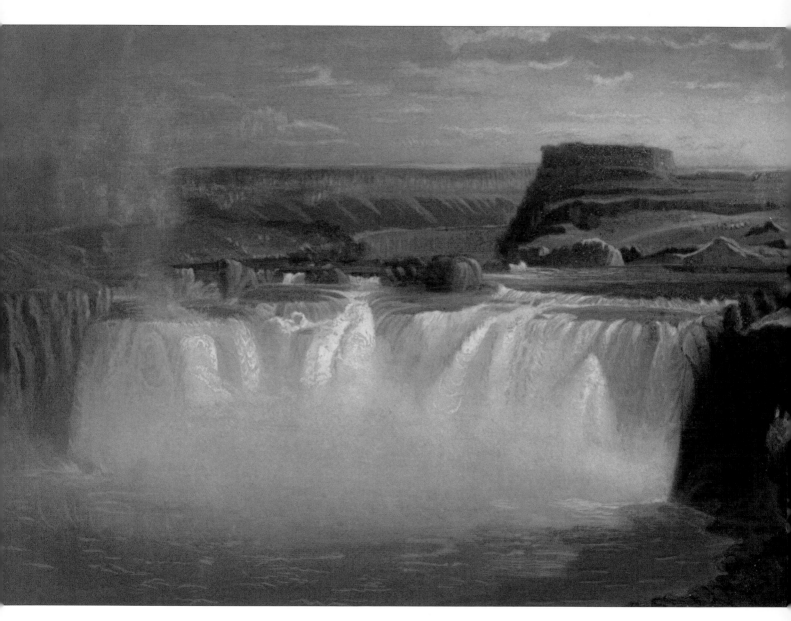

Plate 37: *Shoshone Falls – Idaho,* 1878, 6 x 8.5, chromolithograph. From Clarence King's *Systematic Geology,* Government Printing Office, 1878.

3

"POOR MUNGER": PAINTING FOR SCIENTISTS AND CONNOISSEURS

A PORTFOLIO OF WESTERN SKETCHES

By early December 1873 Gilbert Munger was back in his New York studio. The *New York Evening Post* reported that he had returned with "a portfolio of sketches which exceed in interest and variety any which we have hitherto seen [of] those far western regions. [They] are finely executed and many of them bear the character of finished pictures."[104] A San Francisco critic writing in the *California Advertiser* lamented the artist's departure: "Our art community has sustained a decided loss by the departure of Mr. Gilbert Munger for New York, where he will reestablish himself for a time." The artist's style is "eminently finished and complete . . . further proof of this artist's fidelity to nature, that Prof. [Josiah] Whitney and several other scientific men have given him commissions. Poor Munger! We would rather paint for the most exacting connoisseurs than for scientists. But let that pass; we can bear ample testimony to this artist's genius and talent as well as to his untiring energy and conscientiousness."

The writer for the *Advertiser,* who seemed familiar with Munger personally, described the artist's working methods in a long passage. He explained that Munger supported himself without having to submit to the usual market channels for sales through art dealers: "His success in obtaining commissions *in the field*

from travelers and tourists, will, we expect, stimulate some of our younger men to *sketch* more carefully and spend more time among the beauties of nature." Munger's sketches "have nothing meretricious about them; he aims at strong neutral effects very frequently, it is true, and some think his work a little too scenic, but if so, it is scenic painting of the best and highest order." Munger's "numerous separate studies of foliage, rocks, geologically true, snow under all effects, skies and clouds innumerable, convince us that this artist is working in the right spirit, and is sure of attaining a foremost place in his profession."[105] What proved advantageous in the 1870s and 1880s when Munger made the most profitable use of this direct method of sales, however, would prove to not work so well in the 1890s when securing a reliable dealer became essential for the professional artist operating in a highly competitive and increasingly anonymous market economy.

Some of the western sketches were intended to illustrate Clarence King's *Systematic Geology,* while others served as aide-mémoire as Munger continued to produce western pictures in New York and London. He must have been busy and active socially. Samuel Franklin Emmons's diary is filled with references from late January through early May 1874 with sightings of the artist in company with his

exploring associates. On January 30 Emmons wrote that he expected King's return to the city, but "[he] doesn't come. . . . Munger and I turn in early." The next day: "Go to Water Color Exhibition with King. After to Munger's [studio]." A few days later, on February 9: "Morning Munger's studio with Eva & Martha. . . . Theatre with Munger." Mid-April saw Munger and Emmons going downtown together to see Bertha and visit in the Bowery. On February 27 Munger escorted the future first Mrs. "Lily [Emmons] to Central Park." A day later: "Munger brings in Sachetti. Meet Lily at Munger's and dine with her at Brunswick." The last sighting of Munger in Emmons's 1874 diary is on May 9, when Munger and others saw Emmons off on a trip to Europe. Later newspaper accounts make clear that Munger spent the summer in New York painting.

POETICAL THOUGHT: SUNNING ALLIGATORS

That Munger stayed busy goes almost without saying. He returned to St. Paul on October 19, 1874. His absence from Minnesota was noted in the *St. Paul Pioneer Press:* "He has been busily engaged during the entire time, except four days, in his studio in New York." In New York Munger had completed "over fifty pictures which had been ordered. Fifteen of them were painted for English gentlemen, and were mostly scenes among the Rocky Mountains. It is to be hoped that this talented artist, whom St. Paul claims as her own, will place some of his excellent works on exhibition for the inspection of the public."[106]

By December 1874 the *New York Evening Post* reported that Munger had "gone to St. Paul, Minnesota, for the winter, and is now working on a large canvas, giving a view of Yo-Semite Valley."[107] This picture, which apparently created a sensation in St. Paul, was exhibited to press attention at Metcalf and Dixon's fashionable store. A review claimed that Munger had worked from more than one hundred sketches in his studio to produce the large picture. The painting, which is unlocated, was a sunset view of the valley filled with light effects that were "wonderful beyond description. The scene is looking out of the valley . . . the river Merced is seen threading its silver course to its outlet, while the foreground is rich in splendid foliage and wonderful geological formations."[108] During its two-week run the exhibition resulted in the commissioning of two more pictures ordered from field sketches. "His Yosemite is attracting great attention," the *Pioneer Press* reported, "and there is a possibility that it also will remain in this city. Investments in the works of such great and growing genius are the best that can be made."[109]

Controversy ensued when a critic accused Munger's *Yosemite* of being deficient in "poetical thought." In a humorous reply the *Pioneer Press* recommended that "the author of the notice should order a picture with the same outline as Munger's Yosemite, having a French villa on the highest peak, Minnehaha Falls in the equal distance, the gentle Merced, with Guy Salisbury fishing for speckled trout, an alligator sunning itself on its banks and gentle peasants performing the Mulligan Guards."[110]

CLAIMING A NATIONAL REPUTATION

Just before Christmas 1874 the *Pioneer Press* informed readers that Munger was producing another large version of *Shoshone Falls.*

"Munger has just commenced working up the study of a painting [of Shoshone Falls] which he is to make for the Centennial Exhibition. The picture will be 12 x 7 feet in size. This remarkable falls has been discovered within the past five years, and is the western rival of Niagara, being 40 feet higher."[111] Munger's second *Shoshone Falls* was not exhibited at the Centennial Art Exhibition, according to the official catalog, although it could have been exhibited in other buildings at the fair. The picture remains unlocated.

Munger's climb to standing among established artists of the Hudson River School is suggested by his recognition as an authority on the color of western landscape during the exhibition of Thomas Moran's *Grand Canyon of the Yellowstone*.[112] The event drew a huge crowd to an auction in Clinton Hall, New York, where press, literati, and fellow artists gathered to admire Moran's picture of the newly recognized national park, purchased by the federal government for $10,000, before it was sent to Washington. Munger was in attendance at the opening, and his approval of the brilliant color of Moran's painting was cited along with that of King, explorer Ferdinand V. Hayden, and landscape architect Frederick Law Olmsted.

Munger's affirmation was evidently sufficient for fellow artist Sanford R. Gifford, who had gone west in 1870. Gifford wrote to Hayden, "I was very sorry indeed to miss seeing Mr. Moran's work, which I have been told by a very good author (Mr. [Gilbert] Munger who was with Clarence King several seasons) is excellent not only for its local truths, but as a work of fine art."[113] By mid-January 1875

Munger was "busily at work in New York, painting views in the Yosemite Valley to fill orders from English connoisseurs," the *St. Paul Pioneer Press* reported.[114] In only a few years, Munger had gained an impressive reputation, but Moran's recent triumph spurred him to further effort.

ILLUSTRATING KING'S
SYSTEMATIC GEOLOGY

Munger now counted among his closest friends one of the nation's most influential explorer-scientists and was poised to claim national recognition, having successfully sold work in San Francisco, New York, Minnesota, and Europe. Munger's stay in New York around the centennial was highly productive. King had settled in the city in the spring of 1875 to complete his book detailing the geology of the region he had explored, while old San Francisco friend Bret Harte was a near neighbor. King continued to provide Munger entrée into the company of scientific and professional clubs and refined society. King arranged for the exhibition of Munger's *Rocky Mountains* at the Yale Scientific School, where science and possibly art students would have studied it. Emmons details ongoing social and professional associations. For instance, on February 25 he writes: "Evening to Park Theatre with King and Munger." Throughout March, Emmons, Munger, King, and the Bierstadts were frequent visitors: on March 7, "Bierstadt's come to lunch"; March 19, "Munger & author go to theatre Ristiro [?] in Maria Antonette"; the next day, "King and Munger dine with the Bierstadt's."

The illustrations for King's book were based on Munger's oil sketches, and several closely

match known paintings. Munger's ten color chromolithographs in *Systematic Geology* are impressive examples of scientific art produced under the authority of the federal government. During the early 1870s demand increased for printed views of the western landscape. Such views, besides affording pleasure to art connoisseurs, provided invaluable visual information about the geography, geology, and economic potential of the West to settlers, tourists, and investors. By 1872, for example, Moran's Yellowstone sketches were published by the commercial firm of Louis Prang as chromolithographs. Munger's views of the West, produced around the same time by Julius Bien, rivaled Moran's in topographical accuracy and technical excellence, although, because they were bound with King's book and not published separately, they did not become as well known as Moran's more accessible work for Prang.

Due to King's many distractions, the publication of *Systematic Geology* was long delayed. Although listed as volume one of the King survey reports, it was actually the last volume published, not appearing until 1878, at least a year after Munger had gone abroad. Yet it was immediately recognized as one of the most important scientific books about the West, with illustrations that geologists and art lovers alike could admire, and it played an instrumental role in King becoming the first director of the U.S. Geological Survey. The practical purpose of the volume was "a study and description of all the natural resources of the mountain country near the Union and Central Pacific Railroads."[115] An innovative feature was that plates were called out in King's text and discussed or presented as

visual examples of what was being analyzed. Although this practice is commonplace today, in the 1870s few survey books attempted such specific linkage between text and image. Besides ten four-color chromolithographs executed by Julius Bien (1826–1909) after Munger's sketches, the book contained many monochrome plates after Timothy O'Sullivan's photographs, also executed by Bien, one of the finest and most expensive lithographers of his period. His work translated the artist's and photographer's images at the highest level of reproductive quality available before photomechanical techniques replaced handwork. Emmons evidently was responsible for overseeing part of the work with Bien because his papers contain invoices payable to the printmaker, often for large sums drawn on government accounts. One dated November 5 from Bien is for "preparing 10 colored sketches for geological book illustrations @ $75–$750."[116] These must be the lithographer's drawings from which the Munger chromolithographs in *Systematic Geology* were based. Doubtless, given the frequency of visits by Munger, Emmons, and King to Bien's studio and press during the period, Munger may have overlooked the reproductions made from his original oil sketches.

MUNGER AND DARWINIAN GEOLOGY

Because of the formidable expense of production, the scenes selected for color reproduction were of the greatest importance. King understood clearly that his position as a leader of the western explorers rested on his espousal of scientific rigor and of a progressive, entirely secular vision of natural history. Darwin is cited and his ideas underpin King's text, with the

Munger sketches and O'Sullivan photos subtly supporting his professional agenda. The report of the Fortieth Parallel Survey was a landmark publication because it was one of the first entirely scientific descriptions of the nation's geological history. Its rigorous, detached narrative is the antithesis of the raconteur's poetic flourishes in *Mountaineering in the Sierra Nevada* or the boosterism that sometimes marred the writings of King's rival, Ferdinand Hayden.

Munger's daily contact with King and friendship with Emmons and geologist Arnold Hague, all advocates of progressive science, provided Munger with concentrated exposure to the most up-to-date ideas of Earth science. Although never directly articulated, the artist's charge was to devise ways of visually representing the geological implications of a Darwinian conception of landscape. Direct evidence of Munger's interest in the discourses that swirled around the Darwinian Revolution, already well advanced by the early 1870s, has not been found, however. Munger, in the handful of direct statements we have, never mentions Darwin or for that matter reflects on any philosophical or scientific issues. Munger's art was his philosophy, he later averred. His lifelong association with King, Emmons, and other men of the Fortieth Parallel Survey provided Munger with a professional and personal context to produce awareness of these scientific discourses so vigorously contested around the centennial.

Munger's treatment of the images in *Systematic Geology* was his contribution to securing King's reputation as just this kind of progressive scientist. King's massive report consisted of seven volumes, including two oversized map atlases. It represented in unprecedented detail a vast section of North American mountain geology along the Fortieth Parallel. King aspired for his work to be on "an equal footing with the best European publications."[117] Color plates by Munger and photographs by O'Sullivan were therefore carefully calibrated to support scientific objectives, combining art with rigorous geological, mineralogical, and fossil documentation.

CODES OF ART (COLUMNS, FORTIFICATIONS, BAD LANDS): IMAGES OF EVOLUTION

Munger's challenge was to produce accurate images that served the needs of professional geology while remaining within the conventions and established codes of landscape representation expected by King's highly educated readers. Munger's views of the Washakie Badlands in Wyoming are prime evidence of how he reconciled these objectives (Plates 38 and 39). The badlands are possibly the most visually compelling and utterly unconventional places that King illustrated with chromolithographs. The importance that King assigned them can be gauged by the fact that *Natural Column – Washakie Bad-Lands – Wyoming* served as frontispiece for the volume. In discussing the column King carefully avoided the promotional rhetoric of rival explorers, such as Hayden's reports on the wonders and curiosities of the Yellowstone region. Yet when it served narrative purposes, King retained the well-worn rhetoric of architectural associations to launch his discussion of the stratigraphy and erosional patterns that produced these appealing, colorful, curious-looking formations. This natural column was

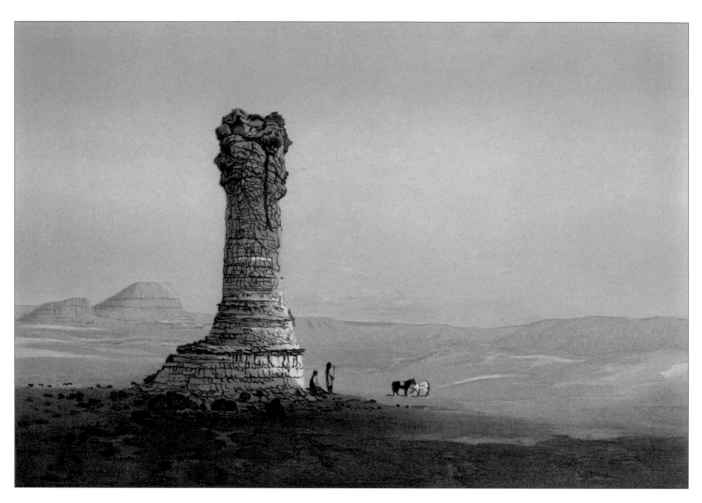

Plate 38: *Natural Column – Washakie Bad-Lands – Wyoming,* 6 x 8.5, chromolithograph.
From Clarence King's *Systematic Geology,* Government Printing Office, 1878.

not the result of divine intervention, nor the handiwork of the "Great Architect." King, the unyielding modern man of geological science, stressed that it resulted from relentless geological processes of enormous antiquity. King's text precisely glosses the descriptive geology represented in Munger's image:

> *The Bridger Beds here rise to 300 feet and present a series of abrupt, nearly vertical faces, worn into innumerable architectural forms . . . which have been wrought into a variety of singular forms by Aeolian erosion. Plate XV . . . shows*

> *some of the curious buttressed shapes. . . . At a little distance, these sharp incisions seem like the spaces between series of pillars, and the whole aspect of the region is a line of Egyptian structures. . . . The most astonishing single monument here is the isolated column shown in the frontispiece of this volume. It stands upon a plain of gray earth, which supports a scant growth of desert sage, and rises to a height of fully sixty feet. It could hardly be a more perfect specimen of an isolated monumental form if sculptured by the hand of man.*

Munger and lithographer Julius Bien went to great pains to capture geological details that King described, particularly the area's color: "The uniform buff and gray marls and clays are seen to be interrupted at several elevations by beds of peculiar green earth, which add to the architectural forms the elements of variegated courses."[118] These unusual forms led King on an extended explanation of geological forces responsible for the region's strange appearance. In response to contemporary artistic conventions, Munger or perhaps Bien introduced Native Americans to enhance the image's appeal, providing a historical and human scale in a bizarre desert landscape.

By 1875 King was aware of John Wesley Powell's explorations in the Colorado River Basin, partially because King's Fortieth Parallel Survey had investigated the northern edge of the Colorado Plateau around Lodore Canyon. Munger would have similarly taken an interest in Thomas Moran's widely publicized paintings of the region. Munger's depiction of three thousand feet of exposed geology in the *Canyon of Lodore – Uinta Range – Colorado* (Plate 40) distinctly recalls Moran's sublime

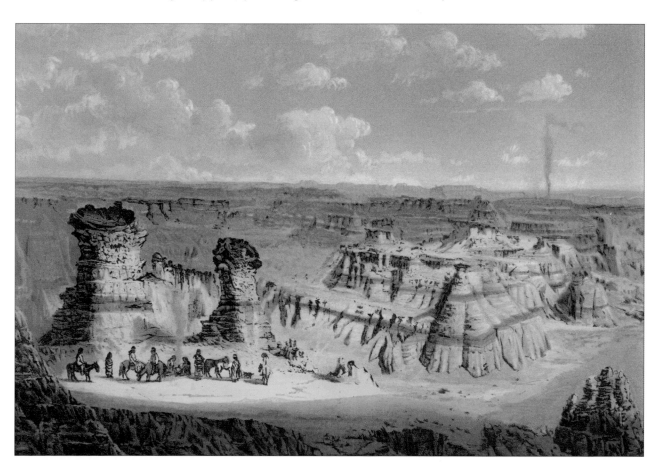

Plate 39: *Washakie Bad-Lands – Wyoming,* 6 x 8.5, chromolithograph. From Clarence King's *Systematic Geology,* Government Printing Office, 1878.

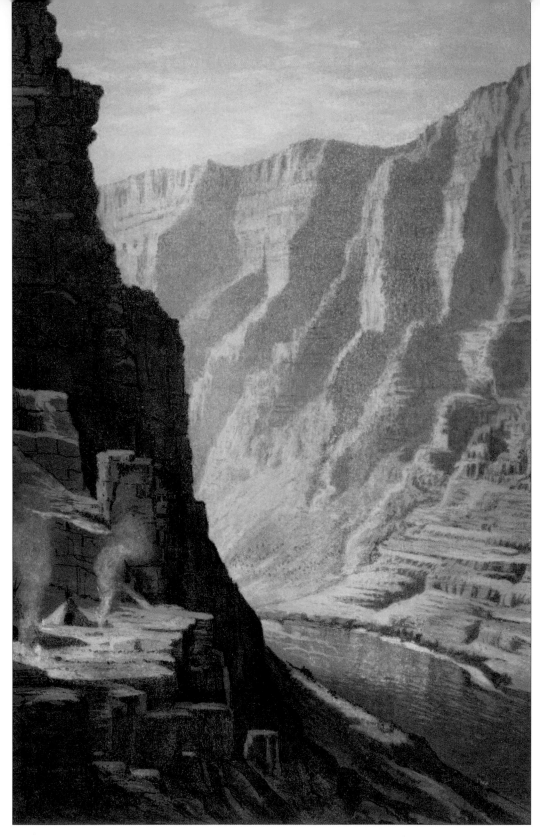

Plate 40: *Canyon of Lodore – Uinta Range – Colorado,* 8.5 x 6, chromolithograph. From Clarence King's *Systematic Geology,* Government Printing Office, 1878.

images of the Colorado that resulted from explorations with Powell in 1873. By the mid-1870s King and Powell were friendly rivals, jockeying for position to become the head of a unified government geological survey. Both were committed Darwinists. Munger's dramatic image of the deep canyon, paired with an O'Sullivan photograph, allowed King to discuss competing theories of the region's geological origins from his progressive Darwinian perspective while simultaneously laying claim to a corner of Powell's geographical and professional turf. Munger's picturesque addition of Native Americans improbably camping in tepees in the depths of the canyon provided a conventional point of visual access for spectators not accustomed to representations of such geological immensity or specificity.

"HISTORY OF THE COUNTRY"

In the chromolithograph *Eocene Bluffs – Green River – Wyoming* (Plate 41) Munger alluded to Moran's depictions of the scene, while emphasizing through lurid colors the specific geology of "excessively thin and fine grained shales."[119] King was excited because the Green River bluffs had yielded fascinating fossil discoveries in the recently completed railway cuts through the soft formations that "possess the . . . outlines of artificial fortifications."[120] Munger, like Moran, was completely willing to suppress all evidence of the industrialization of the scene caused by the arrival of the railway (Figure 11). When Munger exhibited a picture (unlocated) in San Francisco that may have been a study for this chromo, a reviewer lavished praise: "These studies are so faithful that a geologist can

read in them a history of the country—can discern the shore lines of an ancient lake, marking the slopes and branches of the sedimentary rock." But with this "literalness there is the poetic effect of sunset light striking the tops of the rocks."[121]

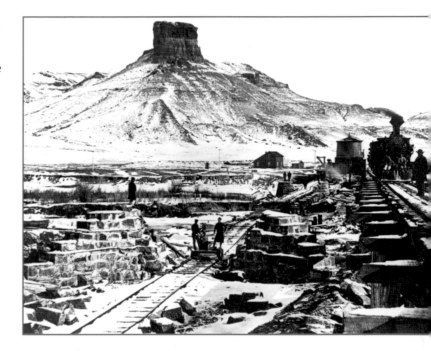

Figure 11. Andrew Russell photographed the transcontinental railroad crossing the Green River in Wyoming around the same time Munger painted the scene, but Munger omitted the signs of industrial progress. Special Collections and Archives, Merrill Library, Utah State University, Logan.

The national importance of *Systematic Geology* soon became evident with the selection of King to fill the position of first director of the U.S. Geological Survey, and its rapid consolidation under him as a civilian-led scientific organization. The seasons spent with King exploring the West and working in New York on illustrations for *Systematic Geology* provided Munger with valuable connections and patronage to be sure, but it also exposed him to a Darwinian vision of nature that he would historicize and deepen later in his career.

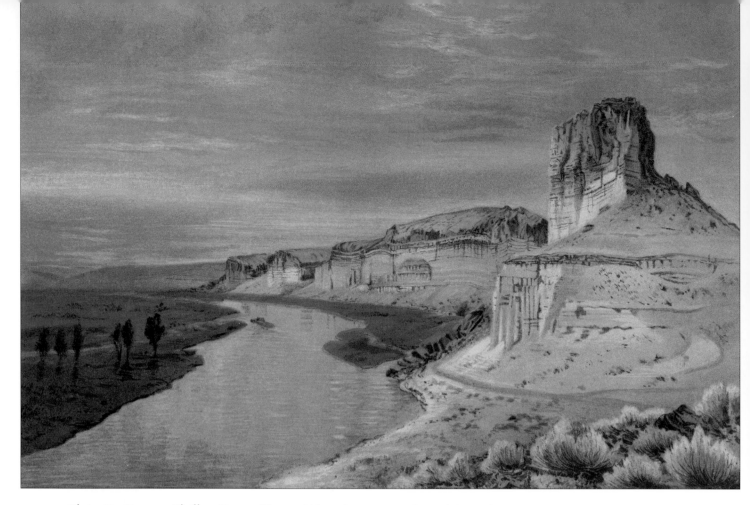

Plate 41: *Eocene Bluffs – Green River – Wyoming*, 6 x 8.5, chromolithograph. From Clarence King's *Systematic Geology*, Government Printing Office, 1878.

MINING WESTERN SKETCHES
AND CAREER MOVES

"Mr. Gilbert Munger is busily at work in his studio in New York, painting views of Yosemite Valley to fill orders from English Connoisseurs," the *St. Paul Pioneer Press* reported on January 17, 1875. Munger's response to newfound recognition and to rival Thomas Moran resulted in a heightening of color in an important series of paintings produced in 1876–1877. Other works from this period of intense studio production include *Yosemite Valley Scene* (Plate 35) and *After the Storm, Utah* (Plate 12). Another example from the series, *Glacier Lake, Kings Canyon, California* (Plate 42), shows striking affinities to Moran's depictions of the colorful

Yellowstone region. This series is a summation of Munger's western experience.

To resupply his inventory of sketches Munger made a third and final trip west to California in the second half of 1875. In comparison with earlier visits, surprisingly little information has surfaced about this trip. Artist Walter Paris later remembered seeing Munger in a studio in San Francisco in 1875, yet Munger did not exhibit in the city as he had earlier and the newspapers did not seem to notice his arrival or departure. An examination of hotel registers in Yosemite documents that he spent considerable time in the valley. He stayed at the Mariposa Big Tree Station near Yosemite

on July 9. He registered at Snow's Casa Nevada hotel in Yosemite Valley on October 24 and he was again at Mariposa Big Tree Station at the end of October. Emmons's diary, which is very thin for 1875, does contain one final reference to the artist on December 6: "Munger arrives." Was this the return from the end of his trip to California? We know that he produced many studio paintings of the West during the following year in his New York studio. His work was included in the prestigious collection of Louis Prang, according to the *New York Evening Post.* An auction of works from Prang's collection, many published as chromos by the lithographer, evidenced "good judgment and taste. The paintings in nearly every instance were executed to order. . . . There are strong pictures by . . . Gilbert Munger."[122]

By the centennial Munger had gained a position as a well-regarded figure in the New York art market. Yet like a number of other artists around that time, he decided to leave the country. The centennial marked a major shift for American artists. Influential art critics like James Jackson Jarves and Clarence Cook were harshly critical of the "cold" scientific realism of Church and Bierstadt. Such criticism would apply to Munger's pictures too. He picked up on this and, like Jervis McEntee, George Inness, and William Stanley Haseltine, decided to travel to Europe. Thomas Moran led the way with his successful absorption of lessons in color from J. M. W. Turner, and it had paid large dividends for him with the critical successes of the Yellowstone and Grand Canyon pictures. In Munger's case, Moran's rapid ascendancy after 1872 among the field of New York landscape artists can be seen as something of a setback to Munger's ambitions to gain national recognition. A move to Europe for the self-supporting painter seemed to offer many advantages by 1876, particularly in light of the decline of patronage that followed the financial panic of 1873.

Munger's perceptive sense of the market and his experience with English and Scottish patrons led him to believe he would find better support in England. Lord Skelmersdale and other English patrons he had met in California had urged him to come to London with his western pictures, assuring him he would find buyers. Munger later recounted: "After I finished my engagement with Mr. King, I went over this ground again on my own account with my own men and supplies, and it was on this expedition that I met with a party of English gentlemen. They took a great interest in my work, and gave me a number of orders, and advised me that I ought to go to England, where my work would be more appreciated and where the artistic atmosphere would be an aid to success." Munger took their advice and went to London, "where I found what they had told me was true."[123] Because of these English connections and Munger's commitment to Ruskinian aesthetics, London, not Paris, was his best choice. The last published notice of Munger in the United States is dated August 1875. We know from the series of paintings he dated 1876 that he probably remained in New York during at least part of that year. He is not noticed again in print until after his arrival in England in mid-1877. Where he was during this time, what he was doing, and his exact date of departure remain unclear.

Plate 42: *Glacier Lake, Kings Canyon, California,* 1876, 20 x 38, oil on canvas. Collection of Mr. and Mrs. Thomas Davies. Image courtesy of Montgomery Gallery, San Francisco.

II

EUROPEAN RECOGNITION

4

EXPATRIATE LANDSCAPE PAINTER

A CONNECTICUT ARTIST IN BRITAIN

Gilbert Munger sailed for England in 1877, arriving there just after another famous American expatriate, author Henry James. By Christmas Day 1877, Munger was successfully established in London, befriended by one of the wealthiest and most influential modern British artists, John Everett Millais. In a remarkable letter to Samuel Franklin Emmons, his old western exploring companion, Munger wrote unabashedly, "I have never been so thoroughly happy as I am here, having given up smoking cigars and pipes." He related excitedly, "London is pleasant at this time of year for the [art] workers are here, distinguished men whom it is a pleasure to meet. I am getting into quite a literary and artistic circle by degrees, and already feel more at home here than I did in New York." A few evenings earlier he had dined with the classical archaeologist Heinrich Schliemann, who, he informed Emmons, "has been digging up Troy, and expects to dig up the whole world before he gets through."[124]

Munger's quest for distinction had led him to the heart of the modern Anglo-American art world. He would achieve a remarkable success there over the next decade. It was an ideal moment to be an American artist in Europe. As Henry James said, Europe was "an excellent preparation for culture." For Munger, as for other American expatriates liberated from stale aesthetic conventions and free to construct new identities, London with its flourishing market for luxury goods, including fine art, and its cosmopolitan high society presented many opportunities.[125]

COLLEAGUE OF JOHN E. MILLAIS

Munger's rapid rise to prominence in London art circles owed much to his connections with Millais. The two seasons Munger painted with him in Scotland gave a powerful impetus to Munger's later career. His Christmas Day letter to Emmons documents details of this relationship and suggests what the young American had to offer the established painter. "Millais is now one of my best friends in London," he wrote, "and has more influence than any other artist here. He lives in splendid style, owns the house in which he lives close to Hyde Park, S. Kinsington. Millais gives swell entertainments to the Dukes & Lords, and makes £20,000 per year they say. He has taken a great fancy to me for some reason, I cannot tell why, and altogether I consider it a piece of great luck in meeting this gentleman." About the time Munger met him, Millais moved to his mansion at 2 Palace Gate, an imposing studio/villa reflecting the wealth and great status Millais enjoyed later in life.[126]

This was a friendship with advantages for both the established English artist and the American visitor. Munger must have been an ideal dinner guest in English high society, where he could fill the role of consummate "outsider," handsome and full of exciting stories about western adventures. The bonds of friendship between Munger and Millais may have been strengthened because both were self-made artists who earned their living entirely from their production, neither having been born wealthy. The two years Munger spent around Millais left an indelible impression. After that time the talented and enterprising American painter self-consciously refashioned himself in the model of the master of 2 Palace Gate.

Munger possessed other modern American traits that may have pleased the older English artist. Munger wrote Emmons: "When I left London four months ago for the Highlands [of Scotland], I had no definite plan as to a permanent abode. . . . After doing the Highlands as a 'tourist' in order to find out for myself all the nice places for painting, I settled down at Dunkeld with J. E. Millais, the leading English artist and we worked there together for two months." Munger went on to complain that it always rains in Scotland, "so we built two small houses of wood seven feet square to paint in, large plate glass window in the side looking toward the view to be painted, and in this manner we are able to work in the drenching rain." Munger's lifelong dedication to painting *en plein air,* first perfected in the extreme conditions of the American West, endeared him to the British artist who had recently begun to paint landscapes outdoors. "These houses are easily taken apart and changed from one location to another, or packed [a]way for next season," he continued. Following his practice of painting full-size pictures out of doors, Munger "adopted the plan of working in these houses upon large canvass & finish the picture entire from nature." Success attended his efforts, he continued: "[I] have already sold a part of my summer's work, besides receiving more orders for my American scenery, and am very busy upon them at my old quarters in London, having returned about three weeks ago."

AIR OF AN ENGLISHMAN

In 1893, when asked about life abroad, Munger replied, "London is much to be preferred to Paris, for the Englishman is the most hospitable man in the world. He is the perfect host, for the wealthy Englishman LOVES TO ENTERTAIN. After I had been in London for a few months I knew more people than I had known through living in New York for eight years." The American is the same as the Englishman, Munger thought, in that he "is particularly welcome if he has something new to tell. In that case the Englishman is delighted with him and . . . asks you to dine with him; that never means a club or restaurant dinner, never; it means that you are to go to his house and dine with him there." With friends like Millais, life in England suited Munger. When he returned to the United States in 1893, an interviewer observed, "That he is distinguished no one who has the slightest knowledge of the world of art can be ignorant. . . . Mr. Munger's long residence abroad has given him somewhat the air and accent of an Englishman, but he is a man without affectation of any kind, one of the simplest men in the world to meet."[127] Munger's problem

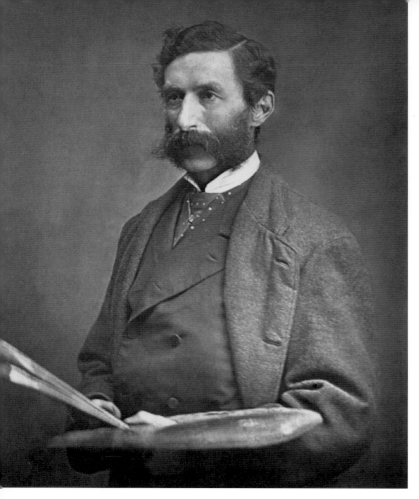

Plate 43: *Gilbert Munger photograph* from *Colburn's New Monthly Art Magazine,* June 1880, London. Image courtesy of the Library of Congress.

in England. *Colburn's* was an old and distinguished journal that by the 1880s featured elaborate illustrated articles about leading British captains of industry, members of parliament, and members of the upper classes along with articles about contemporary issues in science, literature, and philosophy. Munger's article included a hand-tipped-in Woodbury-process photograph by A. F. Fradeler on Regent Street. It is one of two photographic portraits of the artist known (Plate 43).

In a carefully posed image, Munger represented himself in the garb of the respectable, serious artist-businessman favored by Victorian patrons and critics. Although he is well groomed, even impeccable, his pose is far from the elaborate aristocratic self-fashioning exhibited in the photograph made in Nice a decade later. *Colburn's* laudatory article reported on Munger's sketching in the Scottish Highlands with John Everett Millais, who was described as a mentor to the talented American in Britain. Munger spent a season in Skye, Stornoway, Loch Maree, and Dunkeld, according to *Colburn's.* "He intends to adhere to the rule of painting direct from nature," the writer asserted.

was that, by 1900, the air of aristocratic distinction he so carefully cultivated in imitation of Millais was passé in the United States. A new figure of the artist as a bohemian living for art's sake, or as ideologically committed, was increasingly competing for public attention and approval.

GOOD PRESS AND SUCCESS

Munger received a significant public-relations advantage when *Colburn's New Monthly Art Magazine* published an extensive biographical sketch in June 1880. The article introduced the artist to the English public. It remains the best contemporary account of his early reception

His time with Millais in Scotland helps to explain the turn in Munger's work toward scenes of marshes and ponds, or desolate, treeless mountains. These were subjects favored by the famous pre-Raphaelite painter when sketching on holiday in the rugged Scottish Highlands. Millais's paintings of these subjects were strikingly different from his highly finished society portraits and historical subjects. Although Millais's landscapes influenced Munger, his depictions never possessed

Figure 12. Paintings such as *Chill October* (1870) by Munger's painting companion John E. Millais may have stimulated Munger's choice of style. Collection of Lord Andrew Lloyd Webber, London. Image courtesy of the Art Renewal Center: www.artrenewal.org.

the bleak, unrelenting melancholy of some of Millais's Scottish landscapes of the 1870s, such as the often-reproduced *Chill October* of 1870 (Figure 12).[128] This particular painting by Millais was exhibited to great fanfare in 1877, the year Munger reached England. There could be no doubt that Munger would have seen it in Millais's studio at some point. Its subject and composition would help establish Munger's new quest for personal style in the London art market.

Only three pictures by Munger that appear to be Scottish subjects have been identified. All are undated. An exhibition-scale picture is believed to represent scenery around Dunkeld (Plate 44). The dress of the figure suggests an English country hiker, while the bald mountains in the distance are typically Scottish. However, the panoramic expanse and the elevated perspective recall earlier American views rather than his characteristic European work, where the vantage point is lower and panoramic perspectives are avoided.

In the Scottish pictures Munger continued for a brief time painting wild scenes, rugged mountains, and stony lochs, but it was a transitional subject that did not last. A hint of their appearance is provided in *The Art Journal* of 1879, which reviewed Munger's contributions to the Royal Academy exhibition: "*Loch Coruisk,* a characteristic view of the somber and lonely lake of this name in the Isle of Skye; *Loch Maree,* another piece of Scottish scenery, set

Plate 44: *Landscape with Hiker and River,* 26.5 x 42.5, oil on canvas on board. Tweed Museum of Art, University of Minnesota Duluth. Gift of the Orcutt family in memory of Robert S. Orcutt.

about with bold grey rocks and purple heather."[129] A later description of the latter picture, from the 1946 estate of Lyman A. Mills of New York, read: "A darkening sky reflects in the smooth water of a lake outlining the surrounding mountains. In the foreground, a rocky slope with a woman standing at the right."[130]

A MOST PROSPEROUS CONDITION

Munger's old friends in America kept up with him for a time. The most important eyewitness account of Munger in London was given by the artist Walter Paris, who wrote: "I saw Munger in London about the year 1882. He was then occupying a fine studio close to New Bond Street. He had a great display of pictures on the spacious walls and on easels and he appeared to be full of work and in a most prosperous condition of life." Munger was "in those days one of the best dressed men who walked Bond Street and Piccadilly and at the same time was an extremely distinguished looking man. I saw considerable of Munger at that time and found great pleasure in his acquaintance as a friend and as an artist."[131] Paris was a man well suited to make such assessment, as he was himself a restless cosmopolitan artist, confirmed bachelor, and soon

to be appointed Architect to the British Government in India. Munger and Paris shared a love of detailed images of the kind prescribed by John Ruskin and the British and American pre-Raphaelites.

In June 1879 the *Boston Evening Transcript* reported, "Mr. Gilbert Munger, an American artist living in London, has recently been making some exquisite etchings of the older parts of the city."[132] The same paper noted the following year: "Gilbert Munger has had a new series of successes in London. He has sold his six large paintings, which were recently exhibited in provincial exhibitions, and is now sketching in Cornwall."[133] The *London Art Journal* announced that "Gilbert Munger has taken a huge studio in the fashionable neighborhood of Grosvenor Square, in Brook Street London, and will soon open in connection with a gallery containing seventy or eighty of the most important of his pictures of American scenery . . . [it] will create a sensation in England."[134]

The *Memoir: Gilbert Munger: Landscape Painter* states that Munger traveled in search

Plate 45: *Windsor Castle,* 14 x 19.5, watercolor on paper. Collection of Tweed Museum of Art, University of Minnesota Duluth. Gift of Dwight, Henry, and Roger Woodbridge.

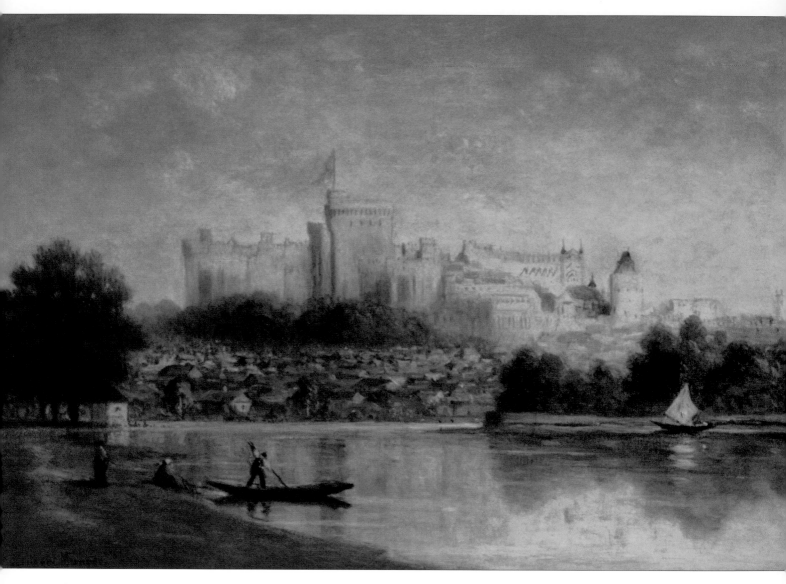

Plate 46: *River Scene with Castle,* 18 x 26, oil on canvas. Private collection.

of scenery to France, Italy, Spain, and Germany, although no pictures of Spanish or German subjects have been found. His only Italian pictures are Venetian scenes. Munger editions of stylish etchings provided an income during his English period, freeing him to pursue other opportunities for gaining distinction and finding patrons. He first exhibited paintings in 1879 at the Royal Academy, where he showed scenes of Scottish lochs along with the painting *Great Salt Lake, Mormon City, and Wahsatch Mountains*. The next year he exhibited at the Royal Academy his *King Arthur's Castle, Cornwall*, "a fine work, which is fortunately on the line and well placed."[135] By 1879 he had been taken in by the Burlington Fine Arts Society, "and he is now overwhelmed with orders for etchings . . . [these] are sold at high prices, yet secure a very large sale."[136]

In England Munger produced at least a few watercolors, perhaps under the influence of Ruskin and J. M. W. Turner. One is located, an outstanding example of his rapid mastery of the medium that was popular among British and American pre-Raphaelite artists. Doubtless his friend Walter Paris, whose exactingly detailed watercolors were popular, influenced him. The subject of Munger's is *Windsor Castle* (Plate 45) as seen from the Thames, which he veiled in atmosphere and historicized in ways Ruskin would have approved. He also developed the image in the weightier medium of oil on canvas (Plate 46). The date of this work is uncertain, in part because it has stickers both from a Paris materials supplier as well as a Washington, D.C., art dealer. Its provenance can be traced from Munger to the estate of James Cresap Sprigg,

author of the *Memoir,* and this may argue that the work was painted in Europe and sold in the United States, or perhaps even completed in the United States from sketches such as the watercolor Munger brought back with him.

ARK ON THE THAMES

Munger's continuing quest for accuracy in paintings done *en plein air* led him to construct "a sort of miniature Noah's ark upon a small punt or raft, and [that] was moored for many weeks at a notable point of the river above Henley-on-Thames. . . . Here he painted in 'rain or shine.'" A Turneresque autumnal scene was extravagantly praised for its golden tones and truthfulness to the place. "This American artist has only been in England four years," the critic stated, "during which time he has worked his way steadily to a foremost place among landscape painters. He trained in the grand school, face-to-face with nature in her broadest field, the mountain ranges and lake countries of California."[137] Munger claimed to be able to paint eight-foot canvases onboard his Thames ark. "The canvas is large, and the subject fills it thoroughly. You stand as it were on the banks of the river at sunset. . . . I knew the locality well, and the selection of the spot for a picture shows how well Mr. Munger has studied the river." There was considerable interest in the river during the early 1880s. The *London Art Journal* published a lavishly illustrated series, "The Backwaters of the Thames," which extolled river scenes saturated with "history and literature" in "this age of utilitarianism."[138] Munger successfully exhibited his woodland views at the Royal Academy in 1882, and three years later he showed scenes drenched in English

history, *Castle Park, Warwick* and *Autumn, on Avon.*[139] None of the large English historical or pastoral paintings have been located.

The Fine Arts Society in Bond Street successfully exhibited Munger's etchings, gaining him notice and providing a steady income from editions. Despite his years of experience as a printmaker and despite documented production in London, it is surprising that only two prints by Munger have been discovered. *Herring Fleet* (Plate 47) is dated 1879, produced during the artist's early years in London. This dramatic scene of the fishing fleet at anchor could be English or Scottish and bears a label from the Fine Arts Society. The etching suggests an aspect of Munger's production, marine subjects, about which little is known. The image is probably related to the unlocated painting *The Herring Boat,* a large exhibition-size painting, forty-three by sixty inches, that was sold in London. Two examples of this etching have been found, both recently. The first was bought at a flea market in Chicopee, Massachusetts. The seller claimed it was from the estate of the newscaster Lowell Thomas of Quaker Hill, N.Y., whose great-grandfather had purchased it directly from Gilbert Munger.

The other known print by Munger is a smaller

Plate 47: *Herring Fleet,* 1879, 7.5 x 11, etching on paper. Private collection.

etching of a single tree in the Barbizon style (Plate 48). He appropriated Theodore Rousseau for his own purposes as suggested by the form of a tree and the open space in the distance. It was found at an estate auction of the daughter of Munger's friend, James Sprigg, framed with a newspaper bearing the date 1906. Sprigg received objects from Munger's studio upon his death.

The Fine Arts Society, a prominent graphic-arts gallery still active at its original address, was founded in 1876 and represented such eminent artists as J. A. M. Whistler. In 1882 it presented a dozen of Munger's Venice paintings in a group exhibition. The Hanover Gallery in New Bond Street also represented him yearly from 1886 to 1891. It cultivated a taste for Barbizon pictures among English patrons, and through it Munger sold numerous paintings. A considerable part of Munger's European production remains to be located in England, including western subjects commissioned by English visitors.

KING, RUSKIN, TURNER
Clarence King visited Munger in London in 1883. He must have been pleased by his old friend's success. King was touring Europe to promote western mining ventures and dressed in the height of fashion in a green velvet suit à la Oscar Wilde (Figure 13). King's reputation as first head of the U.S. Geological Survey and one of America's most famous scientists could have provided Munger with further connections to elite scientific, literary, and business circles, along with invitations to the best gentlemen's clubs. King also had associations with the Royal Society to whom he pre-

Plate 48: *Barbizon Landscape with Tree,*
6.5 x 4.5, etching on paper. Private collection.

sented *Systematic Geology.* While in London King was eager to acquire works by Turner, so lauded by Ruskin in *Modern Painters,* adding to his personal collection that included at least three American artists who were personal friends: Robert Swain Gifford, Albert Bierstadt, and Munger.[140] King's Turners would come back in an ironic way to remind Munger at the end of his career of his success in London.

King soon persuaded the reclusive Ruskin to sell him two fine Turner watercolors at a low price. It appears certain that King facilitated further entrée for Munger to the aged and ill

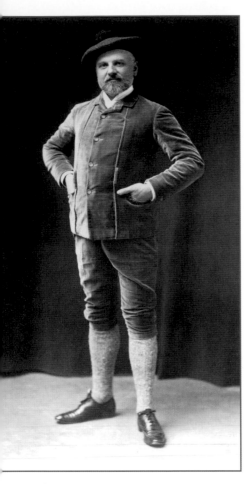

Figure 13. Clarence King toured Europe in 1883 promoting western mining ventures, dressed à la Oscar Wilde in a green velvet suit, here captured in a C. G. Cox photograph. Image courtesy of the Huntington Library, San Marino, California.

but still influential art critic. Although contemporaneous documentation of his introduction to Ruskin has not been found, the *Memoir* states that Ruskin took Munger under his wing and suggested he paint in Venice. By the time Munger met Ruskin, Ruskin had already suffered his first mental breakdown just before the notorious *Whistler v. Ruskin* libel case came to court in 1878. Ruskin was Turner's champion and executor of the Turner bequest. This and King's admiration for Turner may have stimulated Munger's experimentation with the atmospherics and impastoed brushwork of the English master. By the early 1880s Munger's English work was beginning to look very different from his western pictures of a decade earlier.

VENETIAN PICTURES

Evidence of Munger's new style was a series of paintings produced in Venice in 1882. He first exhibited them in London in November of that year at the Fine Arts Society. The same exhibition included works by Arthur Severn and Ruskin. Its catalog mentions that Ruskin was still in Italy, and it is tempting to speculate that Munger was there with him

before the exhibition. In a letter to his brother in St. Paul, Munger states that he painted in Venice for three months, but he does not mention Ruskin. He completed fifty pictures, and hoped to return to London with as many as sixty for an exhibition in his Bond Street gallery. "I rise and breakfast at 5:30, then take my gondola and go to work. I am working twelve hours a day, which is too much for such debilitating climate as that of Italy, and when I have a moment to spare I study Italian, for English and French are little known."[141] Like the work of many other artists, Munger's Venetian scenes are saturated with sentiments of nostalgia for the city's storied history. They were evidently popular in London. He continued to produce Venetian scenes for most of the rest of his career, probably from his sketches as he is not known to have returned there.

Characteristic of Munger's exhibition-scale paintings of Venice is the Tweed Museum of Art's undated *Venetian Scene* (Plate 49). Luminous vapors worthy of Turner veil the ancient city in mysterious light, while stiletto-like gondolas glide silently past. Passages reprise Turner's famed *Dogano, San Giorgio, Citella, from the Steps of the Europa*. It was one of the first of Turner's paintings of Venice to go on public view in 1847 at London's National Gallery of Art, where Munger would have seen it. Much of Munger's Venetian work was produced under the spell of Turner's vaporous atmosphere and bold color.

MUNGER'S OLD VENICE

Munger's selection of subjects reproduced the ideas of Ruskin and Turner of a cultural tourist's

Plate 49: *Venetian Scene,* 40.5 x 56, oil on canvas. Collection of Tweed Museum of Art, University of Minnesota Duluth. Gift of Miss Melville Silvey.

Plate 50: *San Giorgio Maggiore, Venice,* 20 x 30, oil on canvas. Collection of Alice Jamar Kapla.

pilgrimage through picturesque stones of Venice. In most pictures Munger carefully excluded all signs of the modern age. Like many artists, he selected picturesque views of "old Venice," removed from the crush of tourists and steam-powered ferries that were already plying the canals. On occasion Munger could revert to the clarifying style he had perfected in the West with King, as in his oil-sketch of *San Giorgio Maggiore, Venice* (Plate 50). Palladio's great baroque church floats serenely under a luminous sky in a scene King or Ruskin could have admired.

One of Munger's most unusual Venetian pictures is a small, double-sided oil-on-panel sketch that reprises a famous Turner (Plate 51). A plume of smoke on the distant horizon and the richly impastoed sky with its emotional color recalls *The Fighting Temeraire Towed to Her Last Berth to be Broken Up,* which Munger could have studied in London's National Gallery. The elegiac sky of the picture demonstrates how Munger appropriated Turner. Like the paintings of Thomas Moran, who also represented the city in the 1880s and 1890s in a similar painterly style, such nostalgia-laden views were "best sellers." A number of Venetian paintings survive.

Occasionally Munger departed from salable depictions of historicized images of the ancient places and churches and took direct notice of the tourist's experience. A picture provocatively titled *P. and O. Steamer off Venice* (unlocated) may allude to English visitors' ready access to the city by sea via the famed Peninsular and Oriental Steam Navigation Company that promoted excursions to the historic city. The paintings of Duluth, Minnesota, from 1869 to 1870 (Plate 8) make it clear that Munger was comfortable with the promotional function of landscape painting and its connections to the emerging industry of tourism and that he may have created this picture for such patronage. Yet plumes of smoke on the horizon, sign of a modern steam vessel or a railroad, are seldom present in his work.

SIR GILBERT MUNGER: GENTLEMAN ARTIST

Munger positioned himself in a succession of studios near New Bond Street at the center of professional artistic life in London, where he fashioned himself as one of the new breed of international artist-businessmen as posed in the photograph for *Colburn's* magazine. Already sophisticated, Munger joined other American cosmopolitans who passed readily in society. Treatment of Munger's pictures by the London art critics was generous and selections were excerpted in the *Memoir.* A few undated and unattributed newspaper clippings found in Duluth suggest that the artist compiled a press-clippings book, which no longer exists. He was capable in several languages, fluent in French. When asked where he was educated, according to the *Memoir,* he would reply modestly that a private tutor had educated him, meaning himself. Munger was "a man of enormous energy, sixteen to eighteen hours of each day he devoted to his labors." In 1893 he told a newspaper interviewer that it was his habit to work all night, "as long as from 9 o'clock in the morning to 3 o'clock at night."[142]

A cousin reported that Munger's sales were "always phenomenal, bringing in flattering

Plate 51: *Marine, Venice,* 13 x 16, oil on panel. Collection of Tweed Museum of Art, University of Minnesota Duluth. Gift of Dwight, Henry, and Roger Woodbridge.

sums, a few as high as $5,000."[143] The *Memoir* claims, "Through one dealer in London over two hundred paintings were sold to the nobility." If this is so, only handfuls have resurfaced. The Prussian government bought a painting of Niagara for $5,000, the *Memoir* reported, although the picture remains unlocated. However, records at the National Gallery in Berlin show that Munger's Barbizon painting *Waldinneres* entered the imperial collection but it was lost in 1945.

Munger's humor and humanity appear in his few extant letters, mostly located in private collections. His aspirations to literary accomplishment are evident in his delightful comedy in three acts, first produced at the Theatre Royal, Haymarket, on February 4, 1886, with Helen Barry in the lead. The play concerns a subject often on the mind of Americans in Britain: finding, courting, and marrying inherited position. Although it cannot be proven, the stimulus for writing and producing a play may have come from the successes that old San Francisco and New York friend Bret Harte enjoyed from such productions. Harte was U.S. Consul in Glasgow, and through the 1880s he produced eleven plays for the London theater market that brought lucrative returns. In fact, in April 1886, the same year as Munger's play appeared, Harte wrote, "There is just now a great demand for fresh plays."[144] There is no evidence that Harte and Munger resumed their friendship, although it seems likely. Munger's play, *Madelaine Marston*, is signed, "Sir Gilbert Munger." With it, the transformation was complete. The son of a New Haven laborer had refashioned himself into a prosperous gentleman artist of London.

INFINITE PROGRESSION: GROWTH IN ART

In a lengthy interview in Paris dated shortly before his return to the United States, Munger was asked why American painters lived abroad. He replied, "It is the sure means of growth in art everywhere at hand in these old lands." Furthermore, he added, it was "in Europe rather than America that the indefinable and singular charm in painting which men call style is most readily attained. In Europe the gratifying measure of success which has greeted my humble efforts in these later years is due, I am sure, to having found a way to my own style through a number of experiments and a series of careful observations which I should not have been able to make settled at home." Munger expands on this remark in the *Memoir*: "There is a crystallization of style in painting, as in literature. It is, of course, a slow process, and, in my case, in the fruit of long seasons of painting in the foothills of my own Rocky Mountains, in the shadow of El Capitan in the Yosemite, and of St. Paul's Cathedral in London."

In Munger's mind there was no contradiction between his early paintings and the work he produced in the 1880s and 1890s, images that on first glance may look so different to spectators today. From his perspective King or Ruskin would have approved the style of all of it, since from beginning to end Munger painted finished representational oil sketches on the spot. There were other, less immediately obvious intellectual continuities with Munger's exposure to a progressive vision of Earth's geological history. Even before he left New York, he must have grasped that it was not enough to remain fixed in the style of the

1860s as Bierstadt, Frederic Church, and other Hudson River School artists seemed to do. That could result in stagnation, the approbation of critics like James J. Jarves or Clarence Cook, or—worse—a decline in sales. In the 1870s and 1880s many styles flourished in the London art market—Academicism, later-pre-Raphaelite, Historical, Symbolist, Barbizon, and others. Upon his arrival in Europe Munger grasped that a patron's perception of imagination and of originality, *produced within one of the accepted styles,* was a valued commodity in art. Always a practical figure who rapidly adapted to his cultural environment and his markets, Munger, just as he had endured the hardships of exploring the far West, astutely absorbed what he took to be the important trends, first in English and then French art, and internalized them in his own voice and style.

MUNGER'S MODERN STYLE

Munger's European work of the 1880s and 1890s was produced in what he understood as a "modern style." Among the cultural elite of London, New York, and Paris, the Aesthetic Movement, championed by the most notorious American expatriate of the day, J. A. M. Whistler, typified a leading concept of modern art and modernity. When Munger arrived in London, Whistler's lawsuit with Ruskin was sensational news. Whistler emphasized "art for art's sake," delighting in the autonomy of artistic perception and rarified poetic expression of a kind that Munger had minimized in his early work for scientists and geologists. Munger quickly recognized this, and he would have received a strong dose of it through his association with Millias and his friends. Munger adapted by representing landscape in new, more

fashionable and salable ways. A change of style and subject was necessary to gain a position in the hypercompetitive London art market, and this need played a great role in stimulating the emergence of Munger's modern style. He was one of the artists of his generation who grasped a principal lesson of the Aesthetic Movement: that the production of personal style and the construction of an artistic persona had emerged as essential for highly specialized professional artists competing for patrons and recognition in a largely anonymous art market. In this context, cultivating an identity as a *public figure* counted for a great deal.[145]

Although Munger's European pictures engaged some formal aspects of the Aesthetic Movement, and he seemed to have mastered the art of self-fashioning, he never accepted a cardinal tenet of modernism: belief in the autonomy of art. Always, from the beginning of his career to the end, he remained wedded to Romantic conventions that art must represent reality. Up to this point in his career Munger's concept of art's representational powers had been fundamentally shaped by the needs of science and his hopes of becoming a recognized professional artist. Through his long-practiced engagement with the materials, means, and processes of painting, Munger increasingly embraced a subjective, emotional, even poetic view of art as he approached old age. This first began to emerge in the 1880s.

But in the end, as a figure forged in the field of culture during the fateful decade before the Civil War when American art first asserted its

value to the nation, Munger was wedded to a conservative desire to represent specific places. In France he would visit and study a site assiduously. "Some people have an impression that a man goes out and makes sketches and then finishes his pictures at some other place than that at which the sketch was made," he told an interviewer, "but I have never used sketches [that way]. I ascertained the time of day in which the subject appeared the best, either morning, noon, or night, and then went back again and at that hour worked at the subject until the work was done."[146]

Munger's problem, like that of others of his generation, was that in his eagerness to assimilate what he thought were modern styles, he embraced artistic conventions that may be regarded today as verging on passé when Munger adopted them. Such perceptions are, of course, contingent on notions of art's history as teleological, or progressively moving toward some culmination of style, usually impressionism, as well as on ideas of genius, originality, and modernity. Munger became one of many artists working in Europe and America who produced variations on the styles of approved modern masters, such as Turner, Jean-Baptiste-Camille

Corot, or Theodore Rousseau. "I followed as closely as I might without becoming a mere imitator of what is called the Barbizon school of art, the school of the great French artists of 1830–40. Corot, Rouseat [sic] and the others, and in a short time I became very successful, selling everything that I painted to a London firm, which took them at prices that were quite satisfactory."[147]

Like many artists of his period, Munger was comfortable with appropriating or incorporating styles of "the masters" into his own. This accepted practice among artists was swept away by the onslaught of mass mechanical reproduction after 1900, with its privileging of the unique work of art as an autonomous form produced by a "charismatic genius" or "the absolute artist." Munger's later paintings were created on the cusp of this paradigm shift in the structure of visual-art production. It limits understanding of his later works to view them solely from a modernist perspective that he did not share. It is more accurate to see the development of his personal style in historical context as innovative responses to changing market and intellectual conditions, but one that remained wedded to a long tradition of art as representational practice.

5

VARIATION ON A BARBIZON THEME

Gilbert Munger's movements in Europe are difficult to trace. He was guarded about his plans and documentation of this period is sparse. As Munger aged he became intensely private, even secretive, as he confessed in a letter written to James Cresap Sprigg, his future biographer: "I must depart from my usual custom of keeping all my plans and movements an absolute secret from everyone."[148] Family legend speaks of a scandal, but nothing is established. From what little is documented, Munger's personal life seems outwardly uneventful, unlike that of his good friend Clarence King, whom Henry Adams thought was a man who knew "women, even the American woman, even the New York woman, which is saying much." Munger, by contrast, never married. The few references to women in his letters suggest that his first devotion was to his career in art. His private life remains opaque and undocumented, although there are tantalizing hints of sexual preferences that emerge after his return in 1893.

The first notice of Munger's travel to France was in July 1878, when the paper in St. Paul, Minnesota, reported, "He is now visiting Paris, and was recently one of a party of four who partook of the hospitality of [Henry Morton] Stanley, the British explorer, at a dinner party."[149] It appears from Sprigg's *Memoir* and from surviving works that Munger painted as he toured the countryside, and he certainly found the warmer climate appealing. He noted in an 1893 article that he had lived in Paris for six years: "My people [his art dealers in London] preferred eventually the French subjects of the Barbizon school, and I went to France in summer and back to London in winter, but the winter was so dark and foggy that I could not work to advantage, and so decided to live in France all the year round."[150] He continued to exhibit and sell pictures in London at Hanover Gallery, in both winter and summer exhibitions. Perhaps the arrival of John Singer Sargent in London, and the sensation caused by his painting *Carnation, Lily, Lily, Rose* with its "French" style, stimulated Munger's decision to move to Paris.

Evidence suggests Munger relocated to Paris and began sketching its rural environs full-time around 1886 and stayed until his return to America. The 1893 article describes his prospecting for scenes to paint: "In Paris I spent much time in the Forest of Fontainebleau and near the city, as well as made excursion into the provinces." The geography Munger painted was confined, with one or two exceptions, to a core area of about twenty-five

miles around Paris, along rivers like the Seine, Loing, and Oise (Figure 14). He traveled in 1890 to the south of France, where he painted in Nice. There, his presentation photograph was taken and plaster and bronze busts were produced; he also painted one of his most unusual subjects, *Carnival at Nice.* After returning to the United States, he continued to cite Paris as his residence, telling friends and reporters that he intended to return soon to France.

BEST TRAITS OF THE BARBIZON SCHOOL
With his finely tuned sensibility, Munger selected for emulation French artists that fit

Seine River

Oise River

1 Reuilly
2 Poissy
3 Saint-Germain
4 Bougival
5 Nanterre
6 Asnieres
7 St. Cloud
8 Barbizon
9 Marlotte
10 Grez

Paris

Forest of Fontainebleau

Seine River

Locations of Munger Paintings near Paris

Loing River

Figure 14. Munger stuck close to Paris for most of his Barbizon-style *en plein air* scenes of the French countryside.

his already well-developed personal style. Theodore Rousseau and Charles Daubigny, heroic figures associated with Barbizon and French interest in more spontaneous *plein air* sketching, became powerful agents of Munger's artistic growth during his last two decades. London art dealers specializing in imported French pictures stimulated his interest as an American "outsider" in producing pictures in this French style to fill a niche in the market. The term "Barbizon School of Painters" had been in common parlance for at least a decade in England before London art dealer David Croal Thomson (1855–1930) published his famous book of that name in 1890. It marked a debut of the term for many English and American readers. The term "L'Ecole de Barbizon" appears in France later, around 1907. Thomson played a major role in promoting the Barbizon painters in English and American circles. His book alone was so successful that he was able to buy a country house on the proceeds and found a prestigious gallery he named Barbizon House. In 1881, about the time Munger settled in London, Thomson began writing articles about the school for the *Art Journal.* He became one of the leading agents importing French pictures to the London art market at Goupil Gallery in New Bond Street, near Munger's studio.

Munger's interpretation of Barbizon was thoroughly inflected with a strong American accent. Even today there is no consensus of exactly what constituted the Barbizon School. Was it a style, a point of view, a mood, or collections of artists numbering in the hundreds from all over Europe and the Americas who painted in and around Barbizon and

Paris from the 1850s to the 1920s and 1930s? Unlike realism, impressionism, cubism, or some of the other "movements" of modern art, Barbizon was not recognized as either a style or a movement during its own time.[151] Munger would have first seen works by artists associated with Barbizon in London, and in Paris they were plentiful in the state museums, and most notably in the thronged picture department of the Grands Magasins du Bon Marche. He could have read about the place in an 1882 article in the *Art Journal* that extolled the great men of Barbizon as founders of a new style of painting *en plein air,* something Munger had always practiced.[152]

Munger's shift to the French style was noticed immediately, although the problem of what to call it was evident in a review of his first show in the *London Daily Telegraph:* "A living painter of decided genius, Gilbert Munger revives the best traits of the Fontainebleau schools."[153] The term "Fontainebleau schools" did not survive, and not all the art critics were so enthusiastic about Munger's adaptation of the new style. The *Art Journal* thought Munger's group show required spectators to "excuse the commonplace which seems an inevitable ingredient in a show of pictures offered for sale." The review continued: "Mr. Gilbert Munger has little originality, and is content to see nature through the spectacles of [Narcisse] Diaz and Rousseau, but surely this is better than doing without any artist vision at all? Some of [his] work shows an intelligent and feeling adaptation of the ideas and methods of his [French] precursors."[154] The visual and cultural implications of Munger's stylistic shift were deeper than an invented term such as "Barbizon" described.

Few of Munger's works in the Barbizon mode are dated, making a precise reconstruction of his production more difficult. Earlier works were generally characterized by a continuing emphasis on line, edge, clarity in drawing, and bright light. By the later 1890s, this gives way to a slightly darker palette, broader brush strokes, and denser glazes of impasto that produce a tactile presence for the spectator. Throughout the last phase of his career the final stimulus for an image continued to be observation, and Munger's later work never engaged what he probably regarded as a popular taste for fleeting impressions of scenes.

HEROIC PORTRAITS OF TREES
An example of work in Munger's earliest adaptation of the Barbizon mood is *French Forest Scene* (Plate 52). The view is one of the revered groves of ancient trees in the Royal Forest Preserve at Fontainebleau. None of the dark, shadowy light and melancholy repose found in Rousseau or Daubigny, or even of the introspection of Munger's last pictures, for that matter, is evident. In the foreground a great tree is represented with a high degree of realism in brilliant light. An English critic called Munger's depictions of trees "tree portraits." The play of light on the bark, built up with thick impasto, produces vague feelings of organic presence, a visual emblem for the "life of trees." This was a popular subject for many earlier Romantic artists, including John Constable, and the life of trees was associated with Barbizon artists, particularly Rousseau. Munger was already familiar with the scientific importance of trees, having painted what King had called the "vast respiring power" of California's giant sequoias.

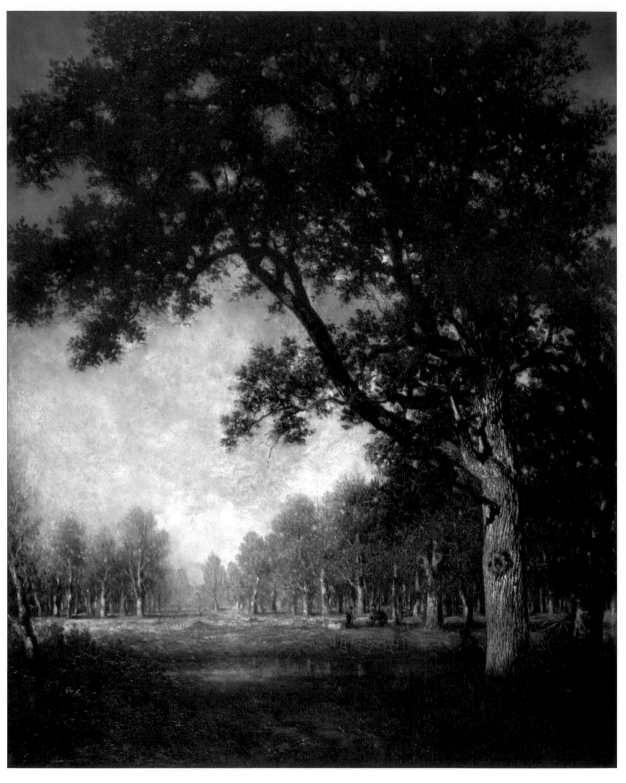

Plate 52: *French Forest Scene,* 32 x 25.5, oil on canvas. Collection of Tweed Museum of Art, University of Minnesota Duluth. Gift of the Orcutt family in memory of Robert S. Orcutt.

By Munger's time the ancient Royal Forest Preserve of Fontainebleau and the nearby village of Barbizon were only a short train ride away from Paris. Fontainebleau and Barbizon were established sites for art tourists, widely visited by French artists and American expatriates such as Munger. Led by William Morris Hunt, George Inness, Homer Dodge Martin, Wyant Eaton, Joseph Foxcroft Cole, Charles H. Davis, and J. Appleton Brown, among others, American artists and art collectors visited Barbizon in droves during the 1880s and 1890s to admire the landscape and to experience the heroic age of French landscape painting. By the 1880s Fontainebleau represented a haute ideal of French scenery, its preservation linked to ideologies of French national identity. For visiting American artists, a cultural site of that stature could confer some instant distinction through its rich art-historical associations. Munger produced a similar evocation of the silent, vital power of trees in *Forest at Fontainebleau* (Plate 53), where crisply rendered trunks and a watery foreground are framed in a cathedral-like ellipse of forest. In both works the brilliant, yellow light is reminiscent of Munger's English period, more than the conventional, often enclosed, darker, and more moody painting of the French masters.

ARBOREAL MODELS: LIVING SOUVENIRS

Visiting Fontainebleau around 1891, American artist and art-writer Charles Sprague Smith proclaimed in the first sentence of his book *Barbizon Days:* "If we call up before our minds the places made notable by great achievements in modern art, Paris and other centers of European life suggest themselves. The only exception to this rule is a tiny hamlet, a single

street . . . [Barbizon]." The appeal of the place was obvious: "The Fontainebleau villages have a rich and varied charm of novelty and art-suggestion for eyes accustomed only to the countryside of the New World."[155] Principally through the efforts of Theodore Rousseau, the Royal Forest Preserve was officially protected from further tree cutting. Rousseau lived in the forest more or less permanently after 1847, situating himself as its ardent champion and protector. By Munger's time, the ateliers of Rousseau and Jean-François Millet were veritable local museums, pilgrimage sites for legions of visiting art tourists.

As a consequence of these efforts, certain sites within the forest, particularly groves of ancient old-growth oaks considered appealing to artists because of their decayed and ruined condition, were protected. These national-forest shrines gained permanent protection by imperial decree after Rousseau and his supporters petitioned Emperor Napoleon III in 1852, writing, "This forest, the most ancient in France . . . is the only living souvenir that remains from the heroic times of the Fatherland from Charlemagne to Napoleon. For artists who study nature, it offers what others find in the models that have been left to us by Michelangelo, Raphael, Correggio, Rembrandt, and all the great masters of past ages."[156]

In other words, the ancient forest, or what was left of it, was to be reserved as a valuable national scenic resource. Its heroic trees were conceptualized as sanctified witness of French history, models of nature for artists as great as the giants of the Renaissance. Munger was quick to pick up on this as he sought subjects

in and around Barbizon and, more broadly, the environs of Paris to paint.

POETIC IMAGINATION

Munger was adamant that, to appreciate paintings of the Barbizon School, Americans had first to visit the place. He seems to have spent time tracking sites sanctioned by the masters, and it is likely he would have consulted one of the many popular guidebooks of the forest. In all of his French pictures it appears that he painted actual sites. When asked by a reporter why he painted in this style, Munger replied, "The American atmosphere has a dryness and hardness that gives the impression of unreality and makes it difficult to feel the proper appreciation. . . . Some people ask, Why these nooks, these trees, a simple pool of water, a few trees with a figure in the foreground and a hazy atmosphere?" He further responded with enthusiasm: "Now that is the very thing I wish I could make plain to everyone; it's the picture that suggests to you; you do not see everything; it is the POETICAL IMAGINATION stimulated by the delicacy of suggestion, and the more the picture suggests, the higher the art, the more lasting the effect upon you."[157]

His success in adopting the style was evident after Munger's first show of French pictures in London in 1886. The *London Daily Telegraph* exclaimed, "Rub out the signature of Gilbert Munger, an American painter, still young, we believe, from any one of his landscapes, and it would pass for a work of that same school which glorifies the forest scenery of Fontainebleau. Corot, in his deeper and firmer moods, is reproduced, with no slavish effort of dull mechanical imitation, but with the appreciative reverence of an original and, by this same Mr. Munger."[158]

AFTER GEOLOGY: NEW NATURE'S WEB OF LIFE

Munger's turn to a new style of painting was not unique. Many artists of the 1870s and 1880s embraced more poetic, subjective ideas of landscape painting. Broadly speaking, this change was produced by a widespread shift in Europe and the United States in perceptions of nature. It was a consequence of a cultural paradigm shift occasioned by the rapid destruction of old ways of country life by urban and industrial development and by the Darwinian Revolution. In paintings of "new nature," landscape painters reworked long-established codes and conventions of visual art to produce a more personal, emotional, empathetic awareness of interconnectedness that Darwin termed the "web of life."[159] Such representations were artistic counterparts to contemporary discoveries of geology, biology, and chemistry that emphasized the interconnectedness of organic life and the role of birth, growth, death, and decay in the natural environment with evolution. A frequent way of symbolizing this awareness in the language of visual art was through images of nature's economy, the farmer's fallow fields, the simple life of rural peasants, or contented cattle grazing in pastoral repose—reassuring images that all creatures great and small live in harmony.[160] The degree of sentiment in such visual palliatives depended on the degree to which the veiling and purifying filters of nostalgia and history were manipulated through the conventions and associations of art.

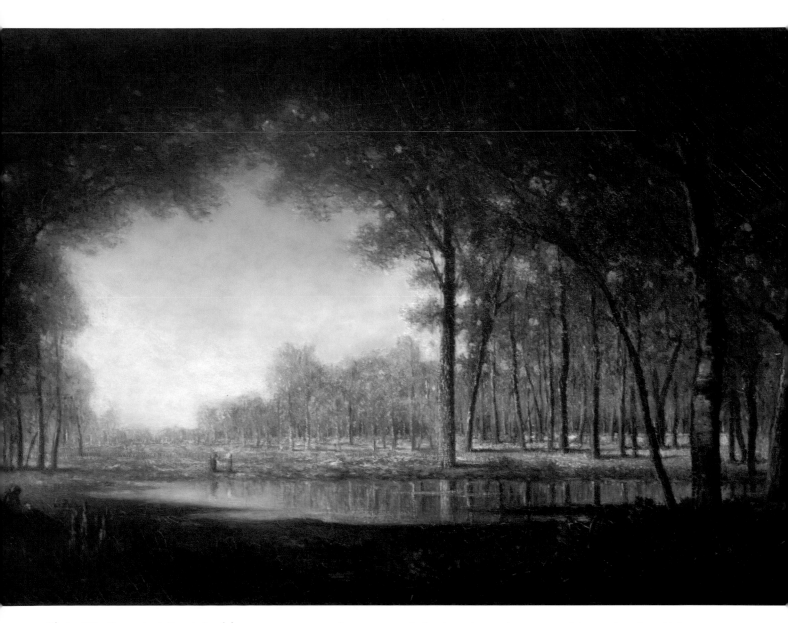

Plate 53: *Forest at Fontainebleau,* 15.5 x 25.5, oil on canvas. Collection of Tweed Museum of Art, University of Minnesota Duluth. In exchange for a work gifted by Dwight, Henry, and Roger Woodbridge.

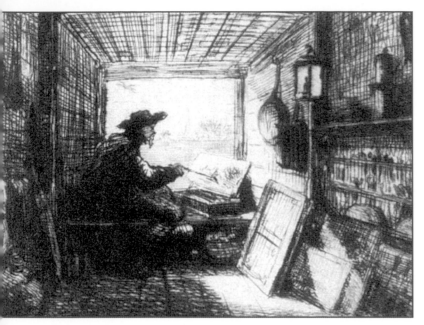

Figure 15. Munger rented a studio boat in France in the late 1880s, perhaps stimulated by Charles Daubigny's 1862 etchings *Voyage en Bateau, Croquis A L'Eau-Forte Par Daubigny*. Private collection.

Painting an empathetic yet almost imperceptible sense of the vitalistic interconnections of life was what Munger may have meant when he said the spectator would not see everything at first glance in his new pictures. Representing this elusive organic reality required the poetry of visual suggestion, the layering of associations, and the artist's subtle orchestration of cues and colors to inscribe new, more complex meanings in a scene. Under the visual tutelage of the French masters whose works he must have diligently studied in Paris collections, Munger radically reshaped his representation of landscapes visually and emotionally. Through selection of ordinary, commonplace agrarian subjects, he refashioned both his personal style and deepened his visual response to "new nature." As he said of these pictures: "The more the picture suggests, the higher the art, the more lasting the effect upon you." Today, with historical hindsight, the sensibility that

Munger evocatively represented in his later works could be described as broadly proto- or pre-ecological in spirit. It posited what in time would be more precisely articulated as a new, interdependent relationship between man and nature, and, in Munger's case, between image and spectator.

AN INFINITE PROGRESSION WORTHY OF A PAINTING

Munger had first encountered the scientific implications of Darwinism decades earlier with King and the survey geologists. Munger recognized this in 1893, recalling proudly that his early work was so detailed that a "geologist could tell the species of rock from LOOKING AT THE PICTURES." They were so accurate, he remembered, that they were used at Yale by professors in their geological lectures: "After exhausting my American studies I changed my method completely, and went to work painting the natural scenery of England and France . . . the soft, mellow and reposeful scenes. . . . The thoughtless person might wonder how it could be worthy of a painting, but in that very thing lies, as I think, the art. There must be the art, the poetical treatment, so that it may appear as an object of beauty and reach the inner subtle sense agreeably. There is infinite progression in this idea."[161]

What did it require to be now "worthy of a painting," to produce an "infinite progression" of an idea? Munger's representation of Barbizon subjects reflected the increasingly subjective attitude toward nature that emerged in the 1880s and 1890s. This was a way of representing nature that hastened a long historical process of decentering the human

116

observer as the prime focus of vision. The spectator was no longer conceived of as possessing a disembodied vision, gazing at the surface of a painting with the detachment of a spyglass or as if from the platform of a panoramic tower. In place of the traditional Renaissance concept of paintings as a view through a portal, the spectator was now closer to nature, his gaze situated as if from within the interior of the picture space, thereby making him a participant in what is vicariously experienced. By positioning the spectator with feet on the ground, or sometimes floating on the water's surface, empathetic associations of private, unseen witnessing of the mysterious process and historical presence of nature is produced for viewers. Such images were the opposite of the panoramic expanses Munger had painted in the 1870s.

Such representations invited spectators to vicariously approach nature as an intimate of past times, evoking emotional responses stimulated by regret at the simultaneous destruction of simple places by the relentless advance of modern society. The Barbizon subjects Munger painted invited spectators to focus on barely perceptible organic processes of nature, the delicate, quiet, or "reposeful" web of life, and to veil in nostalgia concern for its disruption. The destruction of environments, with the loss of natural habitat, lay at the heart of this feeling of belatedness, of regret, that Munger shared with educated art patrons of his time. In important ways his late pictures produced visual associations revealing an intuited, emotional awareness of what we now understand to be a deep human dependence on an invisible web of life—the ecosystem, or, as King

Figure 16. In Daubigny's *Banks of the Oise,* a boxy studio boat is visible, like the one Munger used later. Collection of the Rijksmuseum, Amsterdam.

Plate 54: *On the Seine Near Poissy,* 15 x 21.5, oil on panel. Private collection.

and his contemporaries realized in Yosemite, on the "vast respiring power of trees."

ARK VIEWS EN PLEIN AIR
To realize these artistic objectives Munger rented a studio boat near Paris, just as he had in England, and from it produced a number of views of specific places in his new style and point of view. Many were cabinet pictures, usually around twelve by sixteen to eighteen inches in size, often painted on mahogany panels. As a type of composition and in their selection of subjects they owe a significant debt to Charles Daubigny, whose paintings along the Oise and Seine were made from a floating studio he called the *botin,* or "little

box." In France Munger would have encountered Daubigny's series of popular etchings *Voyage en Bateau, Croquis A L'Eau-Forte Par Daubigny,* 1862, showing Daubigny sketching from inside the boat (Figure 15). Munger at work in his "*botin* of art" may have looked much like Daubigny a few years earlier. In a composition reminiscent of a Daubigny painting (Figure 16), Munger's own *botin* is tied to the shore (Plate 54).

An example of work Munger produced from his studio boat is *Near Reuilly,* painted in 1889 (Plate 55). Its open, water-filled foreground and picturesque grouping of trees on the opposite riverbank suggest a view from the

deck. The atmosphere is palpably moist, its haze veiling the scene with poetic emotions of nostalgia for a disappearing way of life. The scene's repose, its luminous, poetic treatment of warm light, produces a pleasing illusion of peaceful rural life, depicting a place as visual metaphor for an unseen, perhaps intuitively perceived life process.

THE COUNTRYSIDE OF OLD FRANCE

Images with water-filled foregrounds seem to have been especially popular with Munger's English and American patrons. Besides sketches using this design, he produced a number of larger, exhibition-scale pictures with this compositional convention. All are characterized by idealizing veils of light and appear to be views taken from the deck of a boat moored near a riverbank. *Near Bougival* (Plate 56) and *On the River Near Bougival, France* (Plate 57) are a pair of small paintings depicting the Seine just north of Paris that represent Munger's more intimate scale *plein air* works. A few rural houses nestled in the trees, an old stone bridge, and fishermen and washerwomen on the riverbank, along with other country types, provide familiar associations of rural nostalgia and might be mistaken for formulas, save for Munger's relentless insistence on direct observation. Purged of all references to modern life of the 1880s, with its railroads and factories, the scene transports the spectator back in time through its careful design and masterful deployment of pictorial conventions, its repose offering a yearned-for, and highly salable, representation of a simpler time.

Some of Munger's Barbizon pictures must have been best-sellers because they exist in several variations. *Near Poissy* (Plate 58), an example from one series, depicts a sweeping bend of the Seine with a path along the left side. In the middle distance a large building, perhaps a chateau, is surrounded by stately poplar trees. This view is known in three, almost identical versions. They pleased patrons with their representations of man and nature in accord. When a scene could be suffused with historical associations and a luminous atmosphere befitting tourists' expectations of the French countryside, it became more salable.

Munger appears to have been completely uninterested in the figure and genre paintings of Millet, Constant Troyon, Charles Emile Jacque, and Alexandre Gabriel Decamps that were especially popular with English and American collectors, such as businessman George P. Tweed of Duluth, Minnesota, around the turn of the century. Munger's representations always began with the inscription of a visual record of what he saw, but in the process of constructing a painting he subtly manipulated visual codes, conventions, and associations prompting the spectator's empathetic, imaginative desire to see nature and man in organic harmony. Images of groves of trees and contented cattle were invariably fashionable with English and American buyers in ways that may be difficult to appreciate today. *Near Grez* (Plate 59) is an exhibition-scale oil on canvas known today only through an old photograph. It offered a stately line of poplar trees and an Arcadian shepherd. Such poetic, meditative images, with their pastoral associations, are a long way from Munger's early ambition to paint great pictures of roaring waterfalls. A work that combines the

Plate 55: *Near Reuilly,* 1889, 12 x 16, oil on panel. Collection of Tweed Museum of Art, University of Minnesota Duluth. Gift of the Orcutt Family in memory of Robert S. Orcutt.

Plate 56: *Near Bougival,* 12 x 18, oil on panel. Private collection.

Plate 57. *On the River Near Bougival, France,* 12 x 18, oil on panel. Private collection.

Plate 58: *Near Poissy,* 15.5 x 23.5, oil on canvas. Collection of St. Louis County Historical Society, Duluth, Minnesota.

specificity of place and a pleasing production of requisite sentiment is *Near Ablon* (Plate 60). Its serene water reflection with supple bovines and farmers in repose surely pleased an English collector.

A SIMPLE PEASANT'S COTTAGE

Munger painted only a few pictures of rural buildings, even though such depictions were popular with patrons. Most of his architectural forms are set in the distance, and buildings merge with the landscape to become unobtrusive, enduring emblems of a fast-disappearing way of life. A work known as *Barbizon Landscape* (Plate 61) invokes the comforting idea of a farmer's simple hearth. Glimpsed in the distance, almost unnoticed, the low shape of a peasant farmhouse has an air of certainty, as if it too were an enduring part of the landscape like the trees, simple country path, and luminous sky. A soft glow of evening fills

the sky, inviting poetic musing on the close of day and nostalgia for ways of life and habitats that were rapidly disappearing.

Only once did Munger paint a single building as the focal point of a composition. It is an unusual work and also an especially effective image (Plate 62). The thatched cottage with its picturesque sagging roof and farmer feeding pond ducks is clearly French in inspiration. The studied arrangement of the tree trees at the left of the rustic home foreshadows Munger's later attention to the aesthetic conventions established by Rousseau. The picture was presented to Yale University Art Gallery in 1938 in recognition of the artist's Connecticut connections.

ARTIST'S LIFE

Munger was eager to please patrons. He continued to sell directly from his studio, although

122

his London dealers evidently did well by him too. In Europe his art appealed, as it had during the early years in California, to newly wealthy patrons who were seeking an approved style of representation without the formidable cost of a Barbizon "name." *Fame and Fortune* observed: "Where judgment is exercised in the purchase, an investment in pictures by young artists is about as profitable a one as can be made. With this view, let me recommend a visit to the Hanover Gallery, there to choose from Gilbert Munger's landscapes. The atmosphere and breadth of treatment in canvases are wonderful."[162] *Land and Water* referenced a "beautiful Gilbert Munger, the French-American whom Hollander and Cremetti introduced to England last year, and whose fame will yet be great."[163] There were aristocratic patrons: "The two landscapes which Mr. Gilbert Munger, the well-known American artist, has destined for the Universal Exhibition were acquired by H. R. H., The Duke of Saxe-Meiningen for the museum at Meiningen last April. A few days ago, Mr. Munger received from the Duke the Cross of Merit for Art and Science."[164]

During his years in France, Munger's primary market remained in London. His pictures are not recorded as being exhibited at the Salon or in other major French exhibitions of the

Plate 59: *Near Grez,* 20.5 x 31.5, oil on canvas. Location unknown. Image courtesy of Williams & Son, London.

Plate 60: *Near Ablon,* 23.5 x 29, oil on canvas. Collection of Tweed Museum of Art, University of Minnesota Duluth. Gift of the Orcutt family in memory of Robert S. Orcutt.

period, although many other venues existed in which to sell pictures. It is not clear how much time he spent in Paris, around Barbizon, or living on a houseboat on the Seine and its tributaries, although from titles of pictures it has been possible to track some of his travels. Whether aboard the floating studio or ashore, Munger carefully sought out and painted scenery that would be popular in London.

It is unclear whether he was friendly with other American expatriate artists in France,

with French artists, or with anyone at all. The years in France appear to have been far more isolated than his period in London. In an interview just after his return to the United States, Munger complained the English were hospitable, but "IN PARIS IT IS DIFFERENT. The Parisian does not invite a foreigner to his house. An invitation to dine means a visit to a café. The American in Paris is cut off almost entirely from the social life of the people. There is an American colony, and occasionally one may see accounts in the papers of their

great reception and of some very rich American who is there. The French all go to these great affairs, for they will go anywhere where there is a good time to be had, but they do not return these courtesies, except very sparingly, and then only when it is impossible for them to avoid it."[165] In the course of working around Paris it seems plausible that someone in the American colony would have noticed the distinguished-looking artist at work sketching on his boat, or attending "great affairs," but nothing is documented.

MEDALS OF ARISTOCRATIC DISTINCTION

After more than a decade in Europe Munger came to believe that success in the world of fine-arts culture could be consecrated by a display of impressive-sounding titles, elaborate medals, and aristocratic airs. These symbols of cultural capital were valuable in producing sales to newly rich buyers who needed stylish reassurances in their investments in fine art. The Gilded Age was marked by the emergence of a number of gentlemen artists, such as Millais and Munger's other contemporaries:

Plate 61: *Barbizon Landscape,* 26.5 x 36, oil on canvas. Collection of Miami University Art Museum, Oxford, Ohio. Gift of Mrs. Robert H. Bishop and Mr. Philip Mather.

Plate 62: *Landscape with Cottage,* 9 x 14, oil on panel. Collection of Yale University Art Gallery, New Haven, Connecticut. Gift of Miss Jessie Mason Tilney.

John Singer Sargent, J. A. M. Whistler, and Lord Leighton in London, or William Merritt Chase in New York. The press regularly noticed their provocative self-fashioning, courtly pretensions, and elaborate, highly decorated studios (Figure 17).[166] This was also an age in which newly rich Americans gained social distinction by marrying European nobility, as Henry James brilliantly described, or they expended energy furiously in get-rich-quick schemes, as Clarence King would do in his later years. Sometimes they had mental breakdowns and went bust, as King eventually would.

One unusual measure of Munger's concern with gaining accoutrements of cultural capital is the custom-made case of large presentation medals he owned and a companion lapel case duplicating the major awards in lapel-sized miniatures. Munger is wearing these elaborate medals (Figure 18) in his photograph. In a rare

Figure 17. The elaborate studio of William Merritt Chase in New York was filled with objects of art, rare books, prints, and paintings. Munger's studio in London in the 1880s would be similarly elaborated. Etching from *The Art Journal,* December 1879.

letter from Paris dated March 19, 1889, Munger writes of acquiring the medals. "My Saxon Cross came this morning from Berlin and the letter says, 'You should not fail to visit Germany, as you are now entitled to be invited to dinner at Court. The Duke will receive you very kindly.' The next, no. 3, will be like this." Above his signature Munger sketched a large medal with an elaborate crown on top. Below, he added the inscription in French, *Tout vient a point a qui sait attendre. N'est pas* ("Everything comes to those who wait"). Under his signature he drew three small medals in the shape of iron crosses. The *Memoir* lists the medals as "Distinctions Conferred upon Gilbert Munger by Governments and Sovereigns of Europe."

- Cross of the Legion of Honor.
- Member of the Society Litteraire International, founded by Victor Hugo.
- Chevalier of the Legion of Honor, France.
- Knight of the Order of Saxe-Ernestine; Grand Cross for Art and Science, Germany.
- Red Cross with the Ribbon of the Order of St. Andrew, Russia.
- King Leopold Gold Medal with Cross, Belgium.
- Decorations from the Duke of D'Aosta; Gold Medal and Honorary Member of the Academy of Fine Arts, Italy.
- Officer and Commander of the National Order of the Liberator, Venezuela.

Under what circumstances did Munger receive these decorations? Preliminary research has not been able to verify his name as a recipient of the Legion of Honor, for instance—an award that he claimed and one for which precise records have been maintained of all Legionnaires. No matter

that Munger's French artistic exemplar Rousseau died brokenhearted because he was passed over again and again before the French nation finally awarded him the Legion of Honor on his deathbed; Munger had *his* Legionnaires Cross. Whatever their exact origin, Munger's medals are symptomatic markers of an age captivated with displays of aristocratic distinction.

CARNIVAL AT NICE

Munger visited the wealthy resort city of Nice in 1890, where he sat for his portrait bust in the studio of Massimiliano Contini (born 1850) and had a photograph of the bust made

Figure 18. The impressive case of medals was evidence of Munger's cultural capital. Collection of Alice Jamar Kapla. Promised gift to the Tweed Museum of Art, University of Minnesota Duluth.

by J. Fabbio (Figure 19). One version of the bust is at the St. Louis County Historical Society in Duluth, Minnesota, and another casting is in the Madison County Historical Society, Connecticut. During his visit, Munger also painted *Carnival at Nice* (Plate 63). The date of the picture is important because it is one of a few benchmarks, among the dozens of undated pictures he produced, of French subjects.

A brilliantly lit carnival scene was a departure for Munger, who did not usually paint such subjects. On first glance the picture seems more impressionist than Barbizon in subject matter and appearance. Tiny figures in fantastic costumes, most no more than a few strokes of paint, move decoratively in front of theatrical architecture. The picture's urban

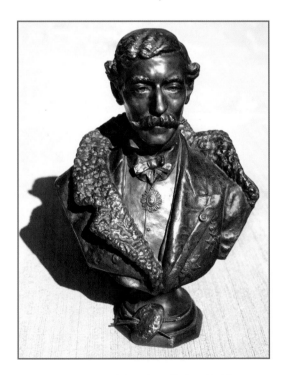

Figure 19. Munger's 1890 bust, displayed in his studio, was essential to his self-fashioning as an artist. Collection of St. Louis County Historical Society, Duluth, Minnesota.

subject and movement of figures might associate *Carnival at Nice* with an impressionist's love of color, light, and the exciting visual spectacle of a mass movement of people in a city.[167] The restless motion of the crowd is as close to a modern subject as Munger ever came. Perhaps the emotion in the picture arises from some autobiographical resonance with Munger himself. At the moment he painted *Carnival at Nice* he enjoyed financial success sufficient to commission his portrait sculpture, dress photograph, and a collection of medals.

IMPRESSIONIST OVERLAP

Munger might have noticed another group of painters working and exhibiting around Paris in the 1880s. Like Munger, they did not exhibit in the official salons. Their works were not to be found in the galleries of the Louvre, and these artists avoided long-revered sites such as Barbizon, so identified with an earlier generation, in favor of the suburbs of Paris, with its edge of modernity and displays of bourgeois leisure. By the early 1880s this group of artists had gained wide public notice as impressionists. No record exists of any Munger encounter with members of this group, whose names so dominate art history today. His style remained stubbornly indifferent to their lighter palette, broken brush strokes, and discourses of modernism. Munger's self-reliance, his eagerness for direct patronage, and his pursuit of more conventional and accessible markers of distinction led his work elsewhere. Ironically, a label on a painting by Munger indicates it was exhibited at "#35 Boulevard des Capucines, Paris" in 1889, the same venue where the impressionists had first exhibited in 1874.

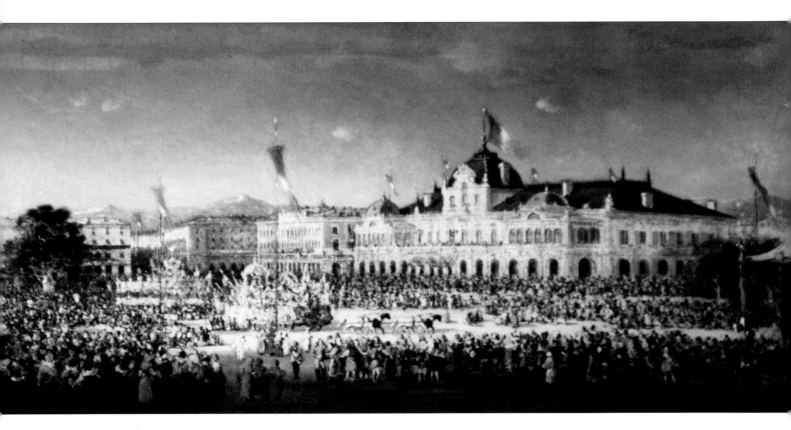

Plate 63: *Carnival at Nice,* 1890, 12 x 24, oil on panel. Collection of the William Benton Museum of Art, University of Connecticut, Storrs. Gift of Lyman A. Mills to the Louise Crombie Beach Memorial Collection.

Plate 64: *Berkeley Springs,* August 1894, 25 x 30, oil on canvas. Collection of Tweed Museum of Art, University of Minnesota Duluth. Gift of Miss Melville Silvey.

III

LONG YEARS OF SEPARATION

6

UNCERTAIN RETURN

"ALL SEEMS STRANGE"

Gilbert Munger arrived back in the United States on April 28, 1893.[168] He stated his reasons for returning this way: "Now I am no longer a child, and I have, I think, learned all I can learn from the masters. I would like to earn that recognition in my own country which I have won abroad. I should like to identify myself with the people of my own land and take an interest in their art life. A man ought not to forget his own country even after a long residence abroad. At least, I shall visit here for several months."[169]

That summer Munger had a painting on exhibition in the Art Building at the World's Columbian Exposition in Chicago. According to the catalog, he was represented by *The Rising Moon,* which was offered for sale at $500. He listed his residence as Paris. Three Munger moonlight scenes, or nocturnes, are known, although none are the Columbian picture. Its appearance was evidently not recorded in any photographs, nor did critics comment upon it. The appearance of this important work and its location are unknown, despite intensive investigation by numerous scholars searching for every work exhibited at the Chicago fair.

On his way to St. Paul, Minnesota, Munger stopped in Chicago and visited the Columbian Exhibition. He commented on the fair's grand buildings, which, however, he complained were constructed of materials that would not endure like the great architecture of Europe. Still, he thought, Americans could learn much from the architecture of the exhibition: "I spent several days at the fair, and hardly went inside one of the buildings. I was lost in admiration of the splendid architecture. . . . It is a pity that they are not built in marble so that they might stand for all time. . . . The huge commercial building is monstrous." He thought the art on exhibit was not the equal of that which he had seen in Paris, except for the work of German artists, which he had not previously seen, since, after the Franco-Prussian War of 1870, German art could not be exhibited in France.[170]

St. Paul retained its affection for Munger as a native son and the newspapers carried notices of his arrival in the city. Although the pictures are unlocated, Munger's Duluth obituary states that his work was represented in the prestigious James J. Hill and Thomas B. Walker collections of St. Paul and Minneapolis.[171] A former director of the Tweed Museum of Art, William Boyce, remembered seeing Munger paintings at the home of railroad tycoon Hill in St. Paul in the 1960s, although no records

of them survive. Hill probably acquired works by Munger after the artist had moved to Europe, perhaps through his brother Russell Munger, who had an art gallery in St. Paul.

Shortly after his arrival, Munger wrote a poignant letter from St. Paul to a niece in Duluth: "Since arriving in America all seems strange. I am constantly meeting old friends who bear with them the evidence of long years of separation, and the new generation which has sprung up in the mean time also serves to remind me of the too long absence abroad. . . . I walk the busy streets unrecognized and unknown in my native land."

Maintaining his sense of humor, Munger continued, "If however in the next few weeks it will be my fate to become a millionaire (this misfortune has come to many of my friends), I shall be better able to adapt myself to the new condition in which I find myself so suddenly placed."[172] His hopes of easy wealth in the stock market were soon shattered.

Munger's precise movements after his return from Europe remain mysterious, but judging from the pictures he produced it was a final period of continued artistic growth and productivity. During this last decade from 1893 to 1903, he painted works in what might be

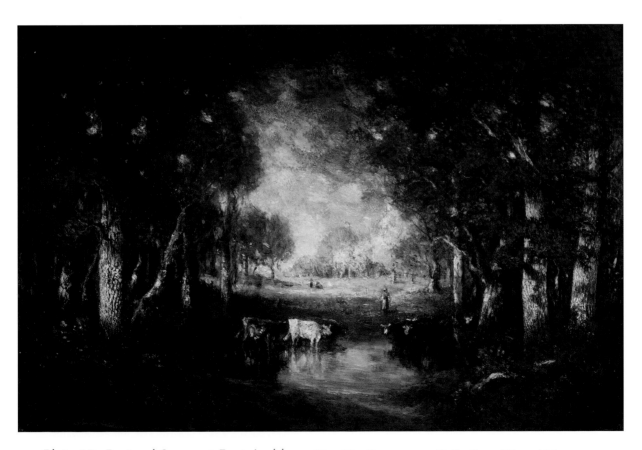

Plate 65: *Pastoral Scene at Fontainebleau,* 20 x 30, oil on canvas. Collection of Tweed Museum of Art, University of Minnesota Duluth. Gift of Miss Melville Silvey.

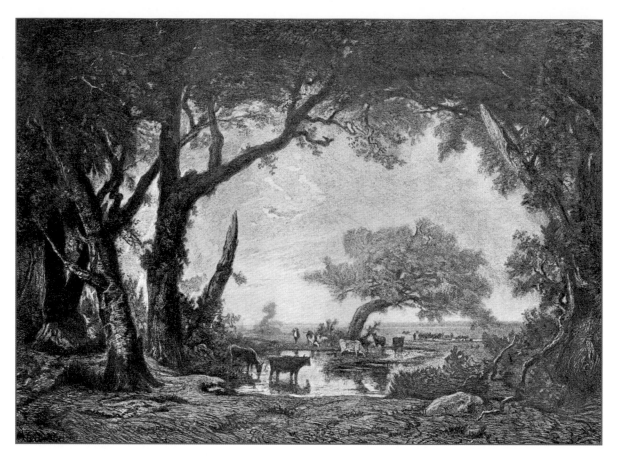

Figure 20. Munger would have first seen Theodore Rousseau's *Edge of the Forest of Fontainebleau, Sunset* in Paris. Munger's admiration for it would have been reinforced by its reproduction (shown here) in Clarence Cook's important study *Art and Artists of Our Time,* published in 1888.

regarded as his "late style." In his last pictures Munger brought the full powers of four decades of study to bear. The result was images whose weight and density of paint and dark, mysterious, often bitumen-laden surfaces cast the spectator not as a disembodied eye gazing through a window, or as a tourist surveying panoramic spaces as he had done in his western paintings, but as an empathetic participant in subtle, poetic mysteries of nature and mortality.

A painting dated 1894 places Munger in Berkeley Springs, West Virginia (Plate 64). It recapitulated the tunnel compositions of

Theodore Rousseau, but transformed it into a sunny American scene. A Paris canvas-supplier stamp appears on the verso.

ART AND LIFE: A NAMESAKE

In 1895 Munger visited Cleveland. "When last in Cleveland," he later boasted, "I made $5000.00 in clear profit in five months painting portraits and refused several other orders."[173] It is puzzling that he mentions painting portraits since none have been found, but he must have made a favorable impression there because Munger met the young Harold Bell Wright, the popular early-twentieth-century author. Wright was sufficiently

impressed with the distinguished-looking artist to name his first son Gilbert Munger Wright.[174] This meeting took place around Christmas in 1895 at the home of a wealthy Clevelander, probably U.S. Representative William J. White, who is mentioned in a Munger obituary as owning "eight or ten of the artist's best works."[175] This encounter with Munger is one of the last eyewitness accounts of the artist. Writing retrospectively some four decades after the meeting where he was smitten with the artist, Wright explains to his son why he came to have the long dead artist's name, perhaps offering rare insight into Munger's intimate preferences.

At the time of his meeting with Munger, Wright was visiting a preparatory-college friend, "the son of a Cleveland multimillionaire" with whom he had formed a "deep friendship . . . a mutual liking with a reckless disregard for anything else."[176] His account hints at aspects of Munger's life and career that are difficult to precisely apprehend. Wright, then a young art student, was deeply conflicted about his social and personal identity, suffering from the recent death of his mother. The older man, Munger, he claimed, brought out all the feminine aspects of Wright that he had repressed following her death. "Under the spell of my association with this new artist friend, all that she taught me to see and feel was renewed a hundredfold. Once he told me, with one of his rare sly smiles, that he liked to have me there [in Munger's studio] because he could paint better when I was with him." Munger provided Wright with his first taste of smoking, and liberally offered him companionship and money. Munger was then in his late

fifties, but so close was the bond of artistic friendship that he offered to take the youth to Europe, agreeing to support Wright while he perfected his writing. Wright recounted long, intense conversations with Munger: "Often he would talk to me of art—not silly jargon . . . but the simple understandable phrases of one who could speak with authority and was concerned only to make his meaning clear. Nor did he, in these talks, speak only of painting. He talked of art as a whole—of its meaning and its relation to life." Sometimes Munger would show Wright paintings from his own collection, and the older man and the aspiring youth "lunched together in some little out-of-the-way corner of the city; and while we ate the plain and simple fare, he fed my soul with the things I was so hungry to hear; bits of observation and experience from his own life while he was struggling for recognition and after he had won to his distinguished position; bits of his own personal philosophy."

Munger's friendship eased the pain of a confrontation with the mother of Wright's college friend, whom Wright was visiting over Christmas. She told him: "'I really had to adopt you or disown my own son.' . . . I think she guessed a little of what was happening to me. She was the kind of woman who would guess that sort of thing," Wright later remembered. He decided to leave "that environment of wealth and luxury" and seek his own way. Munger's response was to take out "his own well-filled purse, [offering] it to me with the words: 'For God's sake, old man, take it. You know I have more than I can use.'" When Wright came back a few years later to repay Munger and was about to take his leave, Munger put aside

his work and walked to the train station. "He even went aboard the train and saw me to my seat. Slipping a handful of cigars into my coat pocket, he said smilingly: 'As you smoke them, think of me.' Then he gripped my hand. 'I shall hear of you, lad. I know that I shall hear of you.' . . . I never saw him again." This man was "Sir Gilbert Munger."[177] The picture Wright paints of Munger is of prosperity, confidence, social and cultural recognition, and a fascinating desire to assist an aspiring younger man.

EARTH NARRATIVES AT THE FOREST'S EDGE

Munger's late pictures in the Barbizon style produced after his Cleveland interlude with Wright are infused with a deepened admiration for the style and sentiment of Theodore Rousseau. A work known today as *Pastoral Scene at Fontainebleau* (Plate 65) is a prime example. The Tweed Museum of Art version, dated 1900, well after Munger's return from France, is an accomplished reprise of one of Rousseau's most famous paintings, and its production seems to have marked something of a turning point for Munger. By the 1890s, Rousseau's *Edge of the Forest of Fontainebleau, Sunset,* which was first exhibited at the Salon of 1850–1851 and at the Exposition Universelle of 1855, was an acknowledged "masterpiece." The picture had been a state commission, acquired by the Musee du Louvre and in the late 1880s exhibited at the Luxembourg Palace, where Munger would have studied it. Rousseau's image influenced many Barbizon painters, including Diaz; Munger was not the first to be captivated by its expressive power and status as an image of forest preservation.

If Munger did not see Rousseau's picture in Paris, which seems unlikely, he could have read about it in Clarence Cook's popular 1888 book *Art and Artists of Our Time,* in which the picture's importance was recognized with a full-page reproduction (Figure 20). By the 1890s, the celebrity of Rousseau's painting had made it a cultural icon of artists' efforts to save Fontainebleau as a valuable scenic resource, much as Thomas Moran's paintings and sketches had played a leading role in establishing the first national park at Yellowstone, or Albert Bierstadt's pictures had done for preserving Yosemite. Even if Munger might not have consciously reflected on these historical and contemporary associations, the production of a dramatic and salable variation on Rousseau's revered picture offered attractive prospects to a painter struggling to regain lost patronage, and perhaps feeling unsure as to which subjects would appeal to patrons in turn-of-the-century New York or Washington, D.C.

Edge of the Forest of Fontainebleau was particularly important to Munger because it was an image that most powerfully affirmed what Rousseau scholar Greg M. Thomas has termed visual "earth narratives."[178] These were emotional and highly historicized images representing the landscape as interconnected through inexorable processes of growth and decay, metaphorically represented by extremes of light and darkness, detail and indistinctness, center and edge. Following Rousseau's example, Munger organized the pictorial space of *Pastoral Scene at Fontainebleau* in the radical style that Rousseau had introduced—a dark, framing, ellipsoidal tunnel of trees separating

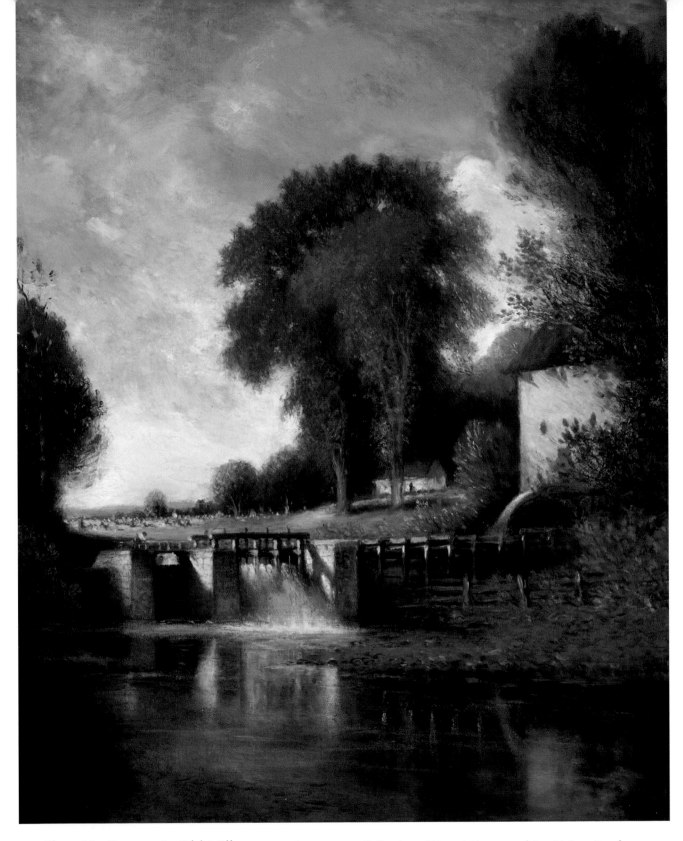

Plate 66: *Cazenovia Old Mill,* 44 x 36, oil on canvas. Collection of Tweed Museum of Art, University of Minnesota Duluth. Gift of Miss Melville Silvey.

a marshy foreground from a light-filled distance. But where Rousseau's oval tunnel of trees is horizontal, Munger's ellipsoidal composition is narrower and vertical. In both pictures the oval composition draws the spectator's eye to the center and out toward the dark periphery of the visual field. The dark edges and ancient trees in Rousseau's picture seem inexplicable and enduring. Human presence is deemphasized, the scene offering no strong social or human narratives. In Munger's picture, as in Rousseau's, the silent life of water, trees, animals, atmosphere, and earth are emphasized while the shepherd appears self-absorbed. This was a compositional formula and a displacement of the spectator perfected by Rousseau, and masterfully absorbed by Munger.

The importance of Munger's reprise of Rousseau's picture is indicated by its reproduction in the *Memoir*. A New York critic reviewing Munger's retrospective exhibition after his death may have noticed it: "It was when Mr. Munger more nearly approached Rousseau that he was most successful. Given a dark tree, some distance illumined by strong afternoon sunlight, a sky of brilliancy, and Mr. Munger would occasionally secure some fine passages, suggestive of the great Barbizon painter."[179]

If the western paintings that Munger produced for Clarence King in the 1870s presented epic geological landscapes as emblems of a Darwinian vision of nature, Munger's late paintings produced under the influence of Rousseau intensified the poetic, evocative treatments he had refined in France, demonstrating his deepening response to new nature. That Munger successfully completed an

extreme stylistic transition is, perhaps, remarkable from our perspective, but it probably seemed less so to the artist. For him there was likely an internal intellectual and emotional coherence that carried forward ideas and concerns about nature first engaged in his early work for survey geologists. It is tempting to believe that he continued to resolve them through the production of visual fields, such as his reprise of the master's work in *Pastoral Scene at Fontainebleau*. In it, as with a few other late pictures, Munger brought his personal style to a new level of expressiveness, producing his own compelling vision of a rural "American Barbizon"—a place where human interests and presence become peripheral in an ideal, self-ordering, soothing, interdependent world of organic forces.

BELATEDNESS AND NOSTALGIA

Around 1900 Munger spent an autumn season with watercolor artist Dwight Williams of Cazenovia, New York, doing "some fine work characteristic of the scenery of that locality," according to Myra Dowd Monroe, an early Munger biographer and cousin.[180] Williams recounted to Monroe in a letter that "we often painted together in the field. He was lovely good fun at times. We have often sat up all night painting and talking art matters."[181] The works done with Williams around Cazenovia deepen emotional effects by offering a new emphasis on the defining power of light. The development of Munger's personal style culminated with these late pictures. The ostensible subject of most was the agrarian landscape of upstate New York; the deeper emotional theme was the representation of belatedness, an emotion

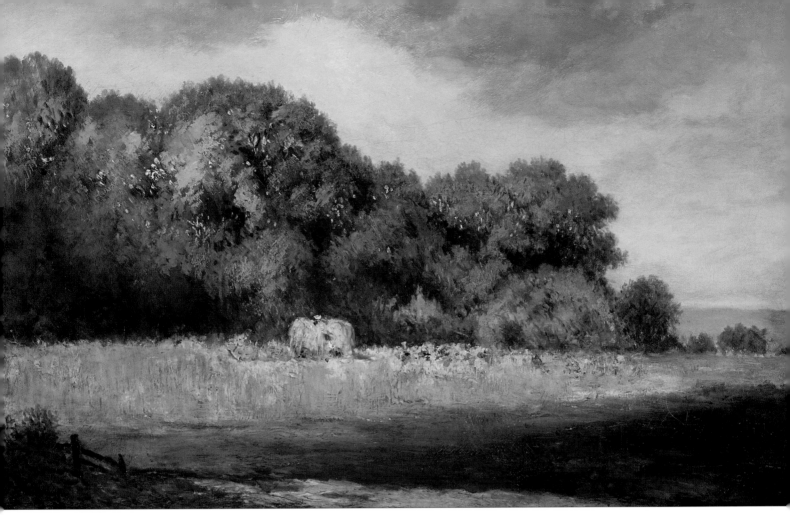

Plate 67: *Cazenovia Hay Field,* 17 x 25.5, oil on canvas. Collection of Tweed Museum of Art, University of Minnesota Duluth. Gift of the Orcutt family in memory of Robert S. Orcutt.

common to the educated, privileged classes of turn-of-the-century America. It signified a denial of the grim realities of industrial America for dreamy visual palliatives representing invariably pastoral images of a happier, more harmonious past. At its best it produced an awareness of the mysterious web of nature's silent economy. Sometimes it was merely sentimental, a reassuring illusion of the environment purged of all modern change. In producing art to supply this market Munger was not unique, but true to his commitment as a professional artist— even as he entered his final years, perhaps already suffering from the illness that would

claim him—he infused new emotion and formal maturity into his work.

In the best of these late works, Munger's interest in the unifying effects of light and a sense of mysterious organic process is powerfully evident. All the images originated in observation of real places, but as before all are shorn of evidence of modern, mechanized farm life. In his late works, in fact, Munger created his most complex illusions of a perfect, serene past, surpassing his French and English work. A picturesque old water mill, an anachronistic relic of the early industrial age yet still in daily use, was the subject of *Cazenovia Old Mill* (Plate 66).

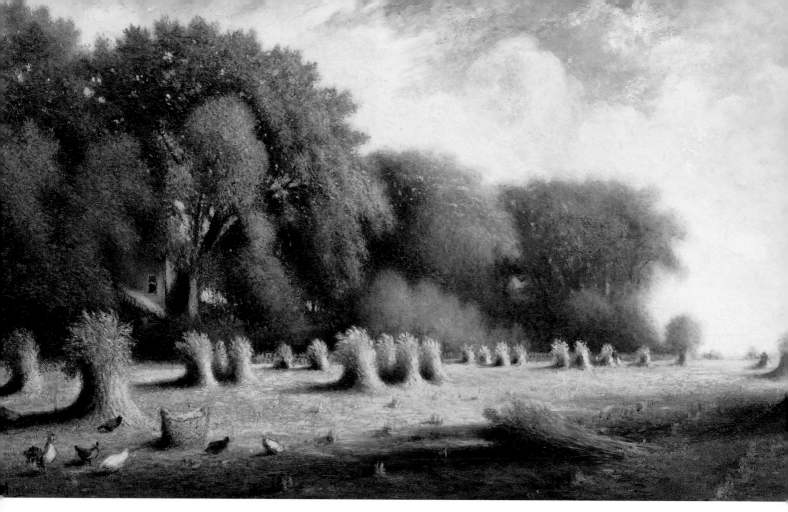

Plate 68: *Cazenovia Corn Field,* 34 x 58, oil on canvas. Collection of Tweed Museum of Art, University of Minnesota Duluth. Gift of Miss Melville Silvey.

The scene is framed with *repoussoir* trees that could be specific types, yet they are composed within the venerated conventions of Claude Lorraine in the beautiful mode and would be instantly appreciated by the most discerning connoisseur of fine art. In the distance beyond the rail fence an old-fashioned cornfield is glimpsed, a place where farmers glean crops not with steam threshing machines, but by hand in time-honored ways.

The soothing visual associations Munger produces in his picture are of a time when farmers were not industrialists extracting resources from the land, but gentle husbandmen cultivating Mother Earth. Unifying the scene is a vaporous, poetic sky, signifying repose in an idealized present gauzed in purifying remembrance of aesthetic convention. The work was evidently salable; two versions are known, the Tweed Museum of Art's being the larger picture.

As Munger deepened the emotional associations in his late pictures, his powers of painting intensified. An oil sketch of *Cazenovia Hay Field* (Plate 67), painted around the same time, demonstrates a handling of light effects that is as fine and fresh as anything the youthful artist painted. Farmers and their animals laboring in the fields the old-fashioned way

are caught in brilliant light that sweeps across the landscape. It illuminates venerable groves of trees behind them, painted with subtly varied strokes of green, each one caressingly touched. The image produces a pleasing feeling of harmony drawing on intuited, empathetic awareness of enduring human connections to seasons and harvest. The origin of the modern term "culture," which derives from "cultivation," meant "tending to natural growth."[182] In the foreground a watery piece of land remains fallow, its dark, mysterious earth habitat for creatures essential to the regulation of nature's invisible economy.

HEAD, MIND, HANDS, EYES: CAZENOVIA CORNFIELDS

Among the most expressive examples of these upstate New York paintings is a large, exhibition-scale painting of *Casenovia Corn Field.* Munger painted the scene in two versions: the larger of these (Plate 68), in the Tweed Museum of Art, is a picture painted for exhibition, because of its size; the smaller work (Plate 69), descended in Munger's family, is painted in a slightly paler palette and with considerable impasto. Its superbly handled foreground establishes a painterly benchmark for Munger's last years. In both pictures upright sheaves of corn are captured in warm yet mysterious light that rakes them, agitating their forms with palpable embodiment. In the Tweed Museum of Art version the heads of corn seem to bend away from the light, their shadows elongated and evocative while a flock of chickens scratches the earth at the spectator's feet. Firmly grounded, the spectator is positioned as privileged, silent witness,

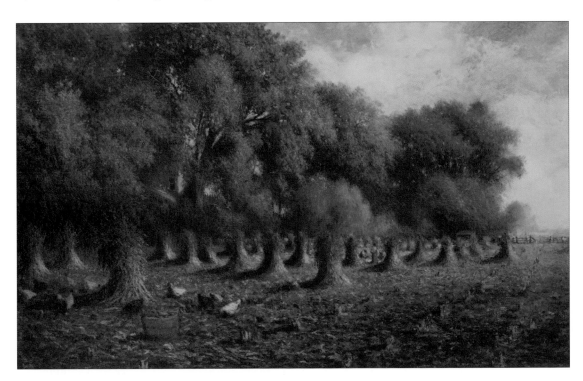

Plate 69: *Cazenovia Corn Field,* 30 x 45, oil on canvas. Collection of Alice Jamar Kapla.

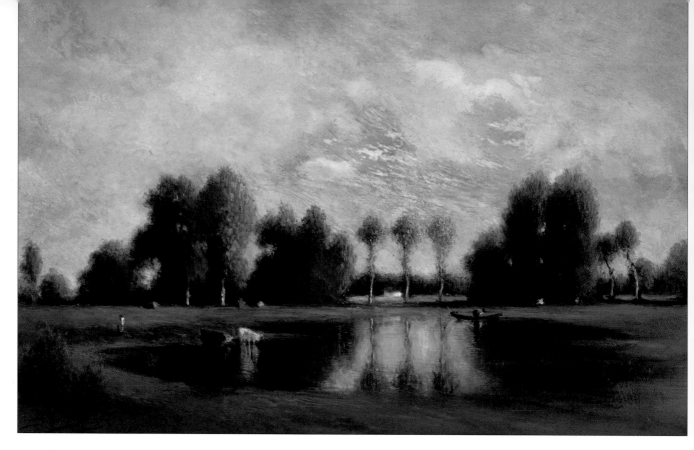

Plate 70: *Forest of Fontainebleau,* 1901, 11 x 15.5, oil. Collection of St. Louis County Historical Society, Duluth, Minnesota.

for the scene is devoid of any other nearby humans. Munger's acutely developed sense of suggestion and association is exercised to its fullest in these images, which possess a feeling of observed immediacy and intimations of mystery. In both pictures, the half-seen presence of a large dwelling nestled in the trees is glimpsed, its windows vacant, staring, vaguely anthropomorphic, as the eyes of the soul.

Idealized, historicized, and painted with his mature painter's touch, Munger's romantic scene is one that King, Ruskin, and, it might be surmised, even Darwin or Rousseau might have admired. Yet the French painter probably would have found Munger's cornfield too sunny, too relentlessly apolitical in its delight at the pleasures of perceptual experience. In the end Munger's art, like the work of many

American painters of his generation, never revealed a political edge. He was unconvinced, perhaps even unaware, of the modernist belief that art could engage the conditions of modern life, or even critique it. Williams summed up what he understood Munger to be: "I would say that Gilbert Munger was careful in the selection of his subjects. He looked upon landscape as the environment of man and tried to paint the qualities of nature that suggest and appealed to the mind. He succeeded in conveying in his art the emotions he experienced himself before nature. To me his art was a philosophy."[183]

Myra Dowd Monroe recounted another, far more humorous appraisal of the smaller *Cazenovia Corn Field* painting by "an Irishman of the old-school type," who often came

and looked over Munger's shoulder as he was painting it outdoors. Quoting a lost letter by Williams to herself, Monroe related an incident: "I met Jerry one evening and said to him: 'Mr. Munger is a hard working man.' Jerry said: 'I never saw the bate of him. He works with his head, his mind, his hands and his eyes, and he's working 'em all to onct [at once].'"[184]

ART AS PHILOSOPHY: MUNGER'S LATE STYLE

Works from Munger's last decade, and particularly the pictures completed during the last two years in his Washington, D.C., studio, exhibited what might be termed his "late style." His emotional use of impasto increased, accentuating his distinct "signature touch." This "signature in paint" by the end of his career had become a defining marker of artistic individuality and originality—among the most precious and expensive of artistic commodities. His late works are remarkable evidence of how successfully Munger realized his transformation from the crisp, Ruskinian naturalism of the 1860s and 1870s. Munger was one of only a handful of artists—including George Inness, Jervis McEntee, Homer D. Martin, Thomas Moran, Henry Ward Ranger, and William Keith—who fully consummated a transition to the new styles needed to represent new conception, or feeling of nature.

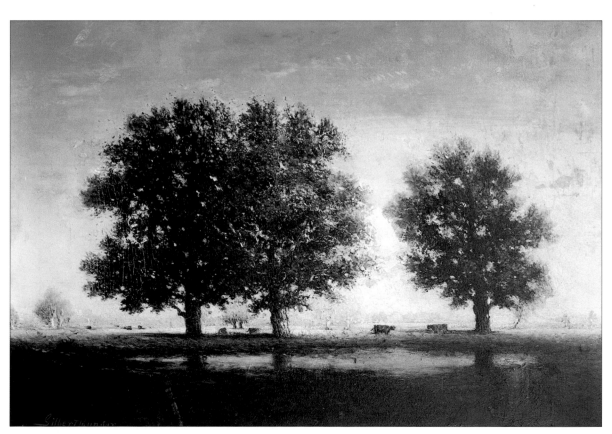

Plate 71: *Three Trees,* 18 x 26, oil on mahogany panel. Private collection.

Plate 72: *Fontainebleau (Three Trees),* 28 x 36, oil on canvas. Collection of Tweed Museum of Art, University of Minnesota Duluth. Gift of Miss Melville Silvey.

Only a few works are dated around 1900, when Munger moved back to Washington for the last time, but they include some of the artist's most compelling late pictures. Among these last works are several with titles that are provisional or modern approximations. Munger's intensifying engagement with nature's poetic harmony is evident in a work generically titled *Forest of Fontainebleau* (Plate 70). Dated by inscription to 1901, long after his return to the United States, the scene possesses expansiveness suggestive of an American scene, although the three trees in the distance and the solitary cottage below might argue for identifying it as French. Whatever the title once given it by the artist, the scene bears marks of being based on observation refined by reflection on the work

of the French artists Munger had so carefully studied. Whether the scene is upstate New York or the environs of Paris is less important in the end than the production of images showing man and nature in comforting balance.

In two related compositions Munger painted the time-honored subject of three trees. Neither is dated or titled by inscription, but judging from the brighter colors and bolder impasto, they may have been done after he returned to America, even though the scene is probably in France. The smaller picture (Plate 71) has a freshness and spontaneity about it that is as fine as Munger's best early work. The larger picture (Plate 72) is treated in a manner reminiscent of Rousseau's Barbizon works, producing associations of heroic tree

strength, a kind of arboreal monumentality, with its dark, water-filled foreground, ancient bowed trees, and luminous beckoning background.

To be sure, Munger did not "invent" the scene; he "composed" it from direct experience as was his custom, but he also drew from a wide knowledge of the history of art in selecting the subject. It would be inconceivable with Munger's background in graphic art that he would not have encountered one of Rembrandt's famous etchings, *Three Trees* (Figure 21). In Munger's day, Paris dealers held vast quantities of the master's plates and restrike editions flooded the market; a complete edition of Rembrandt's prints could be had inexpensively. We know that Munger was a collector in his own right, so he could have seen and even might have acquired Rembrandt's print. Art-historical interpretations abound of Rembrandt's mysterious image. Some stress its symbolic resonance with Protestant iconography of three trees as symbol of salvation through the three crosses on Calvary, others its naturalism. The design power of the image is undeniable. In Munger's large canvas the leaning tree on the right seems to reprise the distant bent tree at the center of Rousseau's *Edge of the Forest at Fontainebleau, Sunset.*

One of the most emotional works from Munger's last years is a picture known today as *Two Trees,* dated 1901 (Plate 73). Breaking from his standard horizontal compositions, he turned to a vertical format, as he did in his etching of the solitary tree. It was a format Munger seldom used. Two stately, if almost leafless trees dominate the space; the distant pastoral background recalls *Cazenovia Corn Field.*

In the dark foreground a self-absorbed figure in a flatboat is lost in the bituminous shadows. The dark trunks of the two trees above him are starkly silhouetted against the light, appearing as if etched out of cloisonné on an impastoed surface. A chilly northern sky painted with Prussian blue is filled with puffy white clouds that float above a low, sun-drenched horizon. The tree at left is withered, the boatman is about to depart the shore, the solitary red-shirted figure reclining beneath the dying tree seems absorbed by the luminous sunset light lingering in the distance. In *Three Trees* Munger affirmed conventional emotions suggestive of personal transcendence; in *Two Trees* a somber, melancholy feeling prevails, most evident in the writhing, dying branches of the left tree. Just above the first branch an agonized face seems to appear in the bark, one of Munger's few concessions to the pervasive anthropomorphization of trees in Barbizon art.

Figure 21. Rembrandt's etching of *Three Trees* stimulated Munger's painting of the same title. The Wetmore Print Collection, Connecticut College, New London.

Plate 73: *Two Trees,* 1901, 44 x 36, oil on canvas. Collection of Tweed Museum of Art, University of Minnesota Duluth. Gift of Pilgrim Congregational Church, Duluth, Minnesota.

7

NO LIVING FOR A GOOD LANDSCAPE PAINTER

"SEVERELY ALONE"

Vivid and disturbing descriptions of Gilbert Munger's activities toward the end of his career appear in a series of letters written to James Cresap Sprigg, his future biographer, and in geologist Samuel Franklin Emmons's diaries. On January 12, 1902, Munger wrote stoically to Sprigg of his isolation in Washington, D.C.: "I know no one in the building—and do not want to. So am left severely alone to do my work." A week later came Munger's cri de coeur: "There is not a living in this country for a good landscape painter. I propose to abandon it and paint portraits. There is no longer any encouragement to work from sixteen to eighteen hours a day, at a loss. A doctor has warned me that if I continue it will result in brain trouble and paralysis." Already gravely ill with cancer, the artist soon found it difficult to go out without falling in the street, yet he continued to produce and to sell. "Eleven of my smallest pictures 11 x 17 have recently been sold in London for $400 each," he wrote. "Since my return from New York, I have sold one of my little foreign pictures for $675 and have offers on more of them. The little picture is only 7 x 10."

In a letter of astonishing candor a week later he declared to Sprigg: "I have already spent over seven years in this country. Seven long years gone out of my life, and all these years I have been trying to get back to Europe where I should have remained, had it not been for the well meaning but unfortunate advise of a friend. At one time I could have returned with several thousand dollars with me which I could re-establish myself in London. A friend instructed me to put this money in under ground trolley." The friend told him to move back to New York, "where he would bring J. P. Morgan . . . and the richest men in New York to the studio." He would make Munger's studio "the resort of all the richest people, would sell all of my pictures for me, and make me known all over the country. Consequently I gave up Washington where I was doing well and took an apartment in the Newark flats."

Bitter disappointment followed. "During the whole of the two years there," Munger lamented, "he brought one man who was not a picture buyer. At the end of two years I gave up the apartment and commenced to pack for Europe." More advice came from another friend, "a lady this time. I must not think of going back. She was one of the 4 hundred [the social elite of New York], she had never seen such pictures, I must take a studio near the Waldorf, she would bring the 4 hundred and many out of Town Millionaires. I believed all this, followed her directions, and

then never saw her again. . . . The result was three thousand dollars out of pocket. Again I resolved to go to Europe with no money and trust to luck, had packed + stored half of my pictures in the Lincoln [storage facility] and was busy packing the rest, so that they could be sent on to me."[185]

RETURN TO WASHINGTON

In February 1901, instead of moving to Europe, Munger had moved back to Washington, D.C., for a milder climate and lower rents. He had old friends there. Emmons, his companion from Sierra Nevada days, resided there with his second wife in grand style. Emmons lived in a luxurious house with his own "wheel" and chauffeur. He played golf daily at the Chevy Chase Club and had become the millionaire that Munger would never be, and that Clarence King had failed to become. Mining, subway, and railroad builders consulted Emmons for his geological expertise and political connections. Munger must have seen Emmons fairly regularly; for instance, Emmons writes on April 7, "Munger meets me on F Street at lunchtime." Old friendships aside, there were pressing reasons for Munger's return to the city of his youth. Investments in streetcars gone sour are hinted at and concerns about money are frequent in the few surviving letters from these years.

Washington, D.C., was familiar territory, but with the disadvantages of southern life in the capital. Munger was back in Washington by Christmas Day 1901, when he and the world of American science were stunned to learn that Clarence King had died the day before Christmas at Phoenix, in the remote Arizona Territory. The great scientist, first director of the U.S. Geological Survey, broke down mentally and physically when speculative mining properties he was promoting failed. King's death was a major news event, and the pathos of his financial disgrace haunted old friends. Emmons, James T. Gardiner, Henry Adams, and artist John Lafarge spent months preparing an elaborate memorial at the Century Club and a commemorative book. It would republish King's last literary effort, the quixotic tale of the *Helmet of Mambrino,* from which the volume would take its title. Munger's reaction to these events, which figure prominently in Emmons's diary, is undocumented, but the links of friendship that had first brought him patrons in San Francisco and New York and later provided the artist entry to the finest studio and drawing rooms in London were severed.

OF LITTLE MARKET VALUE

If the quantity of entries related to King's death in Emmons's diaries are any indication, the demise of the great "avatar" was a matter of deep concern among the small group of men that remained from the Fortieth Parallel Survey. These most certainly included Munger, although he was not asked to offer an image for King's memorial book, nor, as far as could be determined, was he even invited to attend the ceremony at the Century Club. Among King's friends the most pressing concerns were making arrangements for supporting Mrs. Howland, King's widowed mother, whose destitution was an embarrassment in New York, Cambridge, and New Haven high society. Old exploring friend James T. Gardiner undertook the disposition of King's

personal effects, particularly his prodigious art, artifact, and book collection. Gardiner wrote revealingly to Emmons, "You are perfectly right about not applying to Congress for anything for Mrs. Howland. It would be unsuccessful and would be particularly distasteful to us all." He continued, "I have no doubt that when I get the power to deal with the bric-a-brac pictures etc., they can be sold for such a sum that the interest of it will keep Mrs. Howland comfortable for the rest of her life if she lives with Marian." The latter is Marian King, the sister for whom the scientist had tried to name an alpine lake.

Gardiner was particularly concerned about the whereabouts of "the three Turner watercolors [which] alone must be worth $20,000. From Mr. Laffen of the 'Sun' who was with King at the time he purchased, I got the price he paid for one of them which was considered a bargain at the time, twenty years ago. Meantime Turner water-colors have risen steadily in value." Munger's role in the proceedings was key: "Will you kindly ask Munger whether he knows the address of the place where King had his pictures stored in London during the last four or five years and whether he knows how many pictures he had stored?" Evidence of Munger's close association with Millais was much on Gardiner's mind as he further queried Emmons: "If Munger traded the unfinished 'Millais' with King for one of his pictures, I suppose Munger has the picture of his own that the trade was made for. Does Munger want to hold the Estate to the trade or does he want to give the Estate the 'Millais' picture which is salable and will bring something for Mrs. Howland while his picture is,

of course, of little market value? If Munger would be willing to give the 'Millais' to Mrs. Howland direct, the Estate would release any claim on his picture and you might possibly sell the 'Millais' to the Corcoran Art Gallery for a good price."[186]

The outcome of the proposed exchange, along with the location of the unfinished Millais, remains unknown. That Munger had acquired such a valuable picture for display in his studio demonstrated just how well connected he remained with the circle of famous and wealthy men around King and Emmons. The unfinished Millais painting, which, given Munger's reduced circumstances, he must have eventually been forced to relinquish, would have been a talisman of the artist's connection with respected names in English art. But in the end, as the events around King's death played out, it is clear that Munger might appear to a few Minnesota patrons as "Sir Gilbert Munger," but to his old blue-blood friends like Emmons he was still the son of a New Haven laborer, not one to be asked to visit or invited to the theater as Emmons, King, and Munger had once done in the early years in New York. The final ignominy was for his paintings to be dismissed even by his old friends as of "little market value."

"NEARLY STRANDED": THE LAST $10

The physical misery of Munger's last year was compounded for the cosmopolitan artist when he compared life in Washington to the great European cities where he had worked. "I have not been well since I came to this city 18 months ago," he wrote to Sprigg on August 26, 1902. He was treated

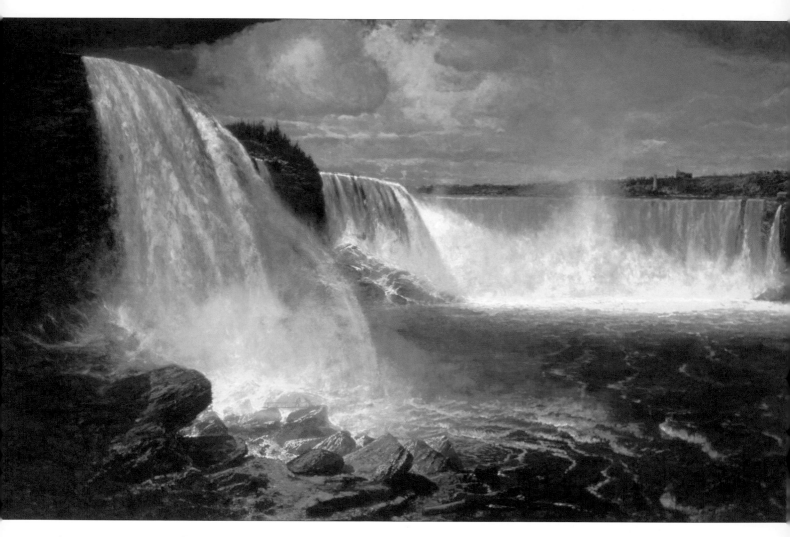

Plate 74: *Niagara Falls Showing the Canadian and American Views,* ca. 1903, 72 x 120, oil on canvas. Collection of Michael F. McNutt.

with electricity for "neuralgia," but it was too late for the artist when inoperable stomach cancer was finally diagnosed. On December 1 Emmons writes in his diary: "After hours go to Providence Hospital to see Munger, who is no better, but going to move back to studio." On December 21: "At four out to call on Munger at his studio." A week later things had taken an ominous turn and Emmons wrote: "After church go down to office then off to Munger's studio to cheer him up. He looks still like a death's head but is more cheerful." By January 15, 1903, it had become a matter of time. Emmons wrote: "At office all day. After hours call on Munger." On January 26, the day before the artist died, Emmons wrote a check to his private club for $10,000 to cover pledges, and on the same page he noted, "Munger seeks to borrow $10." Unable to work "on account of my intense suffering and loss of sleep," Munger remained optimistic. "As soon as I am able," he wrote, "I propose to return to New York . . . and enter into a active and busy life." He continued: "My expenses here are very heavy, and I am nearly stranded."

The next day, January 27, 1903, Munger died "in his studio in that city where he painted his first picture nearly half a century ago." He was conscious and happy to the end and "breathed his last almost at the moment when he had put the finishing touches to his great canvas, *Niagara Falls,* showing both the American and Canadian views," Sprigg reminisced later in the *Memoir.* Emmons would not learn of his friend's death until January 29: "Leave at 5:30 and go to Munger's studio, where I learn that he died two days since." On January 31 Emmons writes the last entry

with Munger's name in his diary: "Morning to dentist. Thence to Munger's studio where I meet his brother and Walter Paris."

Emmons's mention of Walter Paris is further evidence of the degree to which Munger kept up with his old friends from the West. Walter Paris had gone exploring with Ferdinand V. Hayden in 1874 and first met Munger in 1875 in San Francisco. He was an eyewitness to Munger's "most prosperous condition" in London in 1882. Walter Paris appears for the last time at Munger's deathbed along with the artist's brother from Duluth, Roger. That Paris and Gilbert Munger remained in contact over three decades is not, perhaps, surprising. What they shared as bachelor artists in turn-of-the-century Washington, D.C., can only be surmised. It is known that Paris, a man of broad frame and a pompous personality, painted delicate and precise watercolors in the pre-Raphaelite style and helped found the New York Tile Club. He built a grand mansion for himself in Washington and a woman he never married. He never occupied the house. At his death his collection and estate was left to another bachelor friend. Munger, we surmise, moved briefly in this circle.

On February 3, 1903, Gilbert Munger was buried in Duluth. His brother Roger had remained in Washington, D.C., disposing of Munger's studio contents, including helping to arrange the New York retrospective and publication of the *Memoir.* The contents of the studio must have been impressive, even in the drastically reduced circumstances of Munger's illness. His obituary states that the artist "was a noted collector of rare pictures,

books, and miniatures, and his selections were marked by an expert knowledge and the most delicate taste."[187] Roger eventually returned to Duluth with many pictures from his brother's studio.[188] Chief among these may have been the huge *Niagara Falls,* along with many other finished pictures and sketches. *Niagara* looked back to the beginning of Munger's career and his early success.

A LAST GREAT NIAGARA

Niagara Falls Showing the Canadian and American Views (Plate 74) was Munger's heroic final effort to produce a "great picture." He had been working on the six-by-ten-foot picture for months and had virtually completed its final glazing when he became too incapacitated to work. Its enormous size alone was daunting for a man in terminal illness. Munger had produced a few such large canvases early in his career with his *Minnehaha* and *Shoshone Falls,* but the last *Niagara* was a jarring divergence from the more intimate-scaled Barbizon pictures that predominated in the retrospective exhibition. A smaller, more thinly painted undated study has been located (Plate 75), which is almost identical in composition to the large canvas and handled with Munger's distinctive touch and palette. Given that the artist had long perfected the practice of painting large, almost finished studies on the spot, the smaller work, with its fresher and more spontaneous appearance, may be evidence that Munger revisited the falls while painting with Dwight Williams in Cazenovia, but no documentation of this trip has been found.

Whatever the exact circumstances of its production, the last *Niagara,* unlike Munger's early treatment of the falls in the manner of Church, is dark and stormy. Dramatic clouds combine with the effect of water crashing down to produce conflicting emotions of foreboding, oblivion, and transcendence. Tourists are seen on the observation platform at the foot of the falls while a single figure with a walking stick and knapsack is glimpsed climbing among the rocks at left. It might be a self-portrait of the artist—his final autograph—surveying the grandeur and geological decay of the roaring waters.

Munger's relatives, assisted by James Sprigg, arranged a posthumous retrospective exhibition of eighteen works at Noé (formerly Avery) Gallery in New York in early 1904. It was designed to coincide with the *Memoir'*s publication. A single review appeared in the *New York Commercial Advertiser.*[189] The reviewer had never heard of Munger and not read the *Memoir,* mistakenly thinking the artist had trained in France. From the perspective of this study, the critic's understandable mistake might be considered as unintended endorsement of just how effectively Munger had assimilated the Barbizon style. The anonymous reviewer was generally unsympathetic to Munger's interpretation of Barbizon. "Rousseau, Corot, Diaz, have contributed their share," the reviewer caviled, the "result being generally an eclectic canvas suggesting any or all of these men."

The large *Niagara,* on which the artist staked his last hopes of fame, the subject with which decades earlier Munger had announced his entrance in the field of art, came in for the harshest criticism. The painting, whose sheer

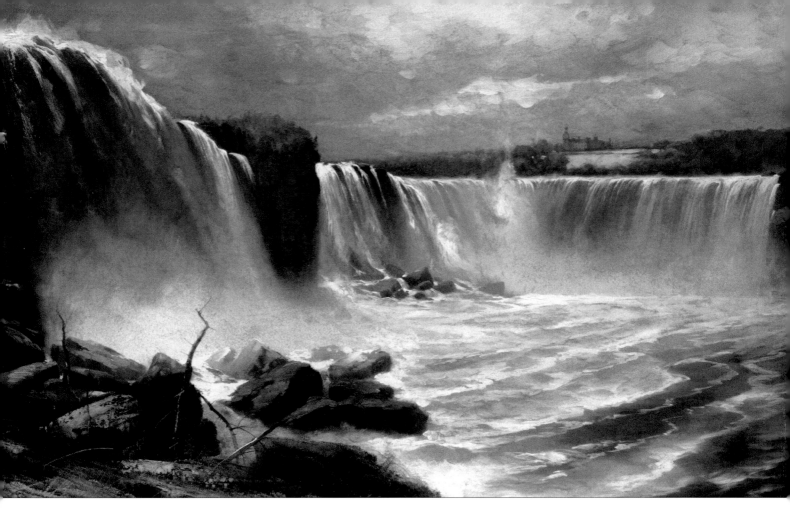

Plate 75: *Niagara Falls,* 29.5 x 48, oil on canvas. Collection of Washington County Museum of Fine Arts, Hagerstown, Maryland.

size and expansive panoramic view alone made it passé, suffered from "commonplace color, the drawing not too distinguished, and the conception only feeble." Revealing his bias in favor of the unique, the "personal," the reviewer admitted, "One or two of the Fontainebleau canvases here are fairly successful and more personal, but as a rule all are so reminiscent as to force comparison,

not to the advantage of Mr. Munger." He could not fathom why Munger had been bestowed with foreign honors "for which excuse is by no means evident in the present display." By 1904 in the eyes of this particular critic, Munger's work seemed inspired by foreign styles and was mostly out of date. Within a generation of this review, Munger's name would be all but forgotten.

8

AFTERMATH

Central to the attempt of associates and family to mark Gilbert Munger's place in the history of art and to promote sales of his works was the *Memoir,* written without attribution by Munger's correspondent and friend James Cresap Sprigg. A political power in the New Jersey Democratic party and a founder of the Smithfield Ham Company, Sprigg apparently was a close friend to Munger by 1900, although we do not know how or when they met. Sprigg's daughter, Julia Duryea Sprigg Cameron, remembered almost one hundred years later the painter's frequent visits to the family home.[190] Sprigg inherited numerous works from the estate, including two large Venetian paintings, one of which was reproduced in the *Memoir.* His text conflated the biographical sketch that appeared in *Colburn's New Monthly Magazine* with excerpts from Munger's now lost newspaper-clipping book and personal recollections. The letters between Munger and Sprigg make it clear that they were friends, but the *Memoir* is written with the detached perspective of a Victorian tribute and there is little evidence the author understood much about Munger's early training or western pictures. As part of his attempt to establish name recognition for Munger, Sprigg tried to donate paintings to the Metropolitan Museum of Art and to Yale University.

A year after the *Memoir* appeared, Myra Dowd Monroe, a second cousin of the artist, published her first account of Munger in *Connecticut Magazine.*[191] She was most concerned to demonstrate Munger's connections to Connecticut and followed the *Memoir* closely, although because of her personal and professional connection to Munger, Monroe proved additional details about personality and working methods. She confirmed his high degree of social charm, "entertaining a bevy of girls in the most refined and charming way." Munger took "a lively interest in politics and affairs, and liked to know men of action. He was a mild user of tobacco. He, like Turner, would accept one glass of wine, and refuse the second. He rarely called upon other artists in their studios."

This last remark may explain why so few other artists seem to have known Munger, particularly later in his career, and why there were so few personal sightings of him in France and after his return to the United States. It also hints at why Munger was ignored by art history following his death. When he began painting in the 1860s, his practice of avoiding dealer commissions by selling directly in the field to patrons had many advantages, but three decades later it proved to be less desirable. The field of art production around the Civil War, when Munger began work, was in

transition from an older model dominated by wealthy elites, in which successful painters usually marketed their works directly to knowledgeable patrons, or cooperatively as at the National Academy of Design or earlier through the American Art Union. By 1900 a vastly larger market had emerged that sold to an expanding class of newly rich. This was an increasingly anonymous market dominated by leading dealers and galleries. These were commercial establishments with the power to sell objects of fine art in a highly specialized or restricted market for using sophisticated new techniques of exhibiting, publishing, and marketing.

Through his absence and his secrecy, Munger had forgone the advantages of an established relationship with an American dealer who would have promoted him long-term. He seemed to recognize this in his final letter to Sprigg, lamenting his difficulty in selling his recent work. Munger praised an unidentified New York dealer at Veerhoffs Gallery as "the cleverest dealer I have ever met . . . he sells to the most prominent men of the country. [He] sells on commission, writes his own art criticisms for the papers, carries a collection of Biographies of all the painters living & dead, prices of their works etc. pays all expenses and only charges 10 percent on sales—has been in the business 35 years."[192] Munger's introduction to an established New York dealer came too late. In the end no one had a vested interest in keeping his name alive. No American dealer had an inventory of his pictures, and Munger quickly slipped from public notice. Part of Munger's failure to be included in art history was probably due as much to a strategy that gained him early

success, but later proved to have limitations for his posthumous reputation.

In the short term the promotional work of the *Memoir* must have been partially successful. Within a few years Munger's last *Niagara* had been sold to Henrici's Restaurant in Chicago's old Loop. Henrici's was noted for its vast art collection, and Munger's *Niagara* hung at the entrance for more than half a century at this most celebrated "European" gourmet restaurant, where countless diners admired it. The entire Henrici collection, including *Niagara,* which by then had lost its attribution, was sold at auction when the restaurant was closed by urban renewal in 1962. *Niagara* languished in a Chicago warehouse until it was rediscovered and identified in 1980 as Munger's work.

In the years immediately following the artist's death, the largest body of Munger's work came into the possession of the wildly eccentric, enormously wealthy Mrs. Alice Silvey in Duluth, who inherited a cache of paintings from her father, Roger Munger. She had been forced to leave her husband onboard the *Titanic* and later had difficulty caring for the work. Over time many of these pictures were disbursed in the Duluth area, and some have found their way through other relatives to the Tweed Museum of Art.

Munger's posthumous connections in Connecticut were also strong. The Honorable Lyman A. Mills of Middlefield, Connecticut, who was lieutenant governor at the turn of the century, owned some twenty Mungers as part of an extensive collection of American art. Six

of these were exhibited at a show at the Morgan Memorial in Hartford in 1923. Subsequently, other works by Munger have found their way to the art market. The late Robert Orcutt, who resided in Guilford, Connecticut, near where Munger was born, collected a group of the artist's works that his family bequeathed to the Tweed Museum of Art. It increased the corpus of works donated over the years by Munger's Minnesota relatives to twenty-two.

Since 1995, interest in the American art market has converged on Munger's western pictures, reflecting a renewed appreciation for the visual sophistication and clarity of his early work. Gaining in appreciation are his European works, particularly the Venetian and Barbizon pictures, and their importance can be recognized in this study. Munger's assimilation of the masters of European art may seem dated to contemporary taste, which still prizes above all things a perceived originality in art. Munger's age did not think that way. His later paintings are inspired, not derived, from his absorption of the visual conventions of Turner and the Barbizon masters. Perhaps the most telling marker of their invention is Munger's distinctive artistic voice, whether produced with the visual conventions of Church and Bierstadt, Turner and Ruskin, or later of Rousseau and Barbizon. Few American artists of his generation were so adaptable.

CONCLUSION

It is our hope that Munger reemerges through these pages as an American artist worthy of admiration for his accurate, poetic views of the American West in the 1870s, later for his contributions to the modern style of Barbizon painting, and ultimately for his lifelong production of high-quality professional landscape paintings that reflect the shifting cultural context for his life. Munger was chameleonlike, intensely private, and highly competitive. As a result, parts of his life and career still remain opaque. We know nothing of his reading habits, for example, and his intimate life, hinted at in various places, remains mysterious. A large number of his works remain unlocated, and the precise chronology of his later production needs to be better established. His connections with Millais, provocatively documented in his 1877 Christmas Day letter to Emmons, still remain to be investigated. Nevertheless, the new research on which this book is based gives a much fuller picture of Munger's life and work than was previously available. In assessing his achievement and seeking to establish a place for him in the history of American art, one can say with confidence that Munger engaged in great issues of his time, was befriended and patronized by leading scientists, was well regarded by leading artists, and was widely noticed by critics and collectors.

It seems unusual that over a half-century career we clearly see Munger in photographs only twice. He did not paint a self-portrait as far as is known. It is probably fair to say that throughout his career he fulfilled Ruskin's call for the artist to become transparent as an optic. In his art Munger was self-effacing and prepared to disappear behind the screen of a picture into which he poured his mind, eyes, and hands. In the 1880 portrait in *Colburn's* magazine we glimpse a serious professional

landscape painter at the height of his career. A decade later, in the *Memoir* frontispiece, we see Munger as a decorated gentleman artist of distinction. In the later photograph we gaze upon the final transformation of the son of a New Haven laborer into "Sir Gilbert Munger," fulfilling his childhood English tutor's expectations of great artistic promise. He represents himself as an American painter honored by monarchs and his peers, elegantly groomed, perfectly attired.

Sometimes we are asked why Munger was so lost that he required discovery, as well as what it means to rediscover an artist. He was never completely lost, to be sure, but by the 1960s his paintings were unnoticed and unappreciated. A few copies of the *Memoir* were available in libraries, and Myra Monroe's article on the artist could be found, albeit with diligence. Yet for reasons outlined above, Munger's long absence abroad and decision to forgo the advantages of selling through dealers never gave him the longevity it provided others. It was not until the 1970s that interest in the artist first emerged, culminating two decades later with this book. The study of Munger, although begun relatively recently, has advanced rapidly. We know much more about the artist today than we did even twenty years ago. A great quantity of previously unknown archival documentation in the form of letters, reminiscences, and newspaper reviews has made possible a far more complete account of the artist's personal and historical contexts. The body of his work has been greatly expanded, and ready access to the on-line *catalogue raisonné* makes answering questions about his work

easy, just as it simultaneously raises interesting new ones.

Munger's "greatness" measured by the standards of his age was considerable. One gauge of his success was a body of work resulting from an entirely self-sustained career that took advantage of the adaptability demanded of American artists after the Civil War. Few landscape painters maintained the level and quality of Munger's half-century-long career, or evidenced his responsiveness to changing market and cultural needs. In many ways his long, varied career offers inevitable comparison to Bierstadt and Moran, whose reputations, once nearly as obscure as Munger's, have now become familiar through recent exhibitions and publications. Can the cumulative evidence of this study argue for Munger's "greatness" in conventional terms, resituating him as an exploring artist who was the equal of the other great artists of his age? Readers and the market will make that judgment.

Gilbert Munger: Quest for Distinction is a collaborative project blending two points of view into a single narrative that tries to meet requirements for careful documentation and interpretative plausibility. The result of this rethinking is a contribution to one of the oldest genres of art-historical narrative: the artist's biography. We show Munger as a figure subject to the relentless pressure and uncertainty of finding and maintaining a position in a crowded, competitive field of painters. We eschew familiar rhetoric of celebration and of the triumph and tragedy of a "genius artist."

The Gilbert Munger presented here was no "absolute artist," standing alone without historical context. Fully embodied in his time and striving to respond to its conflicting and rapidly changing market demands, Munger is an exemplar of the professional American artist who came of age during an era of unprecedented social and intellectual change to which he responded with intelligence, determination, and originality. Our account situates him in this social milieu, demonstrating how responsiveness to the needs of his audience and market led him to produce a personal vision of the landscape. In retrospect can we suggest that near the heart of Munger's "philosophy of art" was this long quest for distinction in art? Perhaps in this there is a measure of art-historical greatness.

APPENDIX I: THE MUNGER AUTOGRAPH

ALMOST ALL MUNGER PAINTINGS are signed. The autograph is always "Gilbert Munger," printed in a stylized manner that remains remarkably consistent over his career. Most of the few unsigned paintings appear to have had the signature removed when the painting was cut down.

EXAMPLE 1:
Painting signature from 1870.

EXAMPLE 2:
Painting signature from 1870.

EXAMPLE 3:
Signature from hotel register in 1875.

EXAMPLE 4:
Pencil signature on etching from 1879.

EXAMPLE 5:
Painting signature from 1890s.

APPENDIX II: THE MUNGER TIMELINE
Specific dates and locations from historical documentation

April 14, 1837: Born at North Madison, Connecticut, to Sherman and Lucretia Munger.

September 28, 1850: Family, including Gilbert, listed in New Haven, Connecticut, census.

1850: Moves to Washington, D.C., to become apprentice engraver for federal government.

June 22, 1860: Listed in Washington, D.C., census as residing in household of artist and engraver William H. Dougal.

November 1861–May 1863: Listed as timekeeper in Employer's Monthly Time Book of Entrenchment for the Defence of Washington 1862–1865.

1866: Moves to New York City to become professional artist. Has two pictures in National Academy of Design exhibition.

July 7–October 27, 1867: Painting from a studio in St. Paul, Minnesota.

January 4, 1868: In St. Paul, Minnesota.

June 22, 1868: At Niagara Falls, apparently having traveled there from New York City.

May 12, 1869: At 82 Fifth Avenue, New York City.

June 12, 1869: With Clarence King's U.S. Government Geological Survey of the Fortieth Parallel in camp in Wasatch Mountains near Salt Lake City, Utah.

June 22, 1869: With King survey at Parley's Park camp in Wasatch Mountains, Utah.

August 1869: With King survey in Uinta Mountains, Utah.

August 28, 1869: With King survey in camp at mouth of canyon above American Fork, Utah.

October 31, 1869: Settles at Lick Hotel in San Francisco. Apparently makes San Francisco his headquarters until late August 1870.

August 27, 1870: Leaves San Francisco with King survey party for California's Mount Shasta area.

September 6, 1870: Arrives at Sissons Inn near Mount Shasta.

October 25, 1870: At The Dalles, Oregon, sketching Mount Hood.

November 16, 1870: Back in San Francisco.

November 21, 1870: Leaves San Francisco by train for the East Coast.

November 28, 1870: Stops over in Salt Lake City with King and Emmons.

December 3, 1870: On train from Cheyenne, Wyoming, to Denver, Colorado.

December 5, 1870: In transit through St. Louis, Missouri.

January 14, 1871: Resident in New York City at 48 West Twenty-sixth Street.

April 11, 1871: Has a studio at 1155 Broadway in New York City.

December 19, 1871: In New York City.

March 14, 1872: In New York City.

June 8, 1872: Meets King survey team in Ogden, Utah.

August 10, 1872: Traveling from San Francisco to Pacific Northwest.

October 16, 1872: In San Francisco, having recently returned from Pacific Northwest trip.

November 1872: Painting at Shoshone Falls in southeast Idaho.

November 15, 1872: Sketching on Donner Pass in Sierra Nevada with Albert Bierstadt.

November 23, 1872: Painting in San Francisco.

February 1873: Has studio in Room 123 at the Grand Hotel, San Francisco.

April 1873: Has returned to San Francisco from a trip to Monterey and points south.

July 5, 1873: At the Grand Hotel in San Francisco with King.

October 19, 1873: At Snow's Casa Nevada hotel in Yosemite Valley, California.

November 15, 1873: Has left San Francisco for the East Coast.

November 18, 1873: Arrives in St. Paul, Minnesota.

December 11, 1873: Has been in New York City for a week.

May 9, 1874: Still in New York City.

October 19, 1874: Arrives in St. Paul, Minnesota.

October 25, 1874: Has established a studio in the Metropolitan Hotel, St. Paul.

December 20, 1874: Still in St. Paul.

January 17, 1875: At his studio in New York City.

April 8, 1875: Still in New York City.

July 9, 1875: At Mariposa Big Tree Station near Yosemite, California.

October 24, 1875: At Snow's Casa Nevada hotel in Yosemite Valley.

October 31, 1875: At Mariposa Big Tree Station near Yosemite.

December 6, 1875: Arrives in New York City.

Fall 1877: Painting in Scotland with John Everett Millais.

December 25, 1877: Living at 15 New Cavendish Street, Portland Place, London.

1878: Spends the "season" painting in Scotland.

March 9, 1879: Living at 6 William Street, Lowndes Square, London.

1880: Living at 11 Fitzroy Street, London.

July 10, 1881: Has a studio in the Brook Street neighborhood of Grosvenor Square, London.

October 22, 1882: Painting in Venice, Italy.

1882: Living at 60 Brook Street, Grosvenor Square, London.

1883: Still living in Grosvenor Square, London.

1886: Living "at Barbizon" in France.

April 1889: Writes a letter to his niece from 35 Bould. des Capucines, Paris.

1892: Interviewed in Paris for a magazine article.

April 28, 1893: Arrives in New York City.

June 3, 1893: Interviewed in St. Paul, Minnesota.

June 19, 1893: Living at the Aberdeen Hotel in St. Paul.

August 1894: Date on a painting of Berkeley Springs, West Virginia.

February 16, 1896: Living in Washington, D.C.

1900 (approximately): Spends autumn season in Cazenovia, New York.

February 1901: Moves to Washington, D.C. (from New York City?).

January 14, 1902: Return address on a letter lists The Grafton, Connecticut Avenue, Washington, D.C.

January 19, 1902: Return address on a letter lists 1420 New York Avenue, Washington, D.C.

January 27, 1903: Dies at New York Avenue address in Washington, D.C.

February 5, 1903: Buried in Duluth, Minnesota, by brother Roger.

ENDNOTES

1 Munger to Alice Silvey, in the possession of Mrs. Lester Shervy and transcribed by Jane Jamar. Cited in Sweeney; see endnote 4, page 64, note 42.

2 *St. Paul Dispatch,* June 3, 1893, 5.

3 *Memoir: Gilbert Munger: Landscape Artist, 1836 [sic]–1903,* written anonymously by James Cresap Sprigg, De Vinne Press, New York, 1904.

4 J. Gray Sweeney, "Gilbert D. Munger" in *American Paintings: Tweed Museum of Art,* University of Minnesota Duluth, 1982, 46–69.

5 Hildegard Cummings, "Gilbert Munger: On the Trail," *Bulletin of the William Benton Museum of Art* 10, University of Connecticut, Storrs, 1982, 3–22.

6 William H. Goetzmann, *Exploration and Empire: The Explorer and the Scientist in the Winning of the American West,* Alfred A. Knopf, New York, 1967, 227.

7 Rena Coen, *Painting and Sculpture in Minnesota,* University of Minnesota, 1976, 68.

8 Patricia Trenton and Peter H. Hassrick, *The Rocky Mountains: A Vision for Artists in the Nineteenth Century,* University of Oklahoma Press, 1983.

9 Andrew J. Cosentino and Henry H. Glassie, *The Capital Image: Painters in Washington, D.C., 1800–1915,* Smithsonian, 1983.

10 William H. Gerdts, *Art Across America: Two Centuries of Regional Painting, 1710–1920,* Abbeville, 1990.

11 Michael D. Schroeder, *The Paintings of Gilbert Munger: A Catalog of Works with a Chronology,* a Web site hosted by the University of Minnesota Duluth, http://gilbertmunger.org.

12 Myra Dowd Monroe, "Gilbert Munger, Artist: 1836 [sic]–1903" in *Madison's Heritage: Historical Sketches of Madison, Connecticut,* Madison Historical Society, 1964, 118. Read before the Madison Historical Society, April 27, 1948.

13 See Linda Ferber and William H. Gerdts, *The New Path: Ruskin and the American Pre-Raphaelites,* ex. Cat., Brooklyn Museum of Art, 1985.

14 John Ruskin, "Letter" *The Crayon* 1, 1855, 409.

15 N. P. C. "Sketchings: Relation between Geology and Landscape Painting," *The Crayon* 6, 1856, 255–56.

16 Entrenchment for the Defense of Washington, The Employer's Monthly Time Book, National Archives, record group 77, entries 561–62. Munger earned about three dollars a day.

17 Cummings, 20, n. 14.

18 Henry T. Tuckerman, *Book of the Artists: American Artist Life,* 1867, 20–21; reprint edition, James F. Carr, New York, 1967.

19 *The Home Journal,* May 12, 1869, 2; cited in Cummings.

20 *The Home Journal,* May 12, 1869, 2.

21 Myra Dowd Monroe, "Connecticut Artists and Their Work," *Connecticut Magazine* 8, 1904, 778.

22 *St. Paul Pioneer Press,* November 29, 1874, 4.

23 *St Paul Pioneer Press,* July 7, 1867, 4.

24 *St. Paul Pioneer Press,* October 27, 1867, 4.

25 *St. Paul Pioneer Press,* January 30, 1868, 4.

26 *St. Paul Pioneer Press,* January 4, 1868, 4.

27 *St. Paul Pioneer Press,* September 13, 1868, 4.

28 Typescript manuscript on Roger S. Munger, courtesy of Jane Jamar.

29 *Duluth Herald,* June 17, 1911, 17.

30 Fly-leaf inscription by author James Cresap Sprigg in a copy of the *Memoir* in a private collection. The brother's name is spelled both "Russel" and "Russell" in source documents. We use the latter since it appears most often.

31 San Francisco *Daily Evening Bulletin,* June 11, 1869; cited in Nancy Anderson and Linda Ferber, *Albert Bierstadt: Art and Enterprise,* Brooklyn Museum in association with Hudson Hills Press, 1990, 7.

32 Tuckerman.

33 See J. Gray Sweeney, "An 'Indomitable Explorative Enterprise': Inventing National Parks" in *Inventing Acadia: Artists and Tourists at Mount Desert,* Farnsworth Art Museum and University Press of New England, 1999.

34 Diary of Samuel Franklin Emmons, June 29, 1869. Library of Congress, Manuscripts Division. Hereafter cited as Emmons, *Diary.*

35 Henry Adams, *The Education of Henry Adams: An Autobiography,* Boston, 1918, 311; cited in Wilkins; see endnote 39.

36 Emmons, *Diary,* September 10, 1870.

37 Rebecca Bedell, *The Anatomy of Nature: Art and Geology in Nineteenth-Century American Landscape Painting,* Princeton University Press, New Jersey, 2001.

38 William H. Goetzmann, *Exploration and Empire: The Explorer and the Scientist in the Winning of the American West,* Alfred Knopf, New York, 1967, 583–84.

39 Thurman Wilkins, *Clarence King: A Biography,* Macmillan Company, New York, 1958, 129.

40 Clarence King, *Mountaineering in the Sierra Nevada,* James R. Osgood and Company, Boston, 1872, 207.

41 C. R. Savage diary, June 12, 1869, Special Collections, Harold B. Lee Library, Brigham Young University, Provo, Utah.

42 King to Gardiner, June 22, 1869, Huntington Library, Pasadena, California, HM 27826.

43 Wilkins, 135.

44 *Alta California,* October 31, 1869, 1.

45 San Francisco *Daily Evening Bulletin,* November 25, 1869, 3; courtesy of Alfred Harrison.

46 See Gary Scharnhorst, *Bret Harte,* Twayne Publishers, New York, 1992, ix.

47 See Wilkins, 135. This is transcribed in Wilkins as "Starr King's knob" and presumably refers to Mount Starr King in Yosemite, named for Reverend Thomas Starr King, a well-known minister and travel writer. Close examination shows that the word likely is "bust," not "knob," more likely a reference to a statuary bust of Starr King. See also the Emmons *Diary,* August 19, 1870.

48 San Francisco *Daily Evening Bulletin,* April 4, 1870; courtesy of Alfred Harrison.

49 *Alta California,* March 18, 1870, 1; courtesy of Alfred Harrison.

50 *San Francisco Chronicle,* March 22, 1870, 3; courtesy of Alfred Harrison.

51 *Alta California,* June 27, 1873, 1. This article also appeared as "A New York Artist in California and Utah," *New York Evening Post,* July 10, 1873, 2; courtesy of Alfred Harrison and Merl Moore.

52 *Sacramento Bee,* April 22, 1870, 3; courtesy of Alfred Harrison.

53 King, *Mountaineering,* 223.

54 Linda Ferber, "Albert Bierstadt: The History of a Reputation" in Nancy Anderson and Linda Ferber, *Albert Bierstadt: Art and Enterprise,* Brooklyn, New York, Brooklyn Museum, 1990, 51.

55 Clarence King, *The Three Lakes: Marian, Lall & Jan, and How They Were Named,* unpaginated, privately published, 1870; reprinted in Francis P. Farquhar, "An Introduction to Clarence King's 'The Three Lakes,'" *Sierra Club Bulletin* 3, June 1939, 1–16.

56 King, *Systematic Geology,* 153.

57 *Memoir,* 10.
58 Alan Wallach, "Thomas Cole: Landscape and the Course of American Empire" in *Thomas Cole: Landscape into History,* exhibition catalog, ed. William H. Truettner and Alan Wallach, Washington, D.C., National Museum of American Art, 1994, Part III: Landscape as History, 51–77.
59 *Alta California,* August 28, 1870, 1.
60 *New York Evening Post,* May 17, 1870, 1; courtesy of Merl Moore.
61 *San Francisco Call,* May 13, 1870, 3; courtesy of Alfred Harrison.
62 *Alta California,* June 5, 1870, 2.
63 *San Francisco Evening Post,* April 14, 1873, 1.
64 *Alta California,* October 10, 1870, 1; courtesy of Alfred Harrison.
65 San Francisco *Daily Evening Bulletin,* September 30, 1870, 3.
66 San Francisco *Daily Evening Bulletin,* November 22, 1870, 3; courtesy of Alfred Harrison.
67 Emmons to his brother Arthur, November 14, 1870, Library of Congress, Manuscripts Division.
68 King, *Mountaineering,* 282.
69 *New York Evening Post,* January 10, 1872, 1; courtesy of Merl Moore.
70 King, *Systematic Geology,* 478.
71 San Francisco *Daily Evening Bulletin,* November 22, 1870, 3; courtesy of Alfred Harrison
72 The hotel registers are at the Yosemite Museum. Munger's signatures were found by Kate Nearpass Odgen, associate professor of art history at the Richard Stockton College of New Jersey, who kindly shared her discovery.
73 *Memoir,* 11; also *California Advertiser,* November 15, 1873, 5; courtesy of Alfred Harrison.
74 King, *Mountaineering,* x.
75 King, *Mountaineering,* 185.
76 King, *Mountaineering,* 171.
77 King, *Mountaineering,* 170.
78 King, *Mountaineering,* 178.
79 *St. Paul Pioneer Press,* December 6, 1874, 4.
80 King, *Mountaineering,* 179.
81 King, *Mountaineering,* 51.
82 King, *Mountaineering,* 52–53.
83 King, *Mountaineering,* 172.
84 *Alta California,* October 10, 1870, 1; courtesy of Alfred Harrison.
85 *Washington Evening Star,* November 27, 1872, 1; courtesy of Merl Moore.
86 Emmons, *Diary,* December 3, 1870.
87 Clarence King, "The Falls of the Shoshone," *Overland Monthly V* (October 1870), 379–85.
88 *New York Times,* May 21, 1871, 5.
89 San Francisco *Daily Evening Bulletin,* December 18, 1872, 3; courtesy of Merl Moore.
90 San Francisco *Daily Evening Bulletin,* January 8, 1873, 3; courtesy Merl Moore.
91 San Francisco *Daily Evening Bulletin,* February 17, 1873, 3; courtesy of Merl Moore.
92 *The Illustrated Press* (San Francisco) 1, no. 2, February 1873.
93 *Alta California,* January 17, 1873, 1.
94 James Yarnell and William H. Gerdts, *The National Museum of American Art's Index to American Art Exhibition Catalogs: from the Beginning through the 1876 Centennial Year,* G. K. Hall, Boston, 1986.
95 San Francisco *Daily Evening Bulletin,* May 21, 1873, 1; courtesy of Alfred Harrison.
96 King, *Mountaineering,* 243.
97 See J. Gray Sweeney, *Drawing the Borderline: Artist-Explorers of the U.S.–Mexico Boundary Survey,* Albuquerque

Museum/University of New Mexico Press, 1996.
98 King, *Mountaineering,* 237.
99 *Sacramento Bee,* April 22, 1870, 3; courtesy of Alfred Harrison.
100 *The California Art Gallery* 1, no. 2, 19; courtesy of Alfred Harrison.
101 *Alta California,* May 26, 1876, 1.
102 San Francisco *Daily Evening Bulletin,* May 16, 1873, 3; courtesy of Alfred Harrison.
103 *Alta California,* May 29, 1873, 1; courtesy of Alfred Harrison.
104 *New York Evening Post,* December 11, 1873, 1; courtesy of Merl Moore.
105 *California Advertiser,* November 15, 1873, 5.
106 *St. Paul Pioneer Press,* October 20, 1874, 4.
107 *New York Evening Post,* December 5, 1874, 1; courtesy of Merl Moore.
108 *St. Paul Pioneer Press,* November 15, 1874, 4.
109 *St. Paul Pioneer Press,* November 29, 1874, 4.
110 *St Paul Pioneer Press,* December 6, 1874, 4.
111 *St. Paul Pioneer Press,* December 20, 1874, 4.
112 *The Independent* (New York), May 23, 1872, 2.
113 Sanford R. Gifford papers, letter May 16, 1872, Archives of American Art, RG57, mfm 623, frame 563. Cited in Joni Louis Kinsey, *Thomas Moran and the Surveying of the American West,* Smithsonian Institution Press, Washington, D.C., 1992, 64.
114 *St. Paul Pioneer Press,* January 17, 1875, 4.
115 King, *Systematic Geology,* 1.
116 Emmons papers, Manuscript Division, Library of Congress.
117 Goetzman, 458, n. 3.
118 King, *Systematic Geology,* 398.
119 King, *Systematic Geology,* 388.
120 King, *Systematic Geology,* 388.
121 San Francisco *Daily Evening Bulletin,* p. 1, c. 3, August 10, 1872.
122 "The Prang Collection of Paintings," *New York Evening Post,* December 6, 1875, 3.
123 *St. Paul Pioneer Press,* June 3, 1893, 5.
124 Munger to Samuel Franklin Emmons, Christmas Day 1877, in the Emmons papers, Manuscript Division, Library of Congress.
125 See Richard Kenin, *Return to Albion: Americans in England 1760–1940,* Washington, D.C., National Portrait Gallery, 1979, especially "Expatriates Incarnate: The World of Henry James."
126 The bibliography on J. E. Millais is large. An important contemporary scholarly reassessment is *John Everett Millais: Beyond the Pre-Raphaelite Brotherhood,* ed. Debra N. Mancoff, Yale University Press, New Haven, 2001.
127 *St. Paul Pioneer Press,* June 3, 1893, 5.
128 See Laurel Bradley, "Poetry in Nature: Millais Pure Landscapes" for a discussion of what is termed "bleak landscapes." Also valuable is Julie F. Codell, "Empiricism, Naturalism and Science in Millais's Paintings." Both in Mancoff, ed. *John Everett Millais.*
129 *The Art Journal* 5, no. 7, 1879, New York, D. Appleton and Company Publishers, 219.
130 Parke-Bernet Galleries, New York, *Catalog for Sale 819,* 10–14, December 1946, lot 178.
131 Monroe, 1964, 122; cited in Cummings, 13.
132 *Boston Evening Transcript,* June 20, 1878, 3; courtesy of Merl Moore.
133 *Boston Evening Transcript,* March 9, 1880, 6; courtesy of Merl Moore.
134 *St. Paul Pioneer Press,* July 10, 1881, p. 5, quoting the *London Art Journal.*

135 *Colburn's* magazine, June 1880, cited in *Memoir,* 13.

136 *Boston Evening Transcript,* June 20, 1879, 3; courtesy of Merl Moore.

137 *St. Paul Pioneer Press,* April 24, 1881, 5.

138 "The Backwaters of the Thames: Old Windsor to Moulsey," *The London Art Journal,* 1883, 397.

139 Algerian Graves, *The Royal Academy of Art,* Henry Graves and Company, London, 1906, 325.

140 Wilkins, 329.

141 *St. Paul Pioneer Press,* October 22, 1882, 12.

142 *St. Paul Pioneer Press,* June 3, 1893, 5.

143 Cited in Cummings, 13, n. 53.

144 See Gary Scharnhorst, *Bret Harte,* Twayne Publishers, New York, 1992, 88.

145 For important discussions of English art and issues of modernity, see *English Art 1860–1914: Modern Artists and Identity,* ed. David Peters Corbett and Lara Perry, Rutgers University Press, New Jersey, 2001.

146 *St. Paul Pioneer Press,* June 3, 1893, 5.

147 *St. Paul Pioneer Press,* June 3, 1893, 5.

148 Munger to J. C. Sprigg, January 22, 1902, private collection.

149 *St. Paul Pioneer Press,* July 22, 1878, 7.

150 *St. Paul Pioneer Press,* June 3, 1893, 5.

151 Haags Gemeente Museum, *The Barbizon School,* exhibition catalog, The Hague, Netherlands, 1985, 47.

152 A. B. Blake, "Fontainebleau and Barbizon," *The Art Journal,* 1882, 326–28.

153 *The London Daily Telegraph,* October 19, 1886, n.p.

154 *The Art Journal,* 1887, J. S. Virgue and Company, New York, 125.

155 Charles Sprague Smith, *Barbizon Days,* A. Wessels, New York, 1903, 11.

156 Transcribed and translated by Greg M. Thomas in *Art and Ecology in Nineteenth-Century France,* Princeton University Press, New Jersey, 2000, 216–17.

157 *St. Paul Pioneer Press,* June 3, 1893, 5.

158 *The London Daily Telegraph,* May 15, 1886.

159 Greg M. Thomas, *Art and Ecology in Nineteenth-Century France,* Princeton University Press, New Jersey, 2000.

160 For a history of this, see Donald Worster, *Nature's Economy: A History of Ecological Ideas,* Cambridge University Press, 1977, 1994.

161 *St. Paul Pioneer Press,* June 19, 1893, 5.

162 *Fame and Fortune,* March 3, 1887; cited in *Memoir,* 16.

163 *Memoir,* 16.

164 *Gilignani's Messenger,* Paris, 1887; cited in *Memoir,* 16.

165 *St. Paul Pioneer Press,* June 3, 1893, 5.

166 See Sarah Burns, *Inventing the Modern Artist: Art and Culture in Gilded Age America,* Yale University Press, New Haven, 1996. Munger might have read the illustrated article on "Painter's Studios" in *Art Journal* 1890, page 11, which described various artists' studios, asserting, "Show me an artist's surrounding, and I will tell you what he creates. . . . The adornment of his studio is almost a duty a painter owes to his public."

167 Cummings, 17.

168 Cummings, 12.

169 *St. Paul Pioneer Press,* June 3, 1893, 5.

170 *St. Paul Pioneer Press,* June 3, 1893, 5.

171 *Duluth Sunday News Tribune,* February 8, 1903.

172 See endnote 1.

173 Munger to J. C. Sprigg, January 19, 1902, private collection.

174 Monroe, 1964, 2.

175 *American Art Annual 1900–1903.*

176 Harold Bell Wright, *To My Sons,* Yestermorrow, Incorporated, Maryland, 1934, 157.

177 Wright, 159–65.

178 Greg M. Thomas, *Art and Ecology in Nineteenth Century France,* 18–34.

179 *New York Commercial Advertiser,* January 5, 1904, page unknown.

180 Monroe, 1964, 125. The authors are indebted to Betsy Fahlman for information on Monroe and her training at the Yale Art School.

181 Monroe, 1964, 120.

182 Raymond Williams, *Culture and Society: 1780–1950,* New York, Columbia University Press, 1958, revised ed. 1983, xvi.

183 Monroe, 1964, 123.

184 Monroe, 1904, 782.

185 The 1902 letters from Munger to J. C. Sprigg are in a private collection.

186 James T. Gardiner, 14 Church Street, New York, to S. F. Emmons, Esq., 1721 "H" Street, Emmons papers, Manuscript Division, Library of Congress.

187 *Duluth Sunday News Tribune,* February 8, 1903.

188 *Minneapolis Journal,* May 2, 1903.

189 *New York Commercial Advertiser,* January 5, 1904, page unknown.

190 Personal conversation with Michael D. Schroeder.

191 Monroe, 1964.

192 Munger to J. C. Sprigg, January 19, 1902, private collection.

The Munger Web site contains the complete text of most of the period sources referenced in this book.

http://gilbertmunger.org

INDEX